Guide to Getting Arts Grants

ELLEN LIBERATORI

ALLWORTH
PRESS
NEW YORK

11 10 09 08 07 6 5 4 3 2

Published by Allworth Press
An imprint of Allworth Communications, Inc.
10 East 23rd Street, New York, NY 10010

Cover design by Derek Bacchus
Interior design by Joan O'Connor
Typography by Integra Software Services, Pondicherry, India

ISBN-13: 978-1-58115-456-6
ISBN-10: 1-58115-456-9

Library of Congress Cataloging-in-Publication Data

Liberatori, Ellen.
 Guide to getting arts grants / Ellen Liberatori.
 p. cm.
 Includes bibliographical references and index.
1. Arts—United States—Finance. 2. Arts fund raising—United
States. 3. Proposal writing for grants—United States. I. Title.

 NX705.5.U6L53 2006
 700.79'73–dc22

 2006013939

Printed in the United States of America

JY 25 '07

CONTENTS

ARTS

ACKNOWLEDGMENTS

Thanks to all the staff of Allworth Press, especially Tad Crawford and Nicole Potter-Talling, for the opportunity to write this book and for their helpful guidance and assistance in putting it together. Thank you to Monica Lugo and Nana Greller for making the task seamless in project management and publicity.

Thank you to my colleagues and associates for their great support and permission to highlight their work:

- Anita Pampusch, John Archabal, and Martha Lee at the Bush Foundation
- Neal Cuthbert at the McKnight Foundation
- Cynthia Gehrig at the Jerome Foundation
- Bill King at the Council of Foundations
- David Gergen, who encouraged me to flee my nest in St. Croix. I draw strength from your kind words
- The Dyson Foundation for the use of its sample grant agreement
- The board of directors, staff, teachers, and students at the West Bank School of Music
- The staff at Open U/Learning Annex

A very special thank you to Jon Harrison at the University of Michigan, who has permitted the use of the great resources and Web links that will help artists and nonprofit organizations in seeking support.

I extend my most heartfelt thanks to my fellow artists, teachers, and mentors for their support throughout a very long journey. Thank you for allowing me to share your successes as you continue to inspire: Bill Banfield, Milo Fine, Clint Hoover, John Minczeski, Carei Thomas, and Barb Tilsen.

To the many grantseekers, clients, and colleagues who are often lost along the way, I thank you for sharing, dreaming, risking, and learning with me.

To my dearest friends and family, here and abroad, who have never wavered in the belief of all my crazy dreams, your continued support has made all the difference.

To Aida Ayoub, whose courage and will in the face of great adversity inspired me to send in this manuscript.

To Karen and Arnold Kustritz, who gave so much to make this happen; without you and the Birdhouse, I would have been lost.

To Mary Olympia, who has been alongside me every step of the way.

And to Marwan El Dewey and Angela Cressaty, whose support of this writer's life helped make it possible.

INTRODUCTION

I listen to [a] concert in which so many parts are wanting.

—HENRY DAVID THOREAU

This is how it feels to live the life of an artist: Many ideas, projects, brainstorms, and muses coming at us at once, a barrage of details to manage. And typically, the biggest challenge is finding the time to be creative. We have so many daily responsibilities that our creative passions take a backseat. And unless you are an established artist, the time you take for your creative pursuit may conflict with time you already spend on supporting yourself in other ways. This time and space equates to money, your livelihood, and financial support. The typical scenario is to juggle day work while you do your art. Often you have special projects and need concentrated time without the distractions and pitfalls of your job. You desperately need to get to that creative place that helps you produce something wonderful. Yet, without the rich uncle, where do you turn?

There is the world of philanthropy and grants. Many of us have heard of it, but few have clues concerning how to enter. Some of us have even tried, and can't understand why we didn't get the grant. And for those of us who are just wired in very different ways, applying for a grant seems so foreign, even though it holds great opportunity and promise.

This guidebook will help you learn about the world of grants and how to navigate it. Through a "present and practice" mode, I provide the tools and support you need to successfully find grant sources and make an application. Obtaining grant support for your project may seem to be an elusive process, especially if you are reading this book after a failed attempt or two. Conversely, you may hear the odd anecdote, which seems to float through every artist community, about

the unsuspecting donor walking the streets who discovers the next prodigy, and the six-figure check and grant that follows. This, I'm afraid, is really not the norm and may be even harder to come by than a grant.

The working model should be to become passionate about your project; hold onto your vision, develop tenacity for grantseeking and fundraising, and articulate your needs well. The winning strategy for getting grants is to meet, meet, meet, write, write, write, and send, send, send.

This book will help you in these endeavors. At the same time it will provide you with basic information about the philanthropic community and help formulate strategies to effectively approach this community. For those who have experience in grantseeking and have been successful in obtaining support for their programs, the guide will provide very specific information that will give a "reality check" to your approach.

✒ HOW TO USE THIS BOOK TO YOUR ADVANTAGE

I have developed this guide using the tools I myself have used in getting grants. Each chapter begins with an overview, which presents a quick synopsis. Also included is a section I call "The Grant Zone," which illuminates helpful hints related to the grant process. And finally, each chapter discusses dos, dont's and things that irritate board members with "Board Pet Peeves" and "Grantseeker's Dos and Don'ts." With these helpful hints you'll have a behind-the-board-room look at the kinds of things that can make your application sink or float.

In writing grant proposals for over twenty years, I have heard every complaint, scrutiny, and criticism. Since I have already done this leg-work, you will benefit greatly from my failures and successes. Hopefully you will gain a strong sense of tenacity and the ability to learn through feedback and review.

Use this guide as if you have a personal grantwriting coach. Pay attention to the comprehensive set of ideas, strategies, and tools that can really help you jump through hoops, which is what it sometimes feels like when you are seeking grants. Whether you are a visual artist, writer, photographer, designer, or filmmaker, this guide will support you in your endeavors.

❧ Something for the Novice, Mid-career Artist, and Seasoned Professional

For the novice I present the basic elements of how to organize a collection and portfolio of work that can be used in the application process. I present many exercises and mini-workshops to help you prepare yourself. Many of you may have an aversion to writing in a book, so please equip yourself with a notebook and pencil to help you complete the exercises. This guide can also help the artist in mid-career who needs a grant for that seemingly elusive project. And for all the unsung artists who are seasoned and professional with many tributes and honors to their name, this book can help you become more visible within funding circles. Even if you have already been a "grantee," you can always improve your grantseeking skills.

At the end of the day, we are creative individuals trying to integrate our natural senses in interpreting our world and its people. It *is* a gift to see and experience life a bit differently. Indeed as Thoreau said, "we hear a concert in which so many parts are wanting." Close your eyes; take a deep breath...it is time to focus your energy, creative passion, and attention, and give your creative spirit what it is due.

CHAPTER ONE

A World of Philanthropy

"But where shall I start?" asked Dorothy.
"It's always best to start at the beginning," said Glinda, smiling.

—THE WIZARD OF OZ

At the beginning, we shall start. Here, we hope to provide an understanding of the type of philanthropy that focuses on giving to individual visual artists, writers, photographers, performers, filmmakers, and creative people from all disciplines. We will touch upon the evolution of grantseeking and grantmaking, demonstrating the ebb and flow of monies and trends for art funding.

PHILANTHROPY'S PLACE IN HISTORY

Philanthropy, like any social science, has its rightful place in history. Private philanthropy is a fabric of life: basic, strong, and certainly colorful. Like Yeats writes in "He Wishes for the Cloths of Heaven," we have the blue threads, the dark threads, and the golden threads all weaving into the fabric we call our cities and communities. Without the threads of philanthropy, we wouldn't have libraries, hospitals, museums, schools, parks, books, paintings, or musical compositions. There are few areas that have not been touched by the philanthropic community. Philanthropists have always tried to find the solutions to the human condition. In our own time, philanthropic monies fight poverty and disease, and support education, housing, and health, to name but a few causes.

Then and Now

A historical overview of philanthropy and how it has affected society would span many centuries and is much too long to include here. There is a bona fide, legitimate Center for Philanthropy at Indiana University that has recently developed academic studies for studying philanthropy. Comprehensive historical data and anecdotes can now be found in one central place. For our discussion, I will touch lightly upon history, focusing mostly on the last forty years of philanthropy and its progress. Understanding the trends that have affected the growth in grantmaking and donor contributions is indeed pertinent to our endeavor.

Certainly the days are gone when John D. Rockefeller handed out shiny dimes to the unsuspecting poor. Even the small loans made by Franklin's Friends, established by Benjamin Franklin himself to "young married artificers of good character" made its final distribution in 1991. In the 1940s, the Rockefeller Foundation came to the aid of individuals. Through special support, the Foundation helped bring scientists to the United States, many of whom were threatened by the rise of Nazism.

Look at the many exhibits of public art and commissioned work and you will see philanthropy's commitment to individuals doing their art. But this has not been easy for foundations, given Congress' great suspicion concerning grants of this kind. Current tax laws and policies governing nonprofits and foundations favor grants to organizations, but foundations that are committed to individual grantmaking seem to gracefully maneuver the accountabilities and tax structures that ensure that monies are granted properly.

✧ THE SOPHISTICATION OF PHILANTHROPY

The "grant to individuals" category is special and one that brings greater scrutiny upon a foundation. Yet all areas of grants in philanthropy have had their share of external pressures to be more accountable. After September 11, 2001, the American Red Cross and some of the nation's largest relief agencies came under great scrutiny and criticism for their distribution and accounting methods.

Delving into this, we begin to see philanthropy in a different light. Grantmakers have great expectations put upon them, as we want them to not only save the day, but to do so in a kindly fashion. We may be quick to point a finger when they show their administrative weakness, but then we are annoyed when asked for a simple report. Even though

I present the experience of both grantmaker and grantseeker, I maintain a neutral position, believing we are all here to advance society.

The needs of society are ever present, and grantmakers are inundated with requests. I well understand the motivations of grantmakers who are particular about the projects that they fund, given the number of requests they receive. This makes the grantseeking process fairly competitive, with the pressure to be unique and special prevalent in the attitudes of many foundation boards. This message should not have you leaping to the conclusion that philanthropists are cynical or greedy people who don't want to support good causes. On the contrary, in 2004, over $31 billion was granted in the United States and abroad with about 2 percent going to international causes. But we need to understand that the Boards of Trustees have "heard it all" in the last forty years. Many approaches and strategies to society's problems have been tried and tried again.

☞ UNDERSTANDING THE BASIC STRUCTURE OF PHILANTHROPY AND FOUNDATIONS

We will study this in depth in chapter 5, but for now it is important to know why foundations give to the arts. Foundations have many purposes, and these are stated in their missions, which are like banners—slogans even—as some have become savvy about their public image. In the arts arena there are four primary *motivations* for giving grants through the arts:

* Supporting art for art's sake. Ensuring that there is an arts culture and that it has longevity and public appreciation.
* Supporting artistic development by supporting individual artists and commissioning work.
* Supporting arts education and organizations that foster art in the community.
* Supporting art as a way to impact the public good through all of the above but also specifically through public art projects.

Here are a few mission statements that will help you understand further these primary motivations:

* From the Bush Foundation: "We improve the quality of life in our geographic region by making grants that help strengthen

organizational, community, and individual leadership. Across our grantmaking programs, and in a variety of ways, the Foundation creates opportunities for people who may lack them."

* From the Jerome Foundation: "The Jerome Foundation, created by artist and philanthropist Jerome Hill (1905–1972), makes grants to support the creation and production of new artistic works by emerging artists, and contributes to the professional advancement of those artists."

* From the McKnight Foundation: "Our mission is to improve the quality of life for present and future generations, and to seek paths to a more humane and secure world."

Interestingly, except for the Jerome Foundation example, you might not know from the mission statements that these foundations support the arts in a variety of ways, including individual artists. These are good examples of mission statements, especially for foundations that make more than one type of grant or have many interests.

✑ TYPES OF GRANTS

The mission of a foundation is further broken down into the types of grants that are given out on a periodic basis. The following list will give you a general idea of what could be available to you:

* Organizational grants for arts programs
* Special projects
* Art career fellowships
* Short-term fellowships
* Travel and study
* Mentoring grants
* Emerging artist grants
* Distinguished artist grants
* Arts collaboration grants
* Production grants to finish a work or collection in any discipline, pre- and postproduction for film and media projects
* Peer learning grants for artists who also work in nonprofits

Even though philanthropists have designated these kinds of grants, generally speaking, all foundations are attempting to improve society

through their support of the arts. There are many examples, but a good one is seen within the independent filmmaking arena. Many philanthropists in this category are inspired and motivated to help artists make and produce good films, which may have their own commercial appeal and success. Many of the grant programs available focus on turning out films that broaden a society's attitude or change it in terms of a social problem.

For instance, the Sundance Documentary Fund makes grants for the production of films that have social significance, which are "focused on current and significant issues and movements in contemporary human rights, freedom of expression, social justice, and civil liberties. In supporting such works, the Sundance Documentary Fund hopes to give voice to the diverse exchange of ideas crucial to developing an open society, raise the public consciousness about human rights abuses and restrictions of civil liberties, and engage citizens in a lively, ongoing debate about these issues."

As you can see through these statements, the motivations to change some segment of society for the greater and public good is more than an appealing notion for philanthropy. Philanthropists want to leave a positive mark through their contributions, and some try to make broad and sweeping change.

❧ PHILANTHROPISTS HOPE FOR SOCIETAL CHANGE

During the era of the Great Society (roughly the administration of President Lyndon B. Johnson, 1963–1969), human developers wanting social change promised funders they would eliminate poverty, drug addiction, and other harmful problems, and improve communities with better education and human service programs. Nearly forty years later, during my tenure as a foundation director and program officer, the very same promises are being made.

Grantmakers want to ensure that their support will indeed improve the community. Now, more than ever they want to maximize their dollars. So when they say they want "unique or special," they really mean they want something that leverages other support and interest, and even raises consciousness in new and different ways. Foundations are not banks, and they resist being treated as such.

Philanthropists *have* become sophisticated during these last forty years, primarily because our society has grown exponentially. Back

then, it seemed that an organization only had to present the problems, and grants would be made. Nowadays, new solutions and ways to evaluate them must also balance the needs presented in a request for support.

Society and Its Impact on Artists Grants

We artists must integrate the passion of our muse with the relevant and persistent themes of society. Certainly there are grant programs that support art for art's sake, but there is a predominant underpinning to most programs that emphasizes that art must relate back to the community. This style of grantmaking is a creative way of catalyzing social change. It is change through "bread and roses" philanthropy. In the hierarchical needs of society, funders see value in providing communities with elements that get at issues of poverty and so on—the bread—while at the same time elevating the human condition through art and culture—the roses. It pushes us to think on a grander scale.

Presently, foundations and corporate boards have developed great infrastructures for grantmaking. Grantseekers have been involved in this process through forums, evaluation, and feedback. With the advent of university and academic programs specializing in fundraising and fundraising sciences, the processes have become more formal on both sides. This generation of contemporary philanthropists advancing in the direction of formality may have you jumping hurdles to apply for a grant. But thankfully, some foundations are returning to a middle ground in the areas of application, reporting, and evaluation—even relaxing a bit. The motivation for funders to serve the community, not only through the grants they make but also through a standard of "best grantmaking practices" that are more user-friendly for applicants, mitigates some of the application complexities. Many foundations have adopted the Common Grant Form for applying and have clear guidelines. There is even a "bill of rights" for grantees, which attempts to provide a professional protocol for grantmaking, ensuring that grantseekers will be treated seriously, respectfully, and professionally.

ஃ IDIOSYNCRASY OF FOUNDATIONS

The very word *idiosyncrasy* looks crazy and different. There are as many differences in foundations as there are in people. Even with more and more foundations adopting generic application practices, each has its

own field of interests and unique ways of presenting them. Foundations for the most part are formed through an individual's last will and testament and final bequest. A wealthy person dies and passes on his or her fortunes to the community through a foundation. His or her last wishes, and how his or her legacy lives on, are quite unique; the way they read in an annual report can even seem poetic. One only has to look at the variety of foundation names to see this uniqueness played out. We find abbreviated surnames, names spelled backward, the full pedigreed name, and the use of themes that capture the main focus of the benefactor's interest.

Having sought grants from hundreds of foundations in my career and having many board trustees and staff as my colleagues, I am always amazed at what I see as a subculture related to the field of philanthropy. Even though a benefactor has long ago passed on, his or her presence is almost a ghostly image prevailing in the boardroom. Staff and trustees can literally spend hours reflecting upon that benefactor's style and approach to giving grants while he or she was alive. It is surprising to me how the nuance of a benefactor's tradition of philanthropy carries forward.

The familial and independent nature of foundations seems to perpetuate a tradition of heredity in the style of grantmaking that gets carried on like other common family traits. As the old guard passes on, so does the torch of responsibility to a benefactor's offspring. Current generations are now responsible for maintaining the family, corporate, or individual's legacy within the community. This can be a daunting task and one that is sometimes led by whim, as when an heir attempts to put his or her own stamp on philanthropy. It is no wonder foundations seem idiosyncratic.

✆ TRENDS IN GIVING OVER THE LAST FORTY YEARS

Grantmakers and philanthropic institutions have exponentially increased since their modest beginnings at the turn of the twentieth century, and we now have over 66,000 grantmaking foundations in the United States. This species of animal has many subspecies, which include private foundations, community foundations, family foundations, and corporate foundations and giving programs. As I mentioned in the beginning of the chapter, foundation giving is truly woven into our society as is demonstrated by nearly $31 billion granted annually.

In looking at foundation giving over the last ten years, the arts received nearly 10–15 percent of all grant monies. This includes a range of giving to organizations, museums, historical activities, media, arts-related humanities, and, of course, artists.

The Achilles Heel of Philanthropy

A central point in understanding philanthropy is that its available cache of grant dollars comes from the stock market. When benefactors leave their wealth behind, there are rules and regulations for how it can be distributed. Typically the corpus is invested, and the interest is what we see through the grant dollars we receive: The greater the principle, the greater the return.

Now, this is fine and good when the stock market is having strong returns but an Achilles heel is exposed here. A foundation's philanthropic portfolio is only as strong as the stock market. Even when a funder has invested the corpus in "safe" or more secure investments, their ability to increase grantmaking and benefit the community is limited by the return on those investments. During the 1990s, philanthropy saw one of the greatest bull markets in history. As double-digit returns came in, the principles of invested dollars grew dramatically. As a result, toward the end of this period, arts funding nearly doubled and even exceeded general grants giving between 1995 and 2001.

In times of plenty, philanthropy has responded with new streams of grants, giving depth to the field by way of grants for planning, technical assistance, evaluation, and so on. Despite fluctuations, the decade of luxury and surplus helped establish a solid infrastructure to philanthropy.

As the pendulum swings one way for private support, it usually swings in the opposite direction for public support. The National Endowment for the Arts (NEA) in particular saw great cutbacks from the federal government, and in 2001 private foundation grants for the arts more than tripled those of the NEA. State funding also outpaced the NEA during this period.

This aspect of funding points to an inherent Achilles heel in the growth of grantmaking. Given its connection to the health and stability of the stock market, there can be great volatility in a funder's ability to make grants. Yet even with the dramatic fall of the market in 2002 and subsequent recession, foundations have weathered the storm. Naturally, a few lost the value of their bulging principles, and there were

some casualties. Some foundations downsized and restructured their investment portfolios, while others held onto some of their monies by "freezing" grants for capital projects. Even though giving dropped off dramatically, it has returned to a midpoint. There has been a leveling off after a couple of tough years, and the rate of return for giving is in a range that is considered more the norm.

Charitable giving has indeed bounced back after the recessive trends in 2001 and 2003. Indications show a modest increase overall, yet a solid return to greater stability has been hampered by the national debt, rising oil prices, the mounting costs of war efforts, and a loss of consumer confidence in the economy, which usually dips before and after presidential elections. Philanthropy does evolve around the investment arena so when the economy is uneasy for whatever reason, charitable giving is affected.

Naturally, during times like these, arts funding shrinks overall. However, we can still look to a future in philanthropy that supports individual artists and projects.

Future Trends

The following information highlights future trends for arts giving. Thirty-five of the leading foundations in arts funding were included in a survey conducted by the Foundation Center. They reported changes in program focus, the types of support given, and their strategies for making grants. The study shows that the majority of funders have introduced changes overall. Even though some foundations noted changes in their giving practices, few also noted that consistency was their strength, thereby not changing much at all.

Since 1996, many have instituted major changes in their focus and the way they define the arts. As the arts evolve, new understandings of their place in society also evolve. Foundations report program changes that help move the arts field forward, as well as changes in the target groups that they serve. Some of the major changes were seen in underrepresented groups, grassroots organizations, midsize arts groups, as well as rural groups and individuals.

As is the case across the board, arts funding and its grantmakers have developed more strategic approaches to their giving programs. Many foundations have narrowed their focus by selecting particular issues that can then be evaluated by both grantmaker and grantseeker. A greater emphasis on singular issues and problems are addressed in

systematic ways—for instance, increasing the field of artists to include greater diversity has been a key theme, and funders have provided seed grants and such in communities of color.

Funders are also integrating their programs more, and so collaborations bridging arts and non-arts programs have emerged. In response to pressures to be more effective, they are making larger grants and initially more multiyear grants, although that trend is being reevaluated after some recession impacts.

There has been an exponential increase in grants for capacity building, organizational development, and technical assistance. This was a product of the fatter years at the end of the bull market, and philanthropy fortified the nonprofit sector in general.

The study predicts a continued growth in arts funding, with funders optimistically committing themselves to expanding philanthropy. Higher expectations and accountability may come with new territories and greater opportunities in the areas of new media, interdisciplinary projects, and informal arts. Finally, technology's role in all this will affect the way artists and funders carry on their work, making it more difficult to distinguish between for-profit and nonprofit activities.

Other General Trends

The outlook is a fairly positive one, given the above findings. Perhaps a harbinger of opportunity is the continued growth in the number of foundations that are still being developed. American foundations saw the greatest expansion during the ten-year period of 1993–2003. Grantmaking foundations rose nearly 77 percent during this time, with approximately 66,400 currently existing. Even though the pace has slowed due to economic factors, more than 1,500 new foundations were created in 2003. As you can see, there is still a lot of giving power at your disposal, and you are just at the beginning stage in tapping it.

✎ MAKING YOUR OWN HISTORY AND DEBUT

Although this isn't the History Channel, a great amount has been covered briefly. You now have some basic knowledge of the inner workings of grantmakers. You now know that many foundations, including many that give individual grants to artists, have their own

longstanding idiosyncratic traditions. Understanding a bit about the history of a foundation will make it easier for you to discern whether it is a good prospect for you. You won't waste precious time trying to "fit" into a foundation whose giving history doesn't support artistic endeavors. With so many opportunities and your creativity, you can move onto the next opportunity and focus your efforts wisely.

Here you go!

THE GRANT ZONE

Remember these vital keys in getting grants:

Be tenacious and learn as much as you can about a foundation before you approach it.

Despite their history and formalities, foundations are bound by law to give grants away, so don't be intimidated.

Philanthropy and grantmaking will always have an ebb and flow.

GRANTSEEKER'S DOS AND DON'TS

Do try to collaborate with foundations and maximize their dollars.

Don't think of them as banks—remember, they are supporters.

Do try to think about the greater good and improvement of the community through your artful life.

CHAPTER TWO

Preparation for Grantseeking

*What can anyone give you greater than now, starting here, right
in this room, when you turn around?*

—WILLIAM STAFFORD, FROM *YOU READING THIS, BE READY*

Yes, be ready, get ready, it's time. The bells of the present moment are
clanging you into action. It's now! No more worrying, fretting—what to
do, how to do it? Yes, you are an artist making that next step in becoming.

This chapter will help you prepare yourself and your work for view-
ing by grant reviewers and by the public. We will discuss the preparatory
phase in grantseeking and cover what is needed before you actually
approach a grantmaker or foundation.

I will present this information in a continuum, covering the needs of
the emerging artist, the artist in mid-career, and the seasoned profession-
al. This chapter will provide many ideas for you to consider, as the steps
following this will involve strategy and planning. But before we get that
focused, let's allow our minds to think of the options and ways we can
advance our creative lives. Let's be ready, and let's prepare for success!

❧ LIFE IS LIKE A GAME OF DARTS

I have always said that life is like a game of darts. Some people
stand in front of the dartboard, darts in hand, but never throw a single
dart. Not one. Like risks and opportunities, few people chance them.

If you don't, you never really have a chance, if you don't throw the dart, you never get the bull's-eye. And yes, you are right; you may throw it and still not get the bull's-eye. But remember—life is like a game of darts—you have to throw the darned things to play. You won't know how close you can get until you do.

You have to get beyond the procrastination, laziness, fear of failure, indecision, and uncertainty that block you from living your dream. Too many artists live in a world where they are "wannabe" writers, painters, photographers, and so on. They envision a life outside of what they are doing right now. They haven't managed to integrate their present situation into their artistic goals. And fairly speaking, it can be difficult to make our dreams a reality. Let's look first at the common barriers that impede our progress in achieving what we want.

Fear of Failing

One of the greatest factors impeding our progress is the fear of failure. It's not an easy thing to face the possibility of failing, but the biggest failure is not trying. Much of life's achievement is about practicing and trying to succeed. The more times you try, the closer you get to the goal. At the very least, like Thomas Edison said, you know hundreds of ways *not* to do something.

In a Zen or holistic way of thinking about it, for some of us, trying is the goal. If you are that far in your thinking, the fear vanishes. You will stop living a label of artist- or writer-wannabe, and do the creative work that brings joy. That is the ultimate goal of any dream.

Fear of Change

Another major block to realizing your dreams is a fear of how they will change your life. Even when the familiar is dull, boring, or painful, we hang on like a bad piece of cling wrap. Please try to understand something here; when I talk about living an artist's life and embracing change, I'm not talking about things that are intangible and out of reach. I'm talking about simple blockades we put up in order to resist achieving what we want—those self-defeating behaviors, judgments, and attitudes that we carry around with us.

A good example is the idea that you can't be an artist because you don't have the time to do your art. How does one find time during a workday to paint, write, design, or sculpt? We can look to our

predecessors and find a rich history in how "art became them," how they whittled away at it and learned their craft. It's as easy as getting up early in the morning and giving yourself *that* time for your creative juices to flow.

When I was the director of West Bank School of Music during the late 1990s, I was surrounded by musicians who gave private lessons as a way to earn some income. This group of individuals, more than any that I have had the honor to know, found creative ways to compose, practice, and play their instruments while making a living. The pay was that of a poor nonprofit. But these musicians were entrepreneurial and passionate about their craft; many went on to do remarkable things. I remember an accordion player who left Minnesota and went to live in Louisiana. There was a flute player who practiced four hours every day (he wasn't a beginner, either), and even the office manager went off to start the successful Galumph Theater company. All of these people had to make changes in their daily lives to do their art. They took risks and were open to having lives that were passionate—sometimes a little scary, but true.

Taking a cue from history and master artists who have gone before us, we see a general theme in their lives—the ability to adapt to change. We see sacrifice in the great painters of the Renaissance who developed themselves by literally moving through Europe and uprooting their lives. There are countless examples of clandestine poets and female writers of the nineteenth and twentieth centuries who worked under pseudonyms just to get their work published. Nowadays, we don't have this barrier and I am not suggesting you become nomadic, but these masters didn't shirk the responsibility they had to themselves. They didn't veer off the path that brought changes into their lives.

Fear of Power

The third side to this triangle of fears, and one that keeps us from achieving our goals, is the fear of power. As we progress as artists and interact with other artists, the community, and benefactors, many of us show our timid or rebellious sides. Some of us can be downright reclusive and even antisocial, preferring to forge an independent path that shuns "the establishment." We tell ourselves we are so unique, so complex, few will really understand us. We believe our peers have "sold out," that they will steal our ideas, or that we have little in common with anyone else.

Artists and creative people certainly are wired in different ways, and they and their creations can be misunderstood. Yet I want to make clear the difference between not knowing how to talk about your muse, process, and creativity, and isolating yourself because you have great mistrust. Some of you are saying that it "takes away" from a piece of work to analyze and talk about it. That may be true at some point in its development, but your creative process is something you can share with others. And some of us need to do this but are afraid.

Vulnerabilities Are Exposed

Even for those among us who are the most confident, there is vulnerability in putting ourselves and our art up to the light. There is a deep-seated fear of lack of control and power in such a situation. In setting ourselves up for "review," we open ourselves up for scrutiny, criticism, and even rejection.

Through the process of getting grants, the fear of power can come into play. The perception is that the foundation and grantmaker have all the money and power to fund or do as they like. But that is somewhat of a misperception, because they are obligated (again by way of tax laws) to give grants away.

Through discussion and exercises in prepping ourselves and our work for greater exposure, we can become desensitized to the fears that can derail us from our true paths.

❧ TOOLS OF YOUR TRADE

The following section describes the tools of your trade, those items that are pertinent to where you are in your career. These relate generally to what is needed to be a successful artist and, more specifically, to the process of grantseeking and exposing your work. I present the tools needed for the inner work and outer work of becoming a great artist.

As I present this continuum, you may want to directly focus on the stage of development that you are working from. Some of the basic elements and "tools" transcend all levels of an artist and are pertinent to all stages of your career. Be open-minded to all of it, as you may find something worthwhile in a stage that you may have actually passed. For example, all artists need inspiration and encouragement, and some of the suggestions here will support this, no matter your level.

The following table outlines some of these basic tools. It also shows how artists advance in their careers. Of course, there is no cookie-cutter pattern for all artists, and this is not meant to generalize, but I have presented this with the criteria and logic of grantmakers who support artists. Key items are discussed in further detail in the following narrative, as they are very important and worth a special note.

The Artist's Table			
	Emerging	**Mid Career**	**Professional**
Essential	* Passion * Inspiration * Discipline * Tenacity * Sense of humor * Support * *Discovery* * *Dreams* * *New practice* * *Courage to start*	* Passion * Inspiration * Discipline * Tenacity * Sense of humor * Support * *Focus* * *Ideas, projects* * *Honing skills* * *Confidence to continue*	* Passion * Inspiration * Discipline * Tenacity * Sense of humor * Support * *Rediscovery* * *Ideas, projects* * *Mastering skills* * *Longevity to create*
Primary	* Creative time * Shared space * The primary tool of your trade: a desk, pen, paper, computer, camera, potter's wheel, clay, paint, metal, film, etc.	* Structured creative time * Independent studio * The primary tool of your trade	* Creative time * Professional studio * The primary tool of your trade * Backup tools
Promotional	* The work itself * Small collection * Growing portfolio * An exhibit, show, or public readings * Published work	* Work in progress * A number of collections * Established portfolio of twenty to hundreds of samples	* New directions * Large collections * Established portfolio of twenty to hundreds of samples * Six to ten years of exhibitions, shows, or public readings

	Emerging	Mid Career	Professional
		* One to six years of exhibitions, shows, public readings * Published work, five to ten pieces or more * Completed films, videos, dances, or compositions, thirty minutes or longer	* Published work, five to ten pieces or more * Completed films, videos, dances, or compositions, thirty minutes or longer
Focus	* Experimenting * Learning * Dabbling * Finding muse	* Establishing style * Progressing self/work * Deeper learning * Consistency with muse	* New directions * Promoting work * Accomplishing work not feasible before * Muse is an old friend

Now let's look at each phase of an artist's career and pay closer attention to some of the necessary tools for that phase.

PRIMARY TOOLS FOR THE EMERGING ARTIST

We have all been there, and some of us still are. The emerging artist has great passion and is inspired by his environment and experiences. In this neophyte stage, we also find that people are inspired by the *idea* of being an artist. Hopefully, as they continue along the creative path, something else takes hold and a slow transformation occurs: the person who is "infected" by a passion for art will eventually achieve an integration of his or her external view of what an "artist" should be, and his or her own true muse and creative spirit. This is what I call the inner and outer working process of an artist.

Some of you are thinking, is she nuts or something? And what is all the talk about integration? I mean, isn't it enough to write a few songs, a few poems, paint for a summer? The emerging and beginning artist certainly has the luxury, it seems, of dabbling, experimenting, and finding a muse. But like a great love relationship, we can't stay in

the flirtation stage forever. Over time, we need to fuel the fire with more than a lust for being an artist.

The next three tools are more practice modes than they are physical tools. Good habits and attitudes are as essential as film, paint, canvas, dance studio, and so on. Incorporate these into your "tool kit," as they are essential to your development as an artist. These tools will help you in the long run and demonstrate to funders that you are indeed serious about your creative pursuit, which is not just a hobby.

Practice Your Craft Every Day

A primary tool or habit to develop is to take time to be creative. This usually means that you will find time for unstructured and spontaneous bursts of creativity. Then as you progress, it is important to transform this unstructured time into more disciplined forms of creative space and time to "practice" your craft. It becomes a vital part of your routine; like wearing an earring, it's a precious part of your ensemble.

Practicing your craft every day will help you incorporate new learning that goes beyond technique and inspiration. After the romance stage of being an artist dissipates with the first blush of inspiration, you will find that you have to face the blank page, canvas, wheel, screen, etc., each and every day. That takes focus, time on task, and an openness to learning the craft.

Study the Craft of Others

Former poet laureate Billy Collins says that if young poets and wannabe writers are going to write good poems, they have to also *read* good poems. He goes on to say incredulously how many of his young students refuse to read literature and poetry, all the while focusing on writing their own.

Emerging artists need to formally or informally learn about the craft they feel compelled to create. Your tools will include books as well as basic tools to be creative. The Internet has also become an encyclopedia of knowledge, and nearly anything you want to know can be found there.

Over time, you may be inspired by that painter, that poet, or that screenwriter you have just learned about. Over time, if you are lucky, your art consumes you, which is a good thing in the beginning stage of

a developing artist. It fuels the fires to create a collection and body of work that will advance your learning and skill over a period of time.

Keep Focused

Many of us have the romantic notion that finding a creative muse is all you need to create art. Inspiration will fuel the fire and whatever we do will be perfect, because we have a muse whispering in our ear. But the muse is fickle and misunderstood. Reality hits a bit hard for the emerging artist when faced with the biggest challenge of all, which is to stay focused on creating our art, whether the muse is there or not. Keeping focused and centered is a very difficult task in general, especially for an emerging artist who has to sustain the vision and dream of becoming an artist. With the myriad of responsibilities we face in our daily lives, finding the time and space to create is a challenge. We have to try to focus ourselves and avoid distractions and tangents as much as possible.

Here's the central message I'm trying to put across: the integration of who you are with your artistic self is a telltale sign to grantmakers as to how serious, passionate, and developed you are in your process. Focus is a means to this integration, and that is why I will be harping like a football coach for you to "get real" about what you want and to balance your creative work with your life.

I have used many tricks to keep focused or at least keep the dream alive. In 1980, after nearly being hired to write children's stories, I got the bug. I was a social worker with a résumé that showed previous stints as a nurse but little in the way of real writing. When I submitted a story I had written, hoping the creative department of a toy factory would see some spark of talent, it got noticed. That was the confidence boost I needed to start on this journey. I continued in social work, in challenging jobs—jobs where they give you a can of mace on your first day and explain that newspaper is a good barrier to sit on if you happen to be in a roach-infested place. These were tough jobs, and it was time for me to get a desk job that included writing.

So I did, as a grantwriter. At the same time, I started writing poetry, short stories, and technical books. I told myself that writing eight hours a day or more had to do something. I was dabbling but having a ball. I decided to take the big leap and started to work independently, consulting with nonprofits. With a flexible schedule, I thought I would have more time for my writing. I became very popular, and at the

height of it all worked some crazy hours, sixty to seventy a week. I became involved in the work of an advocate and activist for environmental and humanitarian causes. I was exhausted and had little balance, and even though I didn't write every day, I never lost sight of my goal. In creative ways, I stayed focused on my vision of being a writer. I carried poetry and literature books with me everywhere. My briefcase always included my own poems, and it seemed that poetry and literature always had a welcome place in my social circles, so I could at least talk about my latest work and favorite writers. I put black-and-white photos of famous writers on my curio tables, inspiring me to carry on. I never gave up the time to read and began my own self-study in art and literature.

And I did something daring, moving to a small cabin-like place amid a two-hundred-acre forest along the St. Croix River in Wisconsin. I finally had a room of my own and a view that was perpetually inspiring. And I was alone. Some of you may say that I lived like a nun or a hermit, and sometimes it felt like it. Aside from Karen and Arnie Kustritz, the owners of the property, who were there only seasonally, I saw few people. I had my own version of Walden Pond. This place high above the cliffs of the St. Croix would be my crucible, and from it came some of the defining moments in my life. I called it the Birdhouse, and it began to transform me.

Certainly, you don't have to find a cabin in the woods to be an artist. This example points to how much people will change their lives to pursue an artist's dream. As you follow your own path, no matter the twists and turns, remember that there are creative ways to keep focused on where you are headed.

VITAL TOOLS FOR THE MID-CAREER ARTIST

In following along the continuum of an artist's life and the tools needed for each phase, you will find that the artist in mid-career has the greatest needs. This is actually corroborated in the grants world as you see that most grants are for mid-career artists. So let's look at the vital tools needed at this stage of development.

As we established earlier with the emerging artist, the basic elements of passion, inspiration, and tenacity are still in play here. In fact, if you become dedicated to your work and set aside enough time for each task, the elements of passion, inspiration, and tenacity become more

profound and familiar. They feel like an integral part of who you are, and hopefully when you "show up for work" these tools are mostly present.

Naturally, inspiration in particular tests us sometimes, especially in this phase of becoming. We "show up at work," and it doesn't. Things don't flow perhaps as easily as they did in the beginning, when the song, the poem, or the art piece was created in a zone of pure inspiration.

Passion . . . But Don't Wait for the Floodgate

A writer friend of mine is widely published and accomplished, regularly getting six-figure advances. He and I spoke a few years ago. I had just come off a particularly passionate and inspired time where I wrote and produced a great amount of work. I told him how it just flowed like a river.

I remember it well. We were drinking coffee somewhere, it was raining torrents, and in a fog-eyed dreamy state, he said, "Wouldn't it be great to write with passion all the time?" He paused and looked so serious, and admitted, "I can't do that. What I write . . ." He hesitated, then said, "well . . . I'm not sure, but it don't come easy."

He was talking about that connected feeling of passion and inspiration that we attribute to the artist and creativity. Some say it's genius or even some sort of divine conduit. He admitted to me that the feeling of the creative spirit while making his art has only come a few times in his career. It made me wonder how this modern, prolific writer could have so much success when "that passionate visitor" only came a few times in his career. I couldn't venture a guess as to which of his writings had that "flow," as all were truly amazing. He taught me an important lesson, which was to work at it, as he did, and over time I could hone my skills enough to produce *all* the time.

We begin to realize that we have to show up, no matter what. Inspiration may have us bringing the car to a screeching halt because the muse comes and the work ideas flow, but we can't rely on it to be like that, and so we succumb and become more disciplined.

Dedication and Discipline

If you are in the middle of your career and reading this, you will understand the need for discipline in your work. Unlike an emerging artist whose muse is sometimes haphazard, artists in mid-career usually are able to feed themselves and their muse with regularity. They

dedicate themselves to the work through a focus of time and space. These are the people who may work regular jobs but have integrated ways to be creative on a regular basis, if not a daily basis. They are the people you know you can't call or disturb after 3 P.M. because they are doing their art. They are the ones who leave early from the party because they get up early the next morning to work on their projects. They don't watch a lot of TV, and some are contemplative sorts.

They quietly, soulfully, patiently create their art without you—their friend, partner, or spouse—even knowing it. Discipline as a basic element has become a primary step in their practice. The mid-career artist knows that when you tap on the shoulder of the muse at regular intervals, it turns around and gives you its attention. Sure, it still may wake you up at 3 A.M. with an uncontrollable flow of passion and ideas, but for the most part you are disciplining it to show up when you need it to.

Space

Early on in your development, you may have acquired a studio and place to be creative in an ad hoc fashion. For the emerging artist, anything will do: a space in the basement, garage, or even utility room. Some of you are desperate and will settle for anything. You may share a studio with another artist, and I know many who do so throughout their careers, but it is necessary to develop some autonomy within that. As your process goes deeper, you need to set up a space that is truly yours. Perhaps you are fortunate enough to have your own independent studio or space. Writers need the proverbial "room of their own." In this phase of development, you need to "get real" about it.

If you have been creating your art on the dining room table or in your spouse's work room, there comes a defining moment when you will need your own space. The artist in mid-career makes this a priority. Look at the number of cities with warehouse space that is converted to artist lofts and studios. Even though the rental price for these has gone up, making them unaffordable for many artists, it points to a necessity for an artist to have space to create.

Equipment

Essential tools of your trade will be the equipment you need to do your work. Certainly, as an emerging artist you obtained primary tools like the camera, canvas, drawing table, potter's wheel, paints, clay,

film, etc. If you are a writer like me, depending when you started, you may have worked on an old word processor or even a typewriter, and maybe you still do. I am actually on my fourth computer in nearly twenty years. (I have burned out the motherboards in every single one of them. I am not kidding.) And like many of my peers, I still use the most basic tools of pen and paper.

As you see in this short discussion about equipment, the artist in mid-career refines what works best, and obtains and focuses with that. During this phase, you may also upgrade your equipment to something more "professional," durable, and solid.

This may be an opportune time to do some grantseeking for your equipment needs. This can be a bit tricky, as foundations are at both ends of the spectrum in regard to equipment grants. Some allow this directly in the project budget, with some allowing a major capitol upgrade, but others do not. Some simply allow enough grant monies to leave it to your discretion how to budget for your equipment needs.

Tools Are like a Primary Palette

Tools are literally like paints in the primary palette used by a master painter. What would Dutch painter Johannes Vermeer have done without lapis blue for his famed painting, *Girl with a Pearl Earring?* Vermeer was known to use only a handful of paint colors in many of his works, but he almost always used the very expensive lapis blue. This was a highly valued paint color in the fifteenth and sixteenth centuries, as it was hand-grinded from real lapis stone. Its high cost and scarcity may be the reason for the incomplete state of many masterpieces, including Michelangelo's unfinished work, *Entombment.*

As you identify your basic tools, think proactively about how to acquire, maintain, and upgrade them. You may have a highly valued tool that would be "perfect," but as in the case of the lapis blue, it may be unaffordable.

Initially, as you enter your creative world, try to create your art with tools that you can easily acquire without a special grant. As you work into it, the need to upgrade can be made at the appropriate time.

New Discoveries

A piece of new equipment can be the trigger in providing a new discovery and direction for your work, as is the case of a photographer

who has relied on manual cameras and then gets a digital camera. This situation can be one that catches the interest of a grantmaker but only if your work has been somewhat established.

❧ BEYOND THE PRIMARY TOOLS

Beyond the primary tools of space and equipment, artists in mid-career focus on their holistic development: those elements and opportunities that help establish an artist within the community. Funders are very interested in your identity and how you extend and engage, through your art, with the community. Let's discuss identity, the work itself, and opportunities that can add depth to your overall development and experience. These go beyond the basic accoutrements of space and equipment but are just as essential.

Identity

Establishing your identity in a particular creative mode is really one of the main emphases of the artist in mid-career. You become comfortable in your own skin so to speak, and as mentioned earlier, instead of living a label, you begin integrating the practices and life changes that make you an artist. You cannot live the label of photographer, writer, singer, musician, etc. Your identity as an artist has to be more than a title. Your art is not separate from who you are—it *is* who you are. Your actions, behaviors, work time, play time—all will become integrated and in balance with the total you in creative grace.

This is something you feel inwardly. And as it is reflected inwardly, it is reflected outwardly as well. It becomes the way you are perceived in social and business gatherings, and it is your anchor in the sea of endeavors that you dabble in through the stages of becoming an artist. This is the time when you have worked enough and understand your own process so that you can begin to communicate who you are as an artist. This is when some of you may get hung up, feeling challenged in needing to share, describe, and be public about a process that has previously been soulful, private, and even introverted.

In the mid-career phase, an identity of the artist emerges from an internal process and you begin to engage with the community that surrounds you. This is the beautiful time for further discovery, feedback,

validation, and support. It is a great cycle of learning to be involved with the community as you extend your creativity. And most importantly, it always comes back to the work itself.

❧ THE WORK

It is safe to say that no matter what level of artist you are, whether you are in the beginning, mid-career, or at a master level, your development and how you extend your creative spirit will inevitably come back to the finished product of your work. And it is during the mid-career phase that we center a lot of our energy. As was stated before, many grantmakers focus their energy and support for artists in this phase. That's because the work of mid-career artists has matured to the point where they can identify with it, talk about it, take it in new directions, or focus it in the particular style that they deem necessary for this stage of their own development. Grantmakers understand that artists who have spent six to ten years producing their work on the small (as well as the grand) scale are at the point of knowing what they need to do to push ahead.

Let me qualify this, since I know some of you are thinking you have an idea about a future, albeit unclear direction for your art. Not to worry, because applying for grants in mid-career usually involves a preplanning stage. Most foundations have developed preplanning processes, whereby they host information meetings and public forums on their granting programs and how to apply. Remember, they want and need to find great candidates for these grants so they have pulled out the stops in making access easier. Also, foundations have staff that may be available for an inquiry. But to have a serious conversation about your bid for a grant, you have to show something that will demonstrate your ability and the promise of your work.

Time on Task

This brings us back to our starting point—the work. Although there are no hard-and-fast rules for when someone begins his mid-career, we usually think in time periods. If you have produced your work over a six- to ten-year period, you may be in that transition time of becoming a mid-career artist. A defining factor for this is how public you have been with your work and how developed you are.

In literary disciplines, are you published, and where? Have you had a show with a group or independently? Do you have a large number of finished pieces, poems, essays, paintings, images, sculptures, plays, scores, and so on?

ADDING DEPTH TO THE ARTIST EXPERIENCE

Our work is a litmus test, as is our résumé and curriculum vitae. Grantmakers will ask for your recent work, pieces produced within the last five years. They will also ask for your résumé or CV to see how you have applied yourself in the community. Now, I've made some of you nervous. Perhaps your CV demonstrates little art experience, similar to mine in the beginning of my career, as I was once a nurse.

Plainly stated, your CV may lack depth. Unless you take advantage of creative ways to expand your reach and scope through your artwork, your CV may not demonstrate the breadth of your ability and experience.

The following section introduces and describes ways in which you can expand your reach during this mid-career phase of your development. Opportunity knocks with new possibilities such as collaborations, artist residencies, competitions, grant programs, and awards, which will help promote you.

Art Collaborations

Art collaborations can be formal or informal. "Informal" connotes that you and a few artists independently join together to produce a body of work. You may do this solely for showing your work (minimizing exhibition costs) or as a way to interact with other artists in your chosen discipline or across disciplines. Formal collaborations usually involve greater resources, more partnerships, and may often be originated by a funder or group of funders.

In Minnesota, where I lived for twenty-seven years, many formal art collaborations were initiated by the funder. They involved grants made to nonprofits that could be the fiscal agents or sponsors to many individual artists. This method provides the necessary tax structures and checks and balances for funders to easily make arts grants to individuals. A few examples to help illustrate these are the arts partnerships that were initiated by a group of funders who jointly committed

substantial grant support for collaborative art projects. Eleven partnerships were initiated over a seven-year period, and many joint projects were created and led by individual artists. These were fairly new endeavors for funders as well as artists, and so there was much learning to be done. Some would say that collaborations are a lot of work in defining and clarifying what everyone needs and wants to accomplish. We will discuss the role of fiscal agents and artist collaboration in greater depth in chapter 9.

Collaboration through the Local Community

Another way that collaborations are implemented is through neighborhood associations that receive grant monies and then regrant to artists. This is a community-development model of city improvement, which marries civic action with art. These projects can be anything from commissioning an artist to work with marginalized youth to make a mural, to projects that employ artists to go into inner-city schools and enhance the curriculum.

Collaborations are a great way to start getting your art into the public eye in mid-career. You will have countless meetings and networking opportunities to find out who is doing what. This discovery phase will help you overall in building a strong network that knows your work and its value.

There are pros and cons as to the efficacy of this type of funding, yet it has proved beneficial to the community and has helped establish collaborative practices.

Artist Residencies and Guest Artists

As you begin to establish yourself, there are also opportunities to work within the community, in academic settings as an artist in residence or guest artist. Some of these posts are semi-permanent and can support an artist well through mid-career and beyond. Many state government humanities and art departments provide short-term grants for artists to be in residence at a school or in a community. But remember, "Be ready." In some of these positions, one has to actually be part of that community or academic institution to be an artist in residence.

Of course, guest artists and some residencies are shorter term, seasonal, and temporary. For one lovely school year, I was the "poetry lady"

to a group of fifth and sixth graders. And for one summer I collaborated with teachers and other artists mixing mediums and disciplines, such as fiber art and poetry.

These were extremely important ventures for me as they helped me extend my art publicly in a community-driven way. They challenged me to produce new work and validated and supported the level of accomplishment that I had already reached. I can't overstate how vital these opportunities were, especially in working with children and turning the poetry lightbulb on for so many. Again, opportunity knocks and the path we choose brings about many life changes. We will explore these further in chapter 8.

Regranting Organizations

A mid-career artist can also find small grassroots arts organizations that offer grants for their projects. As mentioned earlier, these come in the form of fiscal agents or sponsorships where the arts organization acts as an umbrella to many individual artists and projects. Because it is easier for foundations to give to nonprofits and arts organizations, they do so with the caveat that these grant programs support underserved people—namely, artists whose work needs greater attention. These awards can include travel and study grants, mentorships, and special production grants.

Applying for these is no less formal, but these smaller grant awards can be leverage to the larger direct programs and fellowships that directly provide major support for an artist.

Fellowships

Fellowships in the world of grants are a completely different category, as these can provide substantial financial support for a year or more and can ultimately change your life. Where you come out at the end of the fellowship journey is a very different place than where you started, and that is the intention. Fellowships are typically available for artists in mid-career and the seasoned professional. Some foundations wisely require that you quit your day job to focus solely on the projects supported by the grant. These grants can provide living stipends, and such full support will bring about a creative freedom that the funder believes is necessary to do the work.

When Can I Quit My Day Job?

Depending on the requirements from a fellowship, the support it provides, and the factors of focus and intensity, you may have to quit your day job. If you are involved in an artist residency, this is your day job. You are following your bliss, as they say. This opportunity—along with commissioned work, where you are asked to produce something for money—is a great way in which your art can be profitable enough to pay the bills.

Another Alternative

I want to introduce another way to think here. Aside from any of the fellowship requirements, you may not want to quit your day job. If you have worked some balance into your schedule and have the space and time to do your art, there are no rules saying an artist's life need be spent totally in soulful creative mode.

In fact, I have had this discussion with a number of artists who say that without the external distractions of other work, family, community, etc., producing in a creative mode all the time could be too intense. Some of this depends on the artistic discipline, which may or may not lend itself better to producing creatively while working. For instance, a visual artist can develop a very successful graphic design company and continue to work creatively. Writers who work in publishing can make the necessary stretch to work on their creative projects. The balance of projects for hire and projects for your own creativity will be teased out—but these are plausible scenarios. Of course, you may delve into your artistic pursuit head first, but remember to be ready. When and if this time comes and the spirit grabs you (forget the stereotype of the soft muse tapping your shoulder), you may find yourself nonplussed, confronted by your creative muse. Then what? You can't just quit your day job to figure it out and give attention to this wonderful but at first sporadic burst of creative and artistic energy. Anxieties may arise, but hopefully if you are proactive, you will be ready. You will be able to come up with practical strategies that can balance and integrate your creativity into your daily life.

Certainly, there are a few rules here, but instead of thinking that you have to find a way for your art to solely support you in your mid-career through grants, commissions, and sales, you can think of it as

frosting on the cake, and pursue and obtain these things to enhance your development. With a good plan, you can ease into an artist's life and pay attention to a most robust muse.

✒ THE TOOL KIT FOR THE SEASONED PROFESSIONAL

Let's look at this next phase of an artist's development. You may notice that the "tool kit" is atypical, as I focus on those traits and characteristics that funders look for when making their decisions

The vital tools used by artists at this level of development will certainly involve some upgrading of physical means, but the emphasis for an artist in this phase involves process, higher learning, self-mastery, and sophistication of basic elements. A seasoned professional draws great strength from the mid-career years and honing his or her art. Knowing their own processes well, seasoned professionals can manipulate their projects to benefit their muse. These artists have been able to develop an economic scaffolding that supports them through their art. And if that is not completely the case, they are able to balance the various ways in which they express their creativity and make a living.

Whatever the mix, artists in this phase of development have many accomplishments to build upon, whether that is measured in income, independence, exhibition, or publication. To avoid making too many generalizations, we will focus on mastery, a devoted public, and the challenges that the mature artist faces after producing for many years. We will also look at philanthropy's opportunities and the expectations it provides for the seasoned professional.

Technical Mastery Versus Self-Mastery

The benchmarks in the later phases of an artist's career have a very integrated and holistic characteristic, and lines between working, being, and producing are more muted and flexible. A seasoned professional in any chosen art discipline evolves through many experiences and demonstrates an ability to truly learn from these. In many instances, this learning is through trial and error, practice, and skill development, resulting in technical mastery. Yet as many of us know, mastery in art is not all about the applicable skills of a craft or technical ability, but a greater process that integrates many facets of creative brilliance.

Mastery at this level involves integration of every aspect of an artist's life: personal, social, professional, spiritual, and community, all working in a sort of harmony and balance. As I have explained previously, this self-mastery is a lifelong process; it is all about the ability to learn and be aware of ourselves.

Tools for Self-Mastery

We all have favorite artists, writers, dancers, sculptors, storytellers, and so on. They may have great technical abilities, and their creativity touches us. Then there are the artists who simply appear to walk on water. They seem to have it all. There is an authentic and genuine quality about who they say they are.

The following set of tools promotes this level of mastery. It is what many of us see and feel when artists inspire us; it goes beyond their work.

Self-Awareness and Reflection

To help get beyond technical brilliance, you need to cultivate a sense of yourself that integrates your strengths and weaknesses through your vision and goals. "To thine own self be true" is the adage. But before you can find truth, you have to find yourself. Self-awareness and discovery come in the quiet, almost spiritual contemplation that is a necessary aspect of mastery. You must be able to reflect and discern how you are unique.

Renewal

The balance of inner work versus outer work is vital in developing the self-awareness that leads to great lives. If we are constantly running, chasing, and doing, we have little time for the inner workings of reflection and learning. Without time for renewal, how can we know which areas are working and which need improvement? How will we know we are making progress and not just chasing our tails?

Time for renewal helps us realign ourselves. This inner work is like a checks and balances system for our overall learning and success. Without it, we won't know whether our latest tangent, adventure, or artistic direction is fruitful, or how it is fruitful, or whether it has totally derailed the train.

The Ability to Learn

The seasoned professional who has mastery skills approaches his art and craft with a sense of openness that resembles the Zen-like quality of a beginner's mind. It is an attitude and sensibility that embraces the new, the different, and the unknown. It is an almost innocent and curious quality that says, "I am still teachable," and "I don't know it all." There is humility to these kinds of learners, and despite advancing age for many, they seem blissfully childlike and even playful. Even though seasoned professional artists have produced for many years and have many accomplishments, they still possess a wonder about their work.

Master-level artists can take feedback and criticism in stride and even incorporate it to improve their work. They actually welcome the opinions of others and solicit them freely. These master "learners" interact with their communities and seek out opportunities for new learning. It is not a one-sided equation either; in exchange for knowledge, artists with self-mastery are usually generous in spirit and do not hoard their talent.

Risk-Taking

This is an asset that may seem overstated but is a tough one to really harness. Some of us have the courage and sheer will to move our careers and development ahead, but the kind of risk-taking I am speaking of is almost a fluidity—a flow to new ideas and experimentation. You may seem daring, but does it make you difficult to work with and live with? Is there follow-through, and can people trust you when you are on the trapeze of an artist's life? Or are you cavalier, using bravado to get through the fear we all have in risk-taking? Master artists go in new directions but in such a way that shows deep courage. They are perhaps bold but not reckless.

The Genuine Article

Artists who master their art have integrated their vision as an artist with who they truly are. Your values and ethics come into play here, and if these are not aligned with a public image of you, the artist, you will lack the presence and passion that demonstrate this level of artistic mastery. More than that, there will be an obvious quality that may appear superficial and inauthentic.

A Legacy and Commitment to One's Community

As seasoned professionals, we often look to leaving a legacy through our work. Human beings naturally have this tendency as they approach mortality. Beyond the sociological motivations, many seasoned professionals want to develop a more profound experience in this phase of their careers. This may involve pioneering a new direction within your discipline or producing work with a renewed inspiration and intensity. You may collaborate more as you share your talents with the community and intentionally act in a mentoring role.

For artists, the journey is so often very introspective and the seasoned professional may find the need to be more extroverted and community-driven. Depending on the nature of the work and contribution to a particular discipline, one's legacy may be the culmination of the work itself, and many artists are quite busy during this time of their lives. Even though their work is a great contribution, some have a fire that says they want to give more.

For the "talented artists" who have developed along the continuum that I have described, the truest gift may be the integration of the muse with our authentic selves. This is an essential spirit, and feeling, that flows so naturally through our work that it is like breath itself.

GRANTMAKERS AND YOUR DEVELOPMENT

Much of what I've recounted here stems from my own experience in developing as a writer and working with other artists in all phases of their careers. Being a grantseeker and a grantmaker in the arts, I want to impress upon you the importance of developing yourself holistically. Don't underestimate a grantmaker's ability to grasp the challenges and life processes of an artist. What I have explained here goes beyond the basics in grantseeking and touches upon the attitudes of grantmakers who look beyond your artwork in making a decision.

As you continue on your artist journey and proceed in this guidebook, you have to ask yourself the questions—why do you want a grant, and what is it you really want to accomplish? Your development as an artist can certainly be helped by grant support, but as you will see in the coming chapters, it is key to be clear about what you want, where to get it, and how to get it.

And you are almost fully prepared. But we have to return to the work, at least the initial stages of how to show it for public review. The following chapter will help you create, or recreate, and prepare a portfolio—one of the vital tools all artists need.

❧ THE GRANTS ZONE

Focusing on grantseeking means you have to focus on your own development first.

To be ready for the "big grant," or any grant, take some time to reflect on where you are and where you want go.

The opportunities for artistic development are wide and deep and can inspire us no matter what level we are at right now.

Your toolkit will evolve from the basic instruments and tools needed for your artwork and will include the necessary elements of passion, tenacity, and focus.

❧ GRANTSEEKER'S DOS AND DON'TS

Do be still enough to reflect and understand your muse, its motivation, its needs, its way of expression.

Do begin asking yourself why you want a grant and what it will really serve.

Don't assume grantmakers lack understanding about how artists become artists. Many grantmakers in this arena are educated, accomplished, and seasoned professionals who know the many phases of art mastery.

CHAPTER THREE

Creating Your Portfolio

When one buys some of my artwork, I hope it is because they will wish to learn from it and not because they think it will match their drapes!

—CHRISTIAN CARDELL CORBETT

Increasing your opportunities through meeting potential collaborators, supporters, grantors, curators, patrons, publishers, and so on, demands a special vehicle to show your work. It is essential that you create a portfolio that reflects who you are, your accomplishments, and the depth of mastery of your craft through the collection of the work you have produced.

The following provides helpful hints in creating a portfolio. This is not an exhaustive list but a general treatise of how to create and present a portfolio. I also include the dos and don'ts, and helpful hints for artists in any stage of their career. When you approach grantmaking foundations, they may have a particular manner in which they want to see your work. These guidelines will help you produce an industry standard from which you can deviate, as in the case of a specific funder's requests.

☞ THE GRAND MYTH

"Artistic genius gives a person license to be wacky, crazy, and eccentric." Let's dispel the myth right now. Those may be facets of your persona, but when you are in business mode—and that's what grantseeking and the public showing of your work is—you have to

present a credible demeanor. You are building credibility and a rapport with the reviewer from the very first contact, introduction, or page of your portfolio. You are also trying to get noticed among the many portfolios that are being reviewed.

The tone, message, and impression you are aiming to present to anyone who is being introduced to you and your work should be organized, professional, and mature. Anyone looking at a sloppy, disorganized portfolio will quickly disregard it. Reviewers of all disciplines and situations want to know that you are ambitious, qualified, and prepared. If you submit a portfolio or collection of pieces or writings that demonstrates this, the reviewer will immediately conclude that a mature, seasoned artist is on the other end.

Art in all its disciplines breeds competition, and the best way to get noticed is to present a well-rounded image of an artist who is creative and has a business sense. This is not asking you to sell your creative soul or wear a suit. But it is certainly more than showing a few pieces of your work. The portfolio we will create will be complete and cover all aspects of who you are.

❧ ELECTRONIC PORTFOLIOS

We live in a modern and virtual world, and even in today's art business we use computer technology to present our very physical and visual work. Creating a physical portfolio is still a basic need. Even with hard copy portfolios, you will include a CD that has everything virtually laid out and a business card with your Web site address, if you choose to develop one.

And even though it seems like you are doing twice the work, an electronic portfolio draws from images and documents that you have already produced for the hard copy portfolio. Your hard copy materials and originals are still necessary, as many gallery reviewers and grant-makers still rely on slide images that can be projected to their judges and patrons. Also, as you progress in your career, you will be presenting your work to many entities and the cost factor can be minimized with the use of electronic portfolios when allowed. The following list describes each component and how it is adapted for the electronic portfolio.

Barter and Exchange

If you are a "poor artist" without the means to produce an electronic portfolio—or for that matter even a basic hard copy one—check your arts community for support resources. Fortunately, given the increase in arts funding over the last few years, there are agencies that help artists develop these materials. If you live in a community without such supports, identify organizations and businesses that you can barter with to create these pieces.

☙ COMPONENTS OF PORTFOLIOS

The various components of an art portfolio include:

* Cover letter
* Résumé or curriculum vitae
* Reference letters
* Artist statement
* Work samples
* CD-ROM
* Business card
* Exhibition brochures
* Clips from print media
* Audience feedback or quotes page

Cover Letter and Résumé

I like to present a cordial but professionally written cover letter that has one paragraph introducing myself and the portfolio. Your cover letter should also give a list or table of contents for the components of the portfolio, and sign off with a grateful thank-you to the reviewer for considering you and your work.

Letters of Reference and Recommendation

I like to include letters of reference, as they are like frosting on a cake. I use the actual letters versus only a list of names and contact information since the letters are more immediate and the reviewer doesn't have to request these and have the lag time to wait for them to arrive.

Naturally, the letters will be glowing and wonderful, so for these to be taken seriously they have to be sincerely written and reflect the writers' true summation of you and your work. Include up to three letters of reference, unless you are asked for more. Typically, the pools of people you draw from are colleagues, mentors, academic professors, and seasoned or well-known artists in your field who know and trust your work. Try to avoid familial contacts, clergy, and your best friends unless these people have history that pertains to you and your work. You want to have at least one reference from a person who has known you the length of your career and who can speak to your depth and artistic evolution. Noteworthy artists in your field may be helpful, but you may not have these and if you do, the relationship may not be strong enough to ask for a reference. Dig a bit and see whom you have forgotten, or whom you may be too timid to ask. There is no harm in asking; if they can't help, they will usually decline gracefully.

Remember in some review processes, phone calls are made in addition to the reference letters presented, so avoid people you have just met, as they really won't be able to speak at length about your ability.

A Statement from the Artist

When people review your art, you want them to understand and appreciate it. Although you cannot control what another sees or feels when experiencing any form of artistic expression, you still need to present enough information that will hook the reviewer into learning more.

An artist statement is simply a personal statement about you and your work. It is a written statement for the hard copy portfolio and can be adapted for the electronic portfolio and presented in many creative ways.

For many of you, the idea of having to write a statement like this may be a great hurdle, yet this is your first and most important hurdle. Using the following exercise, what you write will translate into what you also say about yourself and your art. In applying for grants, there is much more legwork, meeting, talking, and discussing what you do, well before any written application. These exercises are multipurpose and since getting grants involves meeting reviewers and judges, and writing and sending applications, this statement will help you summarize the overall information that you want to convey through your art.

Brevity Makes It a Winner

This exercise is a simple approach to writing a personal statement that is only a few paragraphs long. You will only need about 250 words. Don't worry—you can do this. In fact, you will probably write more than that, and much of the exercise will be in editing the statement.

Think of it as the written form of you sitting with a friend in a bistro or café, waxing realistic about your accomplishments and why you are doing your art. It is brief and concise, because you are not giving them the grand show in this statement. It is merely a way to introduce you and your art. It is a combination of résumé biography, philosophy, artistic approach, and boasting. Anyway, power up the pen, paper, or computer, and let's get started.

Starting Point—Hooking the Reader

I try to give strong declarative statements (remember those in English class?) about the process that I work from. This may be one sentence and because of its assertive tone, you will immediately grab their attention and begin gaining credibility. They sit up and say, "Whoa—this is an artist who knows where he is headed."

Description of Your Style: Try to write three sentences that describe your artistic style. How do you create your art, your technique, and what is it made from? Example:

> The poems, prose, and essays that I write come from themes of everyday life, with special attention given to relationships and the ever-present foreigner in a strange land. I like to use a narrative form, as it carries stories well although I don't use it intentionally. My process is still one of simple observation, capturing mood, moment, and mindfulness of life's instances. Over time, the ironic and witty voice has come through some of the darker shadows of an emerging artist in self-reflection.

Philosophy and Approach: Write two sentences about your philosophy and one sentence about your approach. Why do you create your art, and what does your art mean to you? Example:

> Like John Adams, who once said, "You are never alone if you have a poem in your pocket," I have always relied on poets to

nurture, encourage, and comfort me along the journey. In the same way, now as I feel fortified and able, I hope to provide the same counsel and inspiration.

Poems mean a lot to me. They are nearly like a meditation and oftentimes they are the only language I find myself using to interpret my world. Although that may be rather personal, I see myself as a bard singing out praise and hope. Given my nomadic wanderings, I have come to realize that my writing is a witness to the human condition.

Influences: Mention formal education (if applicable) and/or artists (need not always be from your discipline) who have influenced you or better yet mentored you. Example:

I am self-taught, although these last ten years I have enjoyed the guidance of poets on the page and poets, writers, and teachers in my community whose counsel and mentoring has encouraged my development—David Gergen, John Caddy, Joe Paddock, John Minczeski, Rick Bass, Trent Alvey, and Terry Tempest Williams, to name a few. Although I am buoyed by many of the classic poets and dead poets like William Stafford, I feel an affinity to contemporaries like Mary Oliver and Billy Collins. In creative nonfiction and deep ecology, I am drawn to the work of many of the writers in the Southwest who keep vigil for a most precious landscape.

Given my current geography, Cairo, I return to ancient teachers like Rumi, Hafez, and Omar Khayyám.

Accomplishments: Sprinkle in major accomplishments by giving examples of awards you have received. Don't have those yet? Mention places in which your work has been shown and published, and if you still don't have that, mention the arts organizations that you are associated with and any membership organization. If you have submitted work and it is being considered, mention the places here. The following three samples show artists with many accomplishments and how they describe these.

This sample is taken from a description of the aesthetics emerging from Milo Fine, a world-class musician based in the Twin Cities. This short statement is much more elegant than the basic sample I derived. The statement focuses on motivations and intentions, which is a great

point to capture, especially when, as in this case, they can be some-
what abstract. This emphasizes his aesthetic and approach:

> Today, Fine remains an aesthetic absolutist who, upon seeing
> unfamiliar faces in the audience, will indulge fears of being
> reduced to a novelty act for avant-garde tourists. As a result, he
> seems to have deliberately estranged himself from the main-
> stream. "Pop music, by its very nature, feeds on the deeper
> streams of creativity," he explains, "and by its very nature, which
> is parasitical, it doesn't do those streams justice." But as Fine
> suggests, the avant-garde is equally suspect. Having knitted the
> highbrow in its own image, institutional art is subject to the same
> pitfalls as any commerce. For Fine, postmodernism is pop writ
> large, favoring pastiche over depth.

This next sample combines some remarks about accomplishment
and musical breadth from Clint Hoover, another musician with unique
talents:

> One of a select handful of musicians to have mastered both the
> chromatic and diatonic harmonica, Clint's work has earned him
> a place in the *Encyclopedia of the Harmonica*. From prewar
> blues to modern jazz, Clint has delved deeply into the musical
> possibilities of the harmonica. This thirty-year love affair with the
> mouth organ began as a teenager when Clint stumbled across a
> Muddy Waters concert at his hometown state fair.

And a third sample shows how remarkable and accomplished some
artists are and how they use these accomplishments to tell their story:

> The forty-three-year-old guitarist-composer and scholar resists
> the trappings of precise categorization. William (Bill) Banfield is
> an endowed chair in arts and humanities, associate professor of
> music. He is the director of American cultural studies, jazz, and
> American popular world music studies at the University of
> St. Thomas in St. Paul, Minnesota. Banfield received his bache-
> lor's degree (guitar, jazz studies) from the New England
> Conservatory of Music, a master's in theological studies from
> Boston University and a doctorate in composition from the
> University of Michigan. In 2001, on invitation from Henry Louis

Gates, he served as a W.E.B. DuBois fellow at Harvard University, and in 2002 was invited by Toni Morrison to be the visiting Princeton Atelier artist. That year he completed an opera on the life of nineteenth-century sculptress Edmonia Lewis with collaboration and text by poet Yusef Komunyaka.

The Editor's Corner

Now it's time to edit your draft and double-check it to ensure that it is understandable. Here are a few tips for editing. These can be used for anything you write in draft mode:

* Read it aloud and check for the tone. Remember, you want it to be declarative and assertive, without run-on sentences.
* Make the necessary corrections for tone and content.
* Now turn your attention to editing in smaller incremental ways, focusing on your grammar and usage. Go sentence by sentence to make your corrections.
* Now edit for style and punctuation.
* Read it aloud to yourself and see how it sounds. Yep, I said, sounds. Poor writing won't flow, and anything that is dangling or extraneous will be obvious.
* When you have it all finished, let it sit for a day. Then do the editing exercise again. Don't worry, this isn't too much or being obsessive. You are just making sure it has had time to "rest" and this short pause in the process gives you greater objectivity.
* Finally, let someone you know read it. He should be reading a clean copy without any spelling or punctuation errors. Ask him to read it for clarity, tone, and content. His job is to see whether he understands what it is you want to communicate. He is to avoid fussing about anything related to style, as this is an area with great variance.

Putting It All Together

We have written all the ingredients for a great artist statement. Sort of like baking a cake, and the ingredients are as shown in the examples. A few final hints: when you double-check your draft, ensure that you use "I" statements and simple English. Even though many artist statements talk about the aesthetic of their art form in abstract

ways, it is best to avoid inaccessible descriptions. Overall, try to avoid using jargon or language that has little meaning. Remember, clarity is a goal here. If you need more practice writing, many Web sites have online help and mini-workshops.

In the short term, you have done it—your first artist statement. It is complete and ready for the *pièce de résistance*—samples of your work.

❧ SAMPLES OF YOUR WORK

You will be providing samples of your work in both hard copy and electronic portfolios. The following hints will help you choose and present your very best.

Show Quality Work

It may go without saying that you will only show your best work, but it is amazing how many samples have weaknesses that detract from the overall presentation. If you are a writer, make sure what you include is finished perfectly. If you are a visual artist, creating slides and images of your work is vital; try to get these done as professionally as possible. Photographers presenting their work have few excuses for showing work prints or low-resolution prints.

Unless your work is specifically written in another language and you qualify this and/or it is expected, submit in English. I had a client once who wrote an entire application (and sent it) in French, as her work thematically involved a French Impressionist. She received a declining letter but wasn't sure why!

Send the Right Quantity

For thematic portfolios and review processes that are not looking at an artist's entire career, fifteen to twenty samples is a good amount. Poetry can be anywhere from three poems to twenty. When submitting short stories, novels, etc., use twenty to forty pages or the first three chapters if it is not too long.

Dance, film, and performance-focused mediums will typically need a tape of about thirty minutes. Music competitions will rely on CDs, tapes, musical scores, and compositions. Also, some music competitions

require live auditions, but these are usually well into the application process. In any case, be prepared to perform. In all instances, try to tailor your submission for your audience and give it just enough information without overwhelming it with quantity.

Organize Your Work in a Meaningful Way

For portfolios showing a retrospective of your entire career, organize the work sequentially. If you use names for your collections, that is fine but give dates so the reviewer will see the flow and maturation of your work. With some disciplines, like photography, you may have hundreds and perhaps thousands of slides and images. Different portfolios showing different themes can be developed. Or you may choose the top fifty slides of your career. Being proactive in all of this helps, as you may want to avoid the eleventh-hour hunt for that one slide, that one collection that you know is somewhere in the vast recesses of your studio or storage areas.

For portfolios presented in major themes, show your collections in visually astute ways. For instance, show all black-and-white photos together. Group the images according to their vertical or horizontal direction. Make it easy for the reviewers to sit quietly and look at what you have presented. Avoid making them turn their heads in gyrations to see your presentation. Arrange the presentation in a way that reflects your vision and technical ability with your craft.

For PowerPoint presentations and virtual presentations, minimize the bells and whistles, literally—go easy on music accompaniment. With the slide presentation feature, diffuse and project images at a reasonable speed so the reviewer has a chance to "see" it. Set up and practice the presentation until it is perfect and user-friendly.

Submit Other Support Materials

For artists with exhibitions, gallery shows, performances, plays, etc., provide a copy of the show's brochure. Any publicity you have in the form of written critiques, newspaper or magazine articles, and interviews can all be presented in a section designated with an appropriate heading, like "publicity," "audience matters," or "community feedback." In the case of art residencies or teaching/facilitating positions, provide some of the remarks and quotes from students in

a one-page abstract. Advancing this idea further in a virtual presentation, blend images of the audience or community group along with their remarks. The same applies for performing arts, in which commentary or feedback from the audience can be shown. "Sound images" are also important and you can do wonderfully creative things with music or short commentary.

Packaging and Presentation Counts

How you package your portfolio also reflects who you are. For grant competitions, pay close attention to the dos and don'ts written in the guidelines for sending samples. Many foundations have very specific requirements for presenting your work. Most do not want any staples used and written text must be formatted in a certain way.

For mailing and long-distance reviews, it is a good idea to spend a little extra money obtaining an archival box, which can provide additional security and longevity to your portfolio. Send it special delivery, ensuring that it will get there.

Despite the cost, try to have more than one portfolio, so you aren't left without something to show when the "big call" comes from another entity wishing to see your work.

Finally, as you put it all together, remember that the people who review your work are fairly astute and are accomplished writers, photographers, designers, and so on. For visual art portfolios, it is important to have white space and allow the "eye" to rest a bit, as your work may be quite stimulating. Similarly, for any written pieces make sure you haven't crammed too many words into your artist statement, résumé, or other accompaniments. Subtlety and brevity are valued in portfolios.

A MULTIPURPOSE TOOL

As you see, portfolios are vital tools for artists and prepare you for many opportunities to show your work during any phase of your career. As mentioned earlier, portfolios can really be a starting point for networking within your community and can ultimately help you find collaborative projects, art residencies, guest contracts, and, of course, grants.

⋞ THE GRANTS ZONE

Preparing for grantseeking involves some personal and professional development, as well as the development of your art.

The more integrated you are within your art, the greater your chance of obtaining a grant.

Getting grants relies on being proactive and prepared.

Begin today on the quest for clarity, self-awareness, and continued discovery in your work of becoming an artist.

⋞ BOARD PET PEEVES

Artists who apply for grants without reflecting on who and where they are in their careers as artists.

Incomplete portfolios and sample information.

Artist statements that fail to make a connection between artists' work, their community, and their development.

CHAPTER FOUR

Creating Your Own Strategic Plan and Getting Grants

A mighty maze but not without a plan.

—ALEXANDER POPE

Becoming an artist can seem like trying to work one's way through a labyrinth, and the process of finding and applying for grants can certainly have its twists and turns. Yet with gentle planning and easy follow-through, the complexities quickly fade away.

In this chapter, I introduce three different methods for goal planning, taking into consideration the different ways in which people work best. These will include a standard planning tool called SWOT, which helps us uncover the areas we can focus on in our goals and objectives. A second method, creativity mapping, encompasses goal planning in a more visual way. And a third method, storyboarding, takes goal planning and charts it out simply through identifying function and action steps.

The first two methods will help us integrate self-reflection and analysis, and have a bit of fun assessing who we are as artists, as well as our strengths and our weaknesses. These assessments need not seem serious and difficult. They can be as easy and uncomplicated as sitting on the banks of a lovely shoreline contemplating the clouds and thinking of what we will do in the next five years. With a proper assessment, we can dream, set goals, and strategize about the future.

I believe that within the maze of creativity and genius there is a plan. It's there—not to worry, I'll help you find and develop it. Come on, it'll be fun.

✎ THE ONE-MINUTE COMMERCIAL FOR PLANNING

Some of you may not be keen on planning per se, as it can seem tedious, but I "planned" for that and have provided a mix of approaches that will appeal to artists from all disciplines. The place you are in, career-wise, begs for new energy, which can come through new projects. Many of you have aspirations and goals, and there are many opportunities out there for you. You just need to give yourself a couple hours to think, do a few exercises, and develop the vital plans to make your goals a reality.

In my previous work as a grantmaker and consultant, I found that the people who had given even a little bit of thought to planning seemed more centered and able to advance their careers. I know I am positively biased about the efficacy of planning, and I strongly encouraged planning when working with clients, grantseekers, and peers.

Some have criticized this thinking, especially as it seemed to be a regional fad, and grantmakers from Minnesota especially were known for their love of the strategic plan. Perhaps it was the immigrant roots of Germanic people who settled in that great state. Perhaps it was those long winters that challenged a person's mettle, causing cabin fever that had people nervously climbing walls or staring blindly into a hearth-warming fireplace, planning away the hours. Perhaps it is a personality trait emerging. But it's safe to note that whatever the motivation, statistics show that 90 percent of successful people have set goals.

It Can Be Very Basic

If you are like me and gravitate toward being spontaneous, especially where your art is concerned, it doesn't mean you can't be a good planner. Early in my career, I made very specific goals and plans to advance myself because I felt I had a lot of ground to cover. For instance, in getting prepared to just "talk" to funders and people about my vision, I needed to attend Toastmasters meetings to get more confident about organizing my thoughts into speech.

Some of you may have a more dreamy approach to planning, which I, too, have incorporated into my process. I reflect a lot, visualize, and try out plans A and B in my head. But planning isn't just staying "in the head" and ruminating about one scenario after the other. It's getting it on paper and transforming dreams, thoughts, and goals into real action.

VITAL STEPS IN GOAL SETTING

The following are the vital steps you will need in setting your goals. Think of these as you proceed:

* Make sure the goals you have are something you really want, not just something that sounds good.
* A goal cannot contradict other goals; you cannot work at cross-purposes.
* When setting goals, shoot high and be ambitious.
* Write your goals down. It seems that the act of putting them on paper makes them more real and doable, and this is the most important step.
* When writing goals, use positive language instead of negative.
* Write your goals out in complete detail.

PLANNING METHODS

With the advent of "life coaching" and "go-get-um gurus," there is an array of planning methods to choose from. Sans guru, we will determine through a fun and simple survey our strengths, weaknesses, opportunities, and risks. With this information, we will develop a personal goal plan.

Try not to worry, if you can't fathom sitting down with paper and pen or a computer, and writing out your goals. I will help you break down a big goal into small manageable steps.

SWOT Method

SWOT is an acronym for strengths, weaknesses, opportunities, and threats. It is one of the most basic assessment tools used today, especially in corporate and business arenas. The SWOT assessment is used

in tandem with standard goal-setting, and so it will have great applicability to your planning. Remember, it is important to know yourself, and identifying these areas in your development is one step in that process. Plus, you will be asked time and again in grantmaking reviews to list and talk about your strengths and weaknesses. This is a great opportunity to not only list them but also to delve into finding ways to use them to your advantage.

Identifying Strengths and Weaknesses

I understand that some of this artistic development has us digging in the corners of our most private selves. This is a very personal journey, and we meet our shadow-selves in various forms along the way and may be resistant to this. When we begin the process of identifying strengths and weaknesses, we may be too modest, shy, or humble to talk about ourselves, so identifying our strengths may be a challenge. On the other hand, we may easily identify our strengths but may be unable or unwilling to admit to our weaknesses and vulnerabilities. Try to trust the process and understand there are ways to uncover our talents and foibles without getting bent out of shape.

Lead with Your Strengths while Minimizing Your Weaknesses

Here is an example of what I mean: I had some timidity in talking publicly, having identified that I had a particular weakness in speaking to people, especially funders and decision-makers. After I attended Toastmasters meetings at two different times in my life, I got a real boost in confidence, as their training helped me improve my public-speaking skills.

At the same time, in identifying that speaking with people can be a challenge area for me, I found that when I connect with people they feel great warmth, presence, and a genuine spirit. In one instance while speaking to 3,000 people in a theater, the remark and feedback from someone in a far row was, "I could feel her passion, her warmth." Even though I recall having classic stage fright, it seems my timidity was quickly overshadowed by my strength.

In reflecting back, I have had the opportunity to give speeches, inspirational speeches even, facilitate countless workshops and classes, and

give numerous poetry readings. No one would guess I have a weakness in this area. The old adage "lead with your strengths" is demonstrated in this example and helps make the point to not obsess or worry too much about identifying weaknesses, as you can reframe and reshape these to your advantage.

In an artist community, opportunities abound and we won't need to search very far. The survey will help identify the opportunities that are easily available and those that are reachable with a bit of work and preparation. Using my example of public speaking, the opportunity to give readings of my poetry would not have crossed my mind in my mid-career had it not been for some of my other speaking experiences. These opportunities were indirect, since my original intent was to become more comfortable speaking publicly and with decision-makers. Now it is a much easier and accessible prospect. As you go through the process, hopefully you will find hidden opportunities that will provide greater potential for you to develop your talents.

Threats and Risks

We talked about risk-taking in the previous chapter, but in this survey we want to get at what kinds of threats, risks, and vulnerabilities you may face in trying to achieve your goals. And in some instances we need only list them, as they may not be imminent. A great example is the inherent risk that you will not succeed in becoming the artist of your dreams, whether it is a writer, photographer, dancer, choreographer, sculptor, or whatever. This survey allows us to list and identify the threats and risks without getting unnerved by them. Again, using a bit of Zen thinking here, you only have to notice and be aware of them.

Most risks are potential situations that could challenge or impede your progress, but won't necessarily materialize. They are future situations that are difficult to predict, and without the crystal ball you don't know that they will become a reality. This part of the exercise will allow you to get a holistic picture of what you are facing in setting up a goal plan. Identifying the potential risk factors will only help prepare you and make you more proactive. OK, we've described each of these well enough. Now it's time for the survey and a step toward greater discovery and planning.

PERSONAL SURVEY

Answer these questions related to the areas of personal, emotional, spiritual, and physical needs.

Personality traits. Select three that are your strengths. You may also write three that are not presented here.

Passion	Kind	Ethical
Tenacity	Assertiveness	Understanding
Patience	Fair	Authentic

Others: _____

Of the same list, select three that you consider weak or challenging areas for you. Again, write three if they are not presented here.

Passion	Kind	Ethical
Tenacity	Assertiveness	Understanding
Patience	Fair	Authentic

Others: _____

Status of Personal Development. Select ONE statement that is closest to your belief of your current personal, spiritual, physical, and emotional status (remember, work needs are not included yet).

I have room for improvement but for my age and development I am where I should be in most areas.

I have let myself go in many areas.

I am dissatisfied with my progress to date even though I have been working toward my goals.

If you selected number one, list two areas that need further improvement and tweaking.

i. _____

ii. _____

If you selected number two, list the areas that are most challenged. Of these, which do you feel are most important?

 i. _____

 ii. _____

If you selected number three, list the three major goals that you are working toward.

 i. _____

 ii. _____

 iii. _____

Now next to each one of these goals, identify how long you have been working on this goal, in weeks, months, or years.

Now list the number of types of interventions, actions, and modes you have used to further this goal. When was the last time you focused your actions to further this goal?

Let's take a personal area of physical condition or health as an example. Let's say your goal has been to lose weight, say forty pounds. How long have you had this goal? How many approaches (diet, exercise, behavior modification, etc.) have you used to achieve your goal? When was the last time you reviewed your actions with the goal?

Choose the answers that fit best.

 My overall feeling is that I am _____.
 a. Happy and satisfied most of the time
 b. Happy and satisfied some of the time
 c. Unhappy and dissatisfied most of the time

Social/Networking. Choose the answers that fit best.

 I have a/an _____ social network.
 a. Large
 b. Average
 c. Nonexistent

 It includes _____.
 a. Friends
 b. Family
 c. Other artists

 d. Colleagues
 e. People from many ethnic backgrounds
 f. People from many age groups

I _____ a significant person or support in my life.
 a. Have
 b. Don't have

Balance of Work. Select from the following:

I have achieved a balance between my creative and artistic projects and other work.

I have not achieved a balance between my creative/artistic projects and other work. This imbalance challenges me financially because I have too many creative endeavors that cannot be supported by a menial job that does not provide enough income.

I have not achieved a balance between my creative/artistic projects and other work. This imbalance challenges me creatively where I am able to support myself but have less opportunity to do my art.

I have not achieved a balance between my creative/artistic projects and other work. This imbalance challenges many areas of my life because I am stretched too far in both arenas.

I have not achieved a balance between my creative/artistic projects and other work. This imbalance exists because both arenas are not complementary and are juxtaposed.

Time Management. Select from the following:

I have enough time to pursue my creativity.

I have set aside time every day/week/month/year to be creative.

I don't have a "creative routine" but I have structured times throughout the year to be creative (summers off, retreats, and work periods).

a. Choose the answers that fit best.

My free time is spent with the following activities:
 a. Watching TV (more than two hours a day)
 b. Talking on the telephone with friends (more than two hours a day)
 c. Going out with friends
 d. Working out and exercising (more than two hours a day)
 e. Shopping, cooking, eating (more than two hours a day)
 f. Time spent with family commitments and responsibilities.
 g. Other: _____

After I subtract time for my responsibilities and other activities, I have _____ hours of free time.
 a. I have a routine that is flexible and workable
 b. I have a routine that is packed throughout the day
 c. I have no routine; every day is a different set of appointments, meetings, and activities.

Status of Creativity. Select from the following:

I am satisfied with the level of my creative work. I am particularly satisfied with my technical ability.

I am satisfied with the level of my creative work. I am particularly satisfied with my pace and output.

I am satisfied and would like to chart a new direction for my work.

I am satisfied and would like to continue at this level until I have mastered it.

I am dissatisfied with the level of my creative work. I am particularly dissatisfied with my technical ability.

I am dissatisfied with the level of my creative work. I am particularly dissatisfied with my pace and output.

My idea or vision of the end product doesn't express what I want to express.

Status of Creative Output and Process

What is the time of day/week/month/year when the creative process is working best?

Quantity of Output. Select from the following:

I have produced over one hundred finished pieces of my work.

I have produced fifty to one hundred pieces of my work.

I have works in progress that I interact with every day/week/month/year.

I have many pieces of my work, but am unsure that they are finished, as I need an expert opinion or outside critique.

I am just beginning and have many ideas but no works in progress.

Briefly describe your creative process (write whatever comes to mind here)

Tools and Equipment

Basic tools I must have

Secondary tools I would like that would advance my technique

Luxury tools

Choose the answers that fit best.

Does the result of your creativity have an expected out-come in that you know what it is you want to achieve? Yes/No

Does the result of your creativity have an unexpected outcome and is a surprise to you? Yes/No

If it is both, what percent is intentional versus unintentional and unexpected?

Motivation and Discipline. Choose the answers that fit best.

What helps motivate you to do your art?
 a. Supporting yourself
 b. Expressing yourself
 c. Conveying a message (personal, social commentary, global)
 d. Advancing learning

What helps discipline you to do your art?
 a. A deadline
 b. Stimulants like coffee, tea, chocolate, drugs
 c. Work behaviors that I have adopted
 d. A routine
 e. My peer group
 f. Other: _____

Ability for Outer Learning. Choose the answers that fit best.

I engage in formal learning through classes, workshops, and seminars _____:
 a. Regularly
 b. Not at all
 c. Don't see the value in it

I engage in informal learning through _____:
 a. Private study
 b. Self-tutoring
 c. Peer interaction/exchange
 d. My own individual learning plan

Ability for Inner Learning. Choose the answers that fit best.

My time for reflection is _____:
 a. Daily
 b. Weekly
 c. Monthly
 d. During special times of the year
 e. Triggered by life-changing events

My favorite time and type of reflection is/could be:
 a. Quiet time in the morning
 b. Quiet time in the evening
 c. Being/walking in a natural setting
 d. Personal retreats away from everyone
 e. Sitting, meditation, prayer
 f. Walking meditation
 g. Don't see the value of reflection
 h. Other _____

Peer Learning and Feedback. Select from the following:

It would be helpful to have a mentor or teacher

I don't need or want a mentor or teacher at this time

I have a mentor or teacher

Outreach and Community. Select from the following:

I am ready to be public with my art and welcome outreach opportunities.

I am ready to be public with my art but my outreach efforts have not yet paid off.

I am not ready to be public with my art.

a. Choose the answers that fit best.

I would welcome any of the following outreach efforts:
 a. Showing my work
 b. Publishing my work
 c. Artist collaborations
 d. Artist residency
 e. Regranting projects with a social/civic focus
 f. Regranting projects with a peer artist focus
 g. Other: _____

Assessment Rubric: A rubric is a scoring guide used in self-assessments. Even though the traditional rubric has some type of scoring or evaluative measurement, let's forego point values, as they are unnecessary for our purposes here.

The following list contains topics that have just been discussed in the survey. Review your answers above. Under each topic here, write a brief comment or summary of how you feel the above answers reflect your progress in these areas. For example, under "Time Management," you may write, "It looks like I use my time well and I have enough time to be creative."

It is a subjective assessment so it is OK to write any helpful comment you wish. They will give you a quick reference for future reflection.

Personality Traits

Status of Personal Development

Social Networking

Balance of Work

Time Management

Status of Creativity

Status of Creative Output and Process

Motivation and Discipline

Ability for Outer Learning

Ability for Inner Learning

Peer Learning and Feedback

Outreach and Community

Creativity Map Method

The creativity map is a visual representation of the dreams, aspira-
tions, and things you would like to have present in your life—
people, opportunities, money, material objects, or experiences that
help you to grow and achieve your goals. It is a visual collage
that shows where you have been, the major events in your life, and
even some of your greatest moments. In creating a map, you can even
represent emotions and vital qualities like courage or patience.

Creating a map certainly seems like a fun, "artsy" project to do, but
it is much more than that. Taking the time to design this map will
challenge you to think hard about what you really want at this time in
your life. The inner guide of your creative spirit will have the opportu-
nity to speak to you through images, without your head getting in the
way. The exercise of thumbing through magazines or catalogs, and
choosing those images that pull at you (without analyzing them) is
a good way to get at certain desires or needs. You may be surprised at
what gets your attention.

The map helps you discover what you want for yourself and your
life. It can be used before goal planning or after, whichever is prefer-
able. Hopefully it will be something you take time and care to develop
so you can frame it and use it in your workspace. By following the steps
below to create your own map, you approach planning and goal setting
in a more abstract way, which for many of us is the way we know best.

Seven Easy Steps to Developing a Creativity Map

The following seven steps will help you develop your own personal creativity map that will enhance your goal plans.

Step One: Gather magazines and catalogs.

Step Two: Go through the magazines and catalogs and pull out images, words, and phrases that evoke feelings and/or inspire you in some way.

Step Three: Cut out these images and words, and set them aside.

Step Four: Include the following in your gathered images:

* An image that represents who you are now and an image of who you will become once you are fully developed
* Images of your heroes and sheroes
* An image of your deepest wish to come true

Step Five: Place the words and images on a large board in any way that feels right to you. This may be a sequential representation or you may decide to use a metaphor: an image of a family gathering could signify community; an image of a three-ring circus could show the ability to handle many acts and performances; a calm lake could show the still waters that run deep. The list can go on and on. In creating this map, you may choose a predominant theme that helps connect the many facets of your life experience. Paste the images on the board.

Step Six: After you have completed your map, give it quiet analysis. Buddhists use pictorial diagrams or mandalas in meditation, and you could use your images similarly; try to reflect upon them and what the detail says about your experience and the totality of what it communicates. Review your creativity map and ask yourself the following questions:

* What do I see when I look at my map?
* What patterns and themes pop out?
* Did anything unexpected or surprising come through?
* Does the map look doable, overly ambitious, or not ambitious enough? How might I change it?
* Looking at the image that represents who I am and who I want to become, is there a big difference? If so, can I identify ways in which these two images can meld into one?

* In looking at the heroes and sheroes, how do these people inspire me? If they are not present, how do I connect with their memory? Write these statements next to each of the names or pictures representing your heroes and sheroes.
* Looking at the image of your deepest wish, have you enshrouded or covered it in any way? Is the image clear? How do you feel about having it being part of the map?
* Of the parts of the map that represent action and change, identify the parts that seem easy, challenging, and downright difficult. What parts can you start developing now?
* List all the things you have in the map that you would like to bring into your life.
* What are the next steps to follow my creativity map?
* Consider displaying this as a gentle reminder of who you are becoming and where you are headed.

Step Seven: Identify the major areas that you will focus on in the next year, and jot them down in your notebook. From this list, write "I will" statements for each of the areas in this list. For example, in my map I have represented three major themes that focus on developing my writing: a writer at a desk, a book, and an audience. From these images, I create the following statements: "I will commit to writing creatively every day." "I will produce a manuscript that I can send to publishers for a possible book contract." "I will reach out to the public through my writing by organizing two public readings this year." I can reinforce my second statement and say something like, "I will reach out to a public audience through the book I will write and publish this year."

Notice that these statements have a general element of time. Number one says "every day," and numbers two and three, "this year." This final step helps us create a map that projects our dreams and ambitions in images and words that give us helpful reminders daily to advance toward them.

❧ DEVELOPING THE PLAN

The map and the survey results have helped identify our dreams as well as our strengths, weaknesses, opportunities, and risk factors. Using these, we will integrate what we know into a personal goal plan. Using the "I will" statements or new goal statements, we will take what seem like fairly large, lofty, and maybe nebulous ideas,

aspirations, and goals, and break them down into a tangible and feasible step-by-step plan.

Your Personal Goal Plan

A couple of easy exercises to do and we are set to go—anywhere! Think of it like you have a truck full of sand—ideas—but you have to sort, sift, and move them into a place that is workable. You use a funnel to help get the huge sand truck of material into something manageable. Through the pull of a lever, you start moving the sand through a small shaft, tons of material funneling down into a tiny hole that gives us kernels of sand. These kernels of sand are the activities and baby steps we will need to get the large ton of ideas and aspirations into a manageable form.

Just What Is a Goal?

A short description is needed here because we seem to always mix up goals, objectives, hopes, and dreams. In working with clients and in teaching classes in grantseeking over the last fifteen years, I find it amazing how many people confuse these. Clarity is important in developing a goal plan, because you will be asked, "Where do you see yourself in five years?" If you haven't thought that far ahead, that will show up in your answer. And you can't fib or make something up on the spur of the moment because that too will lack credibility and show up in your answer.

A goal is the object of an effort. When you state a goal, you declare your ambition to do something. A goal is a dream, a hope, a desire; when it begins to take shape it is usually unencumbered and pretty basic—that is, "I want to be a writer." I first uttered that dream nearly forty years ago, when I was child. I revisited that goal in my twenties but it was still only a dream, since I had little time on task to make it a reality. I had written very little and certainly had not achieved any advancement beyond uttering the desire to be something more than I was. Stating the goal, in itself, does not bring about a result or outcome. Goals can be stated in lofty, larger-than-life terms. We need not limit ourselves to small statements, because goals should express our far-reaching dreams; that is their nature. And because they can be far-reaching, they need not be attached, initially, to measurements of achievement, which I call "objectives."

I recommend using a three-step approach because it is usually difficult for people to think immediately about a goal complete with

objectives or actions that are measurable, with time, specificity, and so on. So we start with big goals and move to a more manageable place—say, the objective, which is a statement that breaks the goal down as we try to advance it. From there, we plan, create, and strategize our actions and sequence of events. Example:

Goal: I want to be a writer.
Goal Advancing: I want to write stories, poems, and creative nonfiction.
(*Here's where you need to break it down more and have elements of measurement, so that it isn't just a lofty desire or romantic notion.*)
Objective: I will write a collection of poems and publish them in 2009.
Plan of Action/Strategy: Collect all of my writings, edit them, and sort for the best and most complete pieces—January–April 2008. Discuss writings and edits with a mentor (possibly a respected poet?) who can support and guide me—April–September 2008. Produce a completed manuscript to send out to publishers, contests, and competitions—December 2008.

Goal-Setting Exercise

We will use all of the exercises that we have already completed and collect our thoughts and results to help set our goals. What I want to encourage here is thinking that incorporates a holistic vision of your development, so I will ask you to create goals that are career-driven, that develop you as an artist, and that help you develop personally.

Personal and Artistic Development

Let's start with your creativity map; take one or two of the "I will" statements from it. Write them down in the spaces on page 65. Then add a statement about the picture or image of who it is you want to become. And finally, from your map, write out the wish you made during the exercise. For example:

"I Will" Statement: I will write, edit, and publish a collection of poems.
Statement from Image: Image of me on the back cover of my chapbook, with the statement, "Ellen Liberatori is a poet and writer living in Cairo."

Wish: I wish to develop my writing more and find success in publishing my work.

Now let's incorporate our survey results and write a few statements that help us develop more holistically. Look at your survey and see what you have written for SWOT. Identify your weaknesses; choose one or two of these. Look for any correlation to how your strengths may compensate. If you don't see any relationship between a weak or challenge area, don't worry. Choose one or two, anyway. Write a goal statement for each of these.

Career Development

For this exercise, write a goal statement focusing on the areas of time management, networking, and community outreach. Other areas you can focus on may be balance of work and creative output. In mid-career, you may still choose these but perhaps you want to also focus on community outreach and inner learning. Seasoned professionals may choose similar areas, but may also focus on producing new work, collaboration, or a self-mastery skill like integrating more reflection time into their day. Collect and write all your goal statements here or in your notebook.

What Do We Have?

Let's look at these before we move on to our objectives and create tangible measures. Do these goals focus your energy in a beneficial way? When looking at this, do the goals address "you" in a holistic way, or are they directed to one area of development? Focusing on one area is useful, but I encourage you to look more holistically at how you can direct your energies. It is like multitasking; you can accomplish more than one thing at a time. Don't worry, it doesn't mean you are going off in a million directions. This plan is a tightly woven set of goals, objectives, and action steps, which will actually make things easier in the long run.

Next Steps

Reviewing your goal statements, let's move on to breaking them down into smaller steps—objectives that are measurable and doable.

Take each of your goal statements and write an accompanying statement that includes elements of time, space, and quantity. You may have a few objectives for each of your goals, so don't worry if at first it seems like a lot. Just stay with the exercise for a minute because it will be less daunting as we break it down into smaller steps. Here is an example of a goal statement I created and its accompanying objectives:

Goal: Increase the creative process through productivity and time spent on the task of learning and writing.
Objective: Use two-hour window of time in early A.M. every day to write creatively.
Objective: Add one to four new poems each month to current collection. Check progress in two months.
Objective: In six months, refine collection by editing poems with mentor.

Back Casting

Now, the final step in all of this is to take an objective and look at the time measurement you have given it. Follow the time sequence backward, or "back cast" as it is called, and identify all of the steps necessary to achieve this objective. Back casting is a way to see and

plan all the necessary steps, but it is also a vital tool in determining whether a timeline is feasible. With the example of publishing a book, when I back cast from seeing the end product, I know a short timeline is inappropriate, because the publishing of a book is not solely reliant on the writer. Therefore, I allow enough time for a publisher's schedule and the time this hand-off will take.

STORYBOARD METHOD

The storyboard process is a charting system used to identify, set, monitor, and implement goals. Used as a tool in time and project management, storyboarding will help you establish goals, plan strategies, and monitor the overall progress in achieving and implementing your goals. (See page 68 for an example.) Storyboarding can enhance an individual's overall productivity. Its value is highly maximized in teams and team process since you can see at a glance all aspects of the team's work and how each project activity interrelates.

Some of you are familiar with storyboards since your art and creative endeavors have taken you into the field of story development, which relies on a visual tool to show the action and progress of the storyline.

How It Works

The process of storyboarding comes from the movie industry, where "the story" for a film is displayed in the steps, cards, or frames. Each frame presents one step critical to the completion of the action/project. We will use this process to display the objectives and actions needed to complete our projects and achieve our goals.

Benefits of the Storyboard Versus Other Methods

Storyboards design a workable, effective plan that includes timelines, achievable deadlines, and the specific tools, people, and resources you need to achieve the goal. It has advantages for artists who may be more visual and provides an actual board that can be manipulated on an ongoing basis.

I like it because it easily monitors progress of projects and helps you identify bottlenecks, barriers, and blocks to steps in your

Living a Writer's Life

To complete and publish one manuscript.

Personal/Prof Development	Book	Audience

Increase Creative Process	Create Manuscript	Increase Outreach
Use two hours in early morning for creative writing. *Every day.*	Conceptualize and outline manuscript. *Complete in three months.*	Work with local Poets Network to arrange two readings. *Contact in one month.*
Add one to four new poems to current collection. *Monthly with progress check in two months.*	Write and edit four sample sections, chapters, or pieces for manuscript. *Complete in six months.*	Attend open mic nights at a local coffee house. *Every other month for three months.*
Edit poems with mentor. *Complete in six months.*		

New Learning	Agent Rep	Public Readings
Identify authors in creative nonfiction genre for MS. *Complete in one year.*	Research and identify five to ten literary agents and make first inquiries. *Complete in three months.*	Prep content for readings; practice with others at home salon gatherings. *Six months.*
	Cull list and send formal queries with sample MS. *Six months.*	

planning. It will help analyze and evaluate the strengths and weaknesses inherent in any process of trial and error. It allows you to "visualize success," reduces the risk of project overload, and helps determine feasibility. It can be a motivator for you by posting goals and visually prioritizing a daily/weekly/monthly schedule. The storyboard is a personal goal plan and doubles as a visual chart and planning tool.

A storyboard differs a bit in how it is created in that it is a visual tool that illustrates a goal accompanied by main objectives, or functions, that then flow into detailed action steps. These, of course, are similar to action steps seen in a standard goal plan. In this process, because it is visually driven, a goal may have a one-word statement to represent it. For example, if you want to publish a book, attract an audience, and increase your personal development, signify your goals with statements like "book," "audience," and "personal development." Another benefit is that the storyboard can be abbreviated in some areas. It will still have detail, but these are mostly seen in the actual action steps of the goal plan.

Creating Your Storyboard

You can create a storyboard on a computer, but I would suggest that you use the process I describe below, because this way you will make a board that can be displayed in your office and workspace. Seeing your goal plan visually can be a great motivator. I know of companies that encourage their employees to use storyboards in this way.

For a storyboard created manually without a computer, you will need three different colored cards—I suggest colored index cards—and a large placard, wall, or whiteboard that you can pin, tape, or write on. Choose a favorite color for the goals, key functions, and activity cards. On the adjacent page you'll find an example of a storyboard I developed around the three main goals and concepts I have been focusing on. Use your imagination for the colors.

I have kept this storyboard simple to give you the basic idea. Once you have completed a "card" or activity, you can cross it off. When using storyboards with groups and work teams, it is also helpful to place the name of the person who is responsible for a given action step next to the date. Revisit this daily, and you will soon accomplish all of your goals.

✑ VOILA!

And there you have it—three methods for goal planning and development. With these, you will have some semblance of a plan to advance in your development. Let's go on to the next chapter to understand the inner workings of grantmakers who support artists and the necessary networking skills to access these.

✑ THE GRANTS ZONE

Developing personal and professional goal plans will have a positive spillover into your grantseeking.

Developing your art without reflection is like trying to develop art without the tools of planning, envisioning the future, and strategy.

Goal statements and plans can be used when funders interview you about your future vision.

✑ BOARD PET PEEVES

Artists who expect a grant but who do not have a clue about their future direction, focus, or plan.

Work, planning, and art that is done in a vacuum that does not relate to the artist's experience, skill, development, or the community.

CHAPTER FIVE

The Insider's Glimpse
of Grantseeking

All men are caught in the inescapable network of mutuality.

—DR. MARTIN LUTHER KING, JR.

Many of you have kept a healthy distance from foundation circles because of timidity and a lack of knowledge. Some of you think because of inexperience you will surely not get a grant. Others fall prey to the idea that you don't have a chance because you have to know someone.

This chapter confronts such notions and dispels the myth that getting grants depends on who you know and not what you know. We will add to our growing pool of knowledge a discussion of the interests of foundations, their idiosyncrasies, and their methods. At the very least we will gain an understanding of the structure of a foundation's staff, review panel, judges, and the board of directors or trustees. I think you may agree after reading this that the burden isn't only on the applicant.

WHAT YOU WILL GAIN

As I stated earlier, getting ready to go grantseeking is more about preparing *you* versus learning to fill out a simple application. Our goal is to increase our visibility and find supportive partners who encourage our artistic dreams. We will find inventive ways to create new circles of opportunities by increasing our networking abilities and contacts.

If you are an introverted artist or a nonconforming one, this will help you take an active approach in developing your own public relations campaign without compromising who you are. Developing the diligence to follow through in building relationships will go a long way in grantseeking. This chapter digs deeper into that diligence and will help increase your overall success and personal growth.

❧ DISPELLING A GREAT MYTH

Many of us grew up in small communities where everyone knew everybody or in neighborhoods that were cohesive. Advancement in such communities often relied upon the easy rapport and relationships that had been built upon traditions that were generations old. In many ways, these relationships gave a sort of protection from the outside world. This idyllic and close-knit community creates the notion that to get anywhere in life, you have to know someone. And for all that I will say in this chapter, there will certainly be an anecdote or two of someone gaining a position, higher status, and even the odd grant because of someone they knew in a decision-making role. But this is the exception and not the rule.

❧ A CLEAR DISTINCTION CAN BE MADE

We need to make a clear distinction between the kind of support that is available only to those artists who already have status and name, and the kind that comes through relationship building, advocacy, and merit. The latter is usually the case, as I have witnessed over the last twenty-five years in both grantseeking and grantmaking roles.

Grantmaking and grantseeking can set up a power structure that may seem unbalanced, with the power solely on the grantmakers' side as they ultimately make decisions. It is true that boards make the final decision in most cases, but as you will see in chapter 11 the process is much more open. I view the playing field as more equal—foundations have the responsibility of giving grants, and grantseekers enable them to fulfill their responsibility. I steer away from thinking that I have to try to influence the decision-making process and the myth that I must know people in high places.

We often view those with money as all-powerful, their lives shrouded in privilege and secrecy. Cartoons, films, and fiction perpetuate the myth of the power of fraternity, where access is obtained merely by saying that "Charlie sent me" or by using the special handshake, password, or door knock. Depictions of board directors are usually of "stuffed shirts"—men wearing monocles and cravats, and engaging in foreign boardroom-speak.

Fiction aside, today's grantmakers bring some of the misunderstanding upon themselves as it is often very difficult to get straight answers about decisions that have been made. And I am not joking when I say that funders speak a foreign language. In the book *Bad Words for Good: How Foundations Garble Their Messages and Lose their Audiences* by Tony Proscio, commissioned by the Edna McConnell Clark Foundation, many examples are used to demonstrate "garbled" messages and help us communicate more clearly. For example: "These grants will incentivize administrators and educators to apply relevant metrics to assess achievement in the competencies they seek to develop."

This is a good illustration of a garbled message, and as Proscio says in this short volume, much of the jargon used by foundations is a way to "dance around" saying something that we perceive to be too blunt or frank. He gives other reasons for this abuse of language, such as trying to impress through fancy writing when the true message seems to be too basic. This helpful discourse on jargon and how to avoid using it is available through the following Web site: *www.emcf.org*.

❧ HOW IT REALLY WORKS

To correct your misperceptions, you need to understand a few basic concepts concerning how foundations operate. If you recall, in chapter 1, we looked at the history of foundations and some of the oversight that Congress has placed on grantmaking entities.

Because foundations work with estates and trusts that invest large sums of money, they are regulated by laws governing what is known as an exempt organization—basically an organization that doesn't pay taxes. Exempt organizations are usually nonprofit organizations like schools, art organizations, and just about any "helping" or charitable agency in the community. Exempt organizations are also private foundations like family and corporate foundations. Although they may seem similar to business and profit-making companies because of their reach

and power, exempt organizations are highly regulated. The government has separate regulations for charitable organizations, churches, and private foundations, and they differ slightly in some of the definitions for such things as "disqualified persons," which is a term we need to look at in understanding that foundations cannot act out of favoritism.

The Laws Make It Clear

The laws state, "In order to qualify for exemption, an organization has to demonstrate that it is organized and operated exclusively for exempt purposes and that no part of the net earnings inure to the benefit of any private person or individual." Plainly said, none of the monies that are granted for charitable purposes can be given to associates within foundations. Associates to the foundations are categorized under the law as "disqualified persons," and these include trustees and members of the board of directors, family, relatives, partners, and substantial contributors and other fiduciaries or people who have financial control and decision-making power over the foundation. This also includes foundation managers, and in terms of family, it covers indirect family like a daughter- or son-in-law.

All that said, one might think that a foundation can easily tiptoe around these kinds of limitations in that this "disqualified" group has far-reaching networks and associations. Although the law per se does not stop a foundation from making grants to its friends, the tax laws that govern all foundations are quite restrictive. In recent years, especially after exposure of exorbitant salaries and high administration costs for some of the leading national charities like the United Way, Congress has really cracked down on private philanthropy through greater accountability.

Thou Shall Not Self-Deal

In refuting any argument that supports an it's-who-you-know scenario, these legal principles prevail. Simply said, foundations "shall not self-deal." This minimizes any potential chance for corruption, favoritism, and unethical practices. Foundations have restrictions about who receives grants, but self-dealing also has to do with other types of transactions, including:

* Sale, exchange, or leasing of property
* Lending money or other extension of credit
* Furnishing of goods, services, or facilities

* Paying compensation or paying or reimbursing expenses to a disqualified person

* Transferring foundation income or assets to, or for the use by or benefit of, a disqualified person

* Certain agreements to make payments of money or property to government officials

This is not meant to confuse you, and an explanation of the U.S. Tax Code is unnecessary, but these examples demonstrate the degree of oversight that exists and, if at any time a foundation operates in this fashion, there are great financial penalties as well as a shutdown of operations for at least a year.

Still, I know some of you are not convinced and are certain that grants are made to people who know people in high places. Be sure that your mistrust or cynicism isn't clouding your perception. And, of course, there are many instances where foundation staff, judges, and reviewers know their applicants outside of the review process, but there are ways to handle this properly that we will discuss. In the next section, I will shed light on situations of leverage and advocacy, which do arise in review of grants and are actually commonplace and relatively innocent.

Grant Leverage without the Backroom Chatter

I think we have established that foundations can't give grants to their associates and engage in self-dealing. But nothing stops them from giving a grant to help increase an artist's visibility and leverage for other grants and opportunities. Leverage in this form is not a bad thing and is commonly done, especially by a smaller foundation that wants to support your work but doesn't have the large grant resources to do so. It will then give a small size grant, lending its name and support to you as a stamp of approval and credibility.

This is wonderful, but it may surprise you that it is a slow and indirect process. For instance, in my role as a program officer and foundation executive it was not an accepted practice to call the staff of other foundations and talk about the grants that were made and what applicants one liked and disliked. That simply is not done and could be construed as scheming and conspiring in some way. In this case, even though it could benefit someone, in that you are praising his or her work, it is best that application processes be open and accessible without "backroom chatter."

Grant leveraging is a common enough practice but done in such a way that maintains a level of ethics and professionalism. This kind of leverage and influence helps to advocate on someone's behalf while keeping the playing field equal.

Advocacy and the Informal Lobby

Most grantmaking involves some type of advocacy, whereby a foundation staff person speaks on behalf of the applicant who is not present at a board meeting. Foundation staff and consultants are often in the position to literally present an applicant's information and special case for awarding a grant. Staff members advocate for and against the various applications. Oftentimes, oral presentations enhance a grant docket of written information that board members and judges may have to review. Rarely will applicants be in the room when a decision is being discussed, argued, and negotiated. All this is done with the most objectivity possible, using criteria that have been chosen ahead of time to help make sound decisions. A persuasive tone rules at a board meeting, and staff must try to field questions, clarify information, and educate board members about a particular applicant.

Even in the rare case that staff members lose their objectivity and their recommendations become clouded as they unintentionally lobby for or against an applicant, there are enough staff members in a foundation that bias can be sorted out. I myself have seen this happen a number of times, when the arguments to support an applicant appeared to be weak and the statements presented seemed more personal and did not follow the given criteria. I am confident in the checks-and-balances systems that exist within foundations and the professional quality that most maintain in their decisions.

A Conflict of Interest

It can be difficult for grantmakers to remain totally objective and to advocate on behalf of good candidates when they have far-reaching networks of friends, peers, and business associates. When this situation arises, there is an obvious conflict of interest. This is common and in most foundations there are policies that ensure that staff and board members acknowledge the conflict up front and recuse themselves from being part of the deliberation and decision-making. In some

situations, the person will even leave the room while that applicant is being discussed.

In the public arena of grantmaking, this is always the case, and conflicts of interest must be stated very early on in the process. In the case of a conflict being determined after a vote or decision has been made, the wrath of every public servant comes down on the panelist who has innocently forgotten an old acquaintance. Public grantmaking has even greater scrutiny, as these are government dollars being granted and the high standard for review maintains equal access and disclosure.

In chapter 1 we looked at philanthropy's evolution and the higher degree of sophistication that has developed. Protocol, policy, and a code for best practices do exist today, which promotes ethical safeguards in grantmaking. Philanthropists understand their own foibles and vulnerabilities, and they have learned from many mistakes. We can trust and feel some assurance that when we apply to foundations, we will have as great a chance as the next applicant. Have confidence that most judges, staff, and reviewers who seriously consider and support an artist's work have been trained well in advance to make sound decisions.

And if you are someone who knows people in high places, it is folly to rely upon power and prestige to advance your application. Between tax laws, best practices, and other protocols governing grantmaking, I believe this cancels out any such influence.

THE APPLICATION PROCESS

As mentioned before, foundations rely on staff, consultants, judges, and review panels to consider applications for grants. For individual artists, some of the leading foundations in this kind of grantmaking have very formal, structured processes for review. There are usually many levels to decision-making whereby staff and a preliminary panel of judges will make first-round decisions. This could cut a field of 200 or more applicants in half. At this juncture in the process, you may receive a letter saying you are being considered and they will call upon you when they need more information.

After the first selection is made, this same set of judges or in some cases an entirely different panel of secondary judges will do a number of things, from a paper and portfolio review to interviews with applicants.

Typically, reviewers will not have the entire pool of applicants to review. They will make their decisions by rating the most competitive applicants to the least competitive. Then all the reviewers will come together with their respective selections from their own pool of applicants, and through oral and written presentation they will deliberate and finalize a second tier or round of selected candidates. Sometimes, this can be the final group decision and this smaller pool of applicants is then interviewed once more to allow each one to make a formal presentation.

Personal Interviews, Studio Visits, and the Marathon

As you see, the peer review process relies upon the concepts of advocacy, persuasive discussion, and the selection criteria. Foundations sometimes drive themselves crazy developing elaborate matrixes, rubrics, and evaluation tools that help score, discern, and quantify the value of one applicant's ability over another.

Foundations review hundreds of applications every year. In general, grantmaking organizations make their decisions through a paper review and do not include studio interviews per se. Because the request is within the greater context of an organization, these may involve what is known as the site visit, which we will explore in chapter 11. In contrast, as mentioned briefly, grants for individuals, artists, and fellowships may have an elaborate process involving personal interviews, studio visits, and what I call the "marathon."

Personal Interviews

Personal interviews are often done with a peer from the artist's discipline and can be two-tiered, with a preliminary interview and a final interview. A written application will have preceded the interview, and you will have already responded to many questions. A preliminary interview may be a formality of going through your application, so be prepared to reiterate, clarify, and explain the information you have already presented. Preliminary interviews may be a perusal of your application along with unique questions about your work, and/or questions related to the criteria that the foundation has set forth. The criteria are usually published along with the application materials, and you should make an effort to address these as directly as possible in your materials.

Studio Visits

Obviously, some artists' works are not easily moved and even when a foundation pays and insures shipping, visits are still necessary. Studio visits can be a combination of personal interview and a look at your work. This is done in combination with the slides and portfolio that you have already sent ahead. One or more reviewers may come for the visit, so be prepared for a small group of judges. It's natural to feel nervous with reviewers but you will be focusing on your work so it will be fairly easy, because you are the expert of your work.

Like a Marathon

Fellowship applications and the process for reviewing them can feel like a marathon for both the grantseeker and grantmaker. Many of these programs only give annual awards, so the process is a lengthy one, seemingly with many hurdles to jump.

After the rounds of review from different panels of judges and peer review, some foundations may host a mini-retreat that all finalists must attend. Sometimes, these are done only with the awardees and sometimes they are done in a final process of selection.

Mile Twenty-Six

A few years ago, I made a bid for a leadership fellowship and can recount the experience, as the planning for these is similar to some travel and study applications. You find yourself involved in a preliminary review, which includes application forms, essays and personal narratives, plans, and interviews. A second round of review is done within the course of a one- to four-day retreat where all final candidates come together for final selections. You go through a series of interviews with a small panel of judges. You also have informal opportunities to engage your peers and judges, like at mealtimes, and so on.

Similar to a travel and study application, these grants were customized to fit a plan or program that each candidate designs on his or her own. For instance, after nearly a year of research, preparation, and life mapping, I decided to go back for a master's degree at the Kennedy School at Harvard. It was a great plan but the budget was nearly $130,000, including the living stipend and a practicum of fieldwork. So I applied for a grant to pursue a master's in public administration.

And for all my preparation, soul-searching, and intuitive guiding, I could not answer definitively the main question posed by the judges: "In five years, where do you see yourself, and what will you be doing?"

Remember, as logical as your plan seems to you—let's say to pursue a mid-career MFA—you must be ready to tell judges what their "investment" would really do in the community. How does having an MFA, which the funder considers the means, not the end, impact and benefit the community? And thinking about ends, impacts, and future outcomes, what could I have done with the degree that I couldn't do already?

All very tough questions, and I pose them here in the context of my experience so you will be prepared to address the long view of your fellowship plan. Even though grant amounts, self-designed budgets, and the economy of fellowships vary, you need to be able to tell the funder what the investment "buys." Whether it is a grant for $5,000 or a six-figure amount, you need to be serious about what you can do after the grant. Remember the grant is just a means to an end, and the savvy funder focuses on end results.

❧ FOUNDATION METHODS AND BOARD STRUCTURES

We can't go on to fun, games, and exercises about networking and increasing our visibility with foundations until we have a better sense of the structure in which foundations make their decisions. These are the inner workings of foundation boards and staff. The information presented here comes from many facets of my experience: professional grantseeker, grantmaker, and applicant. Again, generalizations cannot be made about these experiences, yet they give you a window into a world that sometimes is mysterious at best.

Each foundation is set up with its own by-laws and ways to operate within the context of the original bequest entrusting monies to a board of directors. For example, the Minnesota Council of Nonprofits provides very specific information about how boards are structured. Check out the Web site *www.mncn.org* for more details. In the meantime, note that the by-laws provide guidance for governing board processes. The following are some of the areas addressed in standard by-laws:

* The role of the board, and its size
* The compensation to the members (basically stating that there is none except to reimburse standard expenses)

* When meetings will be held, and the way in which members receive notice of these
* Elections of officers and terms of office
* What constitutes a quorum
* Vacancies
* Resignations
* Special meetings

In regard to the size of foundation boards, each state has regulations about the minimum number of board members (usually three), with no maximums. The standard setup is a small- to medium-size group of three to twelve or even twenty, typically with a board president, vice president, treasurer, and secretary.

The board of directors, the officers, and their duties are also fairly standard areas that are defined in the by-laws of an organization or foundation. The following is an example of how these can be stated from by-laws of the Minnesota Council of Nonprofits Web site *www.mncn.org*:

Officers and duties. There shall be five officers of the board, consisting of a chair, vice chair, secretary, and treasurer. Their duties are as follows:

The chair shall convene regularly scheduled board meetings, shall preside or arrange for other members of the executive committee to preside at each meeting in the following order: vice-chair, secretary, and treasurer. The vice-chair will chair committees on special subjects as designated by the board.

The secretary shall be responsible for keeping records of board actions, including overseeing the taking of minutes at all board meetings, sending out meeting announcements, distributing copies of minutes and the agenda to each board member, and assuring that corporate records are maintained.

The treasurer shall make a report at each board meeting. The treasurer shall chair the finance committee, assist in the preparation of the budget, help develop fundraising plans, and make financial information available to board members and the public.

Remember, this is only one example. In reality, each board operates according to its own protocol. For example, many boards name

a president, but he or she need not be the chairperson for board meetings. There is variation on much of this, since by-laws are unique to each foundation and nonprofit. For instance, the secretary isn't necessarily the person who records the activities of the meeting, as a staff person may do this. Each of these positions will interact with and relate to the executive director of the foundation, who is a staff person, and he or she will coordinate reports, minutes, and policy directives with the appropriate board member.

The staff members at a foundation are typically hired employees who fill various roles in the grantmaking processes—that is, communicating the foundation's mission, initiating solutions, and responding to community problems through grants, and grant processing. The general difference between board members and staff is that staff members are paid and boards are not, and that the fiduciary and overall responsibility for the foundation is on the shoulders of board members with the day-to-day tasks implemented by staff.

Grant Dockets, Board Meetings, and Trustee Meetings

As mentioned earlier, each foundation has its own way of grantmaking but here are some general notes in the way grant dockets and meetings are held. For fellowship grants, a board meeting or trustee meeting is often held after the various processes for an artists' review. After the review has been completed and the staff is ready to make recommendations to a board, they usually prepare a grant docket, which is a slate of recommendations that will be approved, declined, or otherwise tabled by a board of directors. The grant docket may take the form of a "board book" with memos or abstracts of information that are distributed prior to the meeting for reading and review. In my experience as a staff member for foundations, I have found that no matter how brief and concise a board memo may be to read, board members tend to rely upon oral presentation.

The frequency of board meetings depends on the foundations, but many have quarterly meetings. Foundations are required to have at least one annual meeting, and some will do all their business at that time. Again, there is great variety as foundations can choose any meeting schedule they want.

In chapter 11, we will look at the step-by-step process for the board meeting prep and how staff review requests for arts organizations.

✑ ONLINE GRANTMAKING

As much as we rely upon computers and technology, there are few foundations and corporate giving programs that have a "virtual" grant review. Online applications tend to be used in corporate-giving programs or private foundations where the use of technology is more advanced. Many foundations have elements of online processes, like eligibility worksheets and letters of intent, without having the complete application sent in this way.

Having been on the grantmakers' side of this, I have taken part in the pro/con discussion of virtual review. It seems for many foundations a plausible solution, given the great number of requests that they receive, but in the smattering of funders who have attempted this, the administrative factors seemed to outweigh any advantage.

It sounds nifty and easy, but there is resistance to it from funders in general, as many feel that online review does not give them a sufficient understanding of an applicant's request. Many also believe that since philanthropy is about building relationships, online review may miss this opportunity. Safe to say, for a while longer we will probably continue to review grants through traditional means and host board meetings to make the final decisions.

✑ A WINDOW INTO THEIR WORLD

You may think that applying for a grant is challenging, but you may agree after reading the last sections that reviewing grants is not as easy as it may appear. The basic responsibilities of reading hundreds of applications, interviewing people at site visits, writing and preparing grant dockets on top of maintaining a fair, objective, and professional manner, makes the job a challenging one. And for that reason, many who do this and do it well are artists themselves.

Whether you are facing a formal board structure, something less formal, or an online process, understanding the inner workings of foundations ultimately helps you progress in your preparation for grantseeking. Let's move on to the outer working of foundations and discuss networking and how you can increase your visibility within the funding community.

◈ EXPANDING OUR CIRCLES OF OPPORTUNITY

As we have been discussing the process for getting grants, I have presented them in two categories of inner and outer processes. We have just discussed some of the inner workings of boardroom decisions and a behind-the-scenes look at foundations. Now let's focus our attention outward and prepare for greater visibility and exposure.

Artists in all phases of their careers need to continue to grow and shape their own publicity. Much of grantseeking depends on your ability to increase your networks, peer circles, and business contacts. At some point, whether you want to or not it will be advantageous to show up at a workshop, conference, public meeting, or forum. These opportunities are great venues for networking and increasing your knowledge base of the community you work and play in.

The following describe some of these venues and platforms for increased networking. Remember, these take into account a range in artist development and will be relevant to the emerging artist, as well as the mid-career and seasoned professional.

Increasing Our Networks

Our first exercise involves some brainstorming and list-making. Have a small notebook ready and while reading the following list of possible places to network, jot down any and all that are relevant to you. As we follow through with more networking exercises, hopefully these will propel you into action. If you are not inspired by the ideas presented here, or if you are reticent, try to consider at least three of these ideas. If you are gung ho, then by all means put aside some "networking time" and incorporate this list into your personal plan.

Foundation Forums and Places to Informally Meet Funders and Artists

Forums that are hosted by a foundation, which focus on a special area of their grantmaking, are great ways to meet people. These range from conferences that invite both grantseeker and grantmaker, such as the National Philanthropy Conference, to civic action forums hosted by arts advocacy groups.

Some communities have well-established philanthropy forums that help nonprofit organizations build capacity. These include breakfast

talks for nonprofit managers, directors, fundraisers, and other staff. Even if you are not employed or associated per se with a nonprofit organization, these meetings may be open to the public and the content may help you increase your knowledge base.

Foundations also host their annual meetings, which are technically open to everyone. And even though it sounds like a broken record, each foundation does its own thing, and so some host a great public soiree in a community venue and others have a more private affair. Some invite their grantees and if you are associated with an organization that has received a grant that year, you have easy access. If you hear that one of your favorite foundations is hosting its annual meeting, check out whether these are open to the public and how you may attend.

Code of Conduct

I know it sounds so formal, but I want to make a few remarks about this, as it could save you from fumbling. The code of conduct and protocol for the forums we have just described is to attend, observe, and introduce yourself if/when the opportunity is available. You are forbidden to solicit, pitch, or attempt to engage foundation staff in any way about your project, your desire for a grant, or even the preparation of your application. There are no laws governing this, aside from old-fashioned good manners around the business of solicitation. It is not good form to hassle, hustle, or harass foundation staff for grants at any time, but especially in public meetings where the agenda is community relations and learning.

In my experience as a program officer and executive director of a foundation, I can't tell you how many times this boundary was crossed. And even though I managed it professionally, listening briefly and giving my calling card, I still felt there were few places I could relax.

Something I came to understand about this work was that no matter what the occasion or the stated agenda for a meeting, I was in a certain role, and I was perceived accordingly, like it or not. I learned to embrace it, understanding the situation. Some of my colleagues were not as tolerant, and they were very strict in maintaining a boundary. Of course, these are some of the reasons why foundations are misunderstood. If you have had contact with foundation staff outside of the application process and they seem standoffish, this might be why.

It may seem unfair that a public forum should allow for this, but the purpose of these gatherings is not for potential applicants to "work

a room" (that comes later), but to be engaged in learning some aspect of philanthropy, civic or social action. There are more appropriate settings, times, and places to make your requests known.

Grant Information Meetings

Grant information meetings are one of the best ways to open up your network of foundations. These meetings are hosted, focused, and positioned to help prospective applicants understand the foundation through its grantmaking programs. These are truly well-orchestrated forums that will either have a staff member answering questions or going through every section of the application and giving very specific information on how to best present your project.

Some funders combine this format with a panel of past grantees who talk about their experiences. I have attended a number of these, both for individual grant applications and for organizational arts grants, and even have attended a few times before I made my application. (In one instance, I "thought about it" for seven years.)

In public arenas where government grants have a shorter fiscal life expectancy, the processes are more intense because of tighter deadlines. Government-sponsored grant programs or the combination of private/public grants may be available for only a year or two, as federal and state legislators set government budgets annually or biannually. These public funders have a greater responsibility to make the grant dollars as accessible as possible, since any "leftovers" may not be renewed. One of the best ways to achieve greater access is through information meetings. Like private foundations, they go through the application requirement and some even host preplanning grant workshops. These workshops are provided by the public agency for all applicants who have been awarded a small planning grant to make the larger application. This should be underscored and jump out at you. Imagine having a great grant program that not only supports artists and art projects, but also small ($100–$750) preplanning grants for the application. Opportunity most definitely knocks here!

Artists' Forums

A wealth of networking opportunities exists for artists in their own purview. Workshops, conferences, poetry readings, art crawls, retreats, arts organizations, and even folk schools provide community-based venues for meeting other artists, funders, critics, and patrons.

Also, some communities have a number of arts organizations and professional groups specifically focused on your discipline or medium, and it is a very good idea to engage with these. In some communities, there are nonprofit organizations that provide support for the "business of art" to artists in all disciplines, such as the Resources and Counseling for the Arts in St. Paul, Minnesota. You may not have this resource per se, but it is worth adding to your research list, to see what kinds of resources like these are nearby.

Strategic Plans

Another common way to expand your network is to pay attention to the growth of nonprofit arts organizations in your community. Whether it is a music school, a small theater troupe, a gallery, etc., as they grow they will want to reach out to the artistic community. Some of them will have engaged in strategic and development planning and will host a "community unveiling" of it, which is usually open to the public. Attendees here will include artists, as well as foundation staff and these are excellent places to meet a blend of people. Again, the "no-solicitation rule" applies and your sole purpose is to show up, pay attention, and introduce yourself. In doing so, you will slowly become more visible in the community *and* you will become inspired in new and different ways.

Other Community Venues

There are many art events and community venues where artists, critics, funders, and patrons gather. These community-driven events are often hosted and planned by neighborhood arts organizations, which celebrate an ethnic holiday or cultural occasion. These could include festivals like May Day, Day of the Dead, or Cinco de Mayo. Add these to your list and you not only have a networking opportunity but you will have fun as well. Also, some of these will have community organizing and sharing time, whereby anyone is welcome to come and lend a hand in the creation of the parade float, mural, theatre project, picnic, or art fair.

Community art projects are similar to the opportunity to network via festivals but are a bit more formal and make use of collaboration. Perusing an organization's Web site or storefront will oftentimes apprise you by means of a "call for artists."

Art exhibits and openings hosted by a foundation showing off their grantees or art organizations are the more obvious places where

you can network and create opportunities for outreach and increasing your visibility.

Web Sites, Forums, and Artist Labs

Any list of networking opportunities and places to gain greater visibility would be incomplete without mentioning the World Wide Web. I am not just talking about the blog phenomenon. One can find nearly anything on the Internet and the ideas and list of opportunities here are for the purposes of community interaction. Outreach in the mode of hosting your own Web site will showcase your work, which is a great idea, but what I want to focus on here are the ways in which you actively seek to engage, interact, and participate with a virtual community.

A great example is the McKnight Foundation Artists Lab, hosted by the McKnight Foundation in Minneapolis, Minnesota, which hosts a wide-ranging database that includes artists from all disciplines, forums, curator- and member-made collections, articles, and arts-related issues, community announcements and new music, writings, and video releases. It is an exceptional Web site that was the result of a community-wide survey and collaboration of the Walker Art Center's New Media Initiative Group, which is based in Minneapolis. Databases and forums such as these have it all, and so are precious in that they can meet many needs no matter your level of experience. The Web address is *www.mnartists.org*.

For other Web forums, you may have to hunt around to find one to your liking. I have had some luck with photography forums, in particular, some of which have a variety of people represented from many backgrounds, styles, and levels of experience. You can post some of your work, and there is an array of technical information from equipment overviews and troubleshooting to discussions about photography, and so on. There are countless forums for literature, poetry, and creative writing that may meet your needs. In researching many disciplines, I found forums for just about every type of artistic expression, and it seems quite true that we live in a virtual and global community that is getting smaller and more connected due to the Internet.

Peer Labs, Artist Zones, and Districts

Some communities have it all, in that you can find places where many artists live. Famously, Greenwich Village housed well-known poets,

writers, and artists of the twentieth century, including one of my favorite poets, Edna St. Vincent Millay. Since those early times, the reputable low-rent districts that offered refurbished studios, lofts, and apartments for artists have increased in value and so finding something affordable may be difficult. Moving or living within a neighborhood of artists may not always be conducive to your plans, and I am only suggesting it as a networking mode, merely as one of the brainstorming ideas.

Living in an artist community may not be your style, but here is another option for you to consider. Some communities have turned old buildings and schools into artist studios and workshops. I know of a few of these and they are very nurturing and supportive places to develop your creativity and your peer community.

The term "peer labs" is used in a variety of grantmaking categories. For the purposes of the arts community, peer labs are small cohorts of artists or art organization representatives who are given grants along with technical assistance and specialized training to build organizational capacity in administration, fundraising and fiscal management. Peer labs provide a different opportunity for networking, and entry into these is still competitive and will involve making an application. Once you are part of one of these, you work in a peer-learning environment with a group of artists or art organizations who come together to understand something that builds their organizational capacity. To understand these better, check the list of resources in chapter 12.

Mailing Lists and List Serves

Getting on a snail mail or e-mail list is a great way to stay connected about art news, exhibits, the latest publications, and grant competitions. I receive a monthly e-mail from a regional arts board, and it is very helpful in keeping me apprised of what's happening. As you engage with a community group, ask whether they have a list serve or e-mail list that you can be part of and how often they send information. I was on a list serve once where I received something nearly every day, which was more than I needed, so check out the frequency of the news they send.

Finding These Resources

Finding these is really easier than it seems. You simply must have your antennae up and be paying attention. In this brainstorming

session, we have connected the dots and made a line that extends through many arenas: community development agencies, neighborhood associations, peer groups, galleries, foundation grant meetings, annual meetings, art openings, exhibits, the Web, artist labs, newspapers, libraries, and coffeehouses.

And in some cases, as you find your web of networks, they may intersect in synchronized ways. For instance, I took writing classes at the Loft in Minneapolis; years later, in some of my community work, I helped design a program that collaborated with its members. In my role as a program officer, I had the opportunity to meet them again in grant reviews. The main point here is that networks are meant to circle around, and the broader they are, the greater the opportunities they provide. Even though it is a bit of work initially, the impact of networking will greatly improve your overall career, so get out there and meet, meet, meet.

NETWORKING EXERCISES

Getting grants is about reaching out to the community and increasing your visibility. The following networking exercises will help you discover potential opportunities for collaboration, new projects, grant competitions, and ways to stretch yourself in your career. Some of these may seem academic and elementary, but they are a great starting point for those of us who have an undeveloped network.

Exercise One: Develop Your Hit List

The "hit list" is an actual list of people, places, and communities that will help you make your introductions. The following will get you started:

* **First Tier:** *Identify the closest library to you; a state, county, or city arts council; and your local United Way agency.* In your notebook, Rolodex, or electronic address book, make a contact profile for these three. The library will be a main source for some of your research, and the state, county, or city arts council is a great place to start increasing your network of contacts and knowledge. I have listed the United Way agency, since most communities have these

and you can start with them in finding out where arts services and resources exist.

* **Second Tier:** *Now, let's list ten artists that you know in the community.* Start with your own discipline and venture out from there. If your community is large enough and you can identify ten artists of your discipline, add them to the list or make a list that blends artists from all disciplines. If you are at a loss for these prospects, start with the Yellow Pages and make a list of professionals who are working commercially.

* **Third Tier:** *This last tier will be ten art organizations or entities that support artists.* Using the brainstormed list that you have just created from the preceding narrative, choose from the networking ideas that will work best for you.

Contacts and Meetings

Your hit list will be progressive, starting with the very basics like the library and following through to people and organizations. Establish a goal for yourself that you will contact these and try to make appointments to meet the people. Even if you have schedule conflicts because of daytime work, there are breaks and pauses in which you can do some of the initial contact by telephone. If scheduling one-on-one meetings is a major hurdle, choose the networking ideas that are community-focused like readings, exhibits, art openings, and festivals. These will not be tied into a nine-to-five schedule, and you can still meet artists, peers, and potential supporters. Try to schedule a meeting or attend an event weekly, so you can gain momentum in the practice of networking.

The Purpose of This Meeting and the Interview

When you are able to make appointments, the purpose of your meeting is very straightforward. All you need to do is tell the artist or organization representative that you are an emerging artist trying to establish yourself and would like a short meeting to help you understand the breadth and scope of your art discipline in this community. Meetings with people who are new to you can sometimes feel uncomfortable in that you may not be sure how or where to start the conversation. In any meeting, you are trying to have a greater understanding of the person in front of you, so a good starting point is with

that person. The following list of questions and areas to discuss will help you understand what you want to accomplish in these brief networking meetings:

* Ask the person to describe what he or she does. If the person is an artist, ask about his or her work, exhibitions, publishing, performances, etc.
* Ask pertinent questions related to the person's art, process, and ways in which he or she draws inspiration, exhibits art, etc.
* If the person is an organization representative, ask him or her to describe the various programs and ways in which the organization supports artists. Ask the person to tell you how he or she came to this job/role. Even the most modest people like to recall how their careers evolved and/or how they landed where they are.
* Ask the person what is most personally rewarding and challenging about his or her art/work, how the person sees your art discipline evolving, and what trends you should be aware of.
* As you progress, you can begin to talk about yourself. Spend a little time telling the person where you are in your career, your current focus, and short-term goals. Try to discern whether the person knows other people who would be helpful to you and how you can advance the goals that are your focus right now.
* Remember, be a good listener and use a notebook. You could even have your questions typed out and ready so you can jot down their remarks. Ask permission to do this first. Avoid using a tape recorder, because the formality of it will usually impede people from opening up. Keep your promise and finish the meeting when you said you would. If you said an hour, watch your time, and be respectful and cognizant of the how the hour is passing by. If you don't have all the information that you need in the time allotted, ask the person whether you may follow up at a later time with a phone call.
* Finish the meeting by clarifying e-mail, business card information, or other contact data.
* After the interview, collect your notes, and add the new contact information to your evolving hit list where you add and subtract pertinent and potential contacts to meet. Follow up with a thank-you through snail mail or e-mail or with any promises you made for exchanging more information.

Exercise Two: Web Browsing and Links

Find one grantmaker in your area, and go to its Web site. Investigate the links provided and bookmark the ones that are pertinent to your needs.

Exercise Three: Working a Room

Find and attend one event, perhaps a festival, a grantmakers' forum, a public exhibit, or any community meeting from the brainstormed ideas above. Before you go, decide what your energy level is for the day, and make a commitment to yourself that you will meet and introduce yourself to at least three people at the functions. Have business cards to exchange; if you don't have a business card, at least get theirs so you can follow up.

The concept of "working a room" conjures up some gregarious personality going from circle to circle of people, giving a hardy handshake and engaging in witty conversation. I am not suggesting you incorporate this behavior per se, but I do want you to take advantage of new ways to meet people. Many public functions have huge gaps in their programs where there is a lot of standing around and opportunities for brief chats and introductions.

Go early so you can meet more people. Always attend the reception before a program and remember, the more you do this the easier it becomes.

Here is my easy and simple approach to working a room, especially for the days I am not feeling "public" or very extroverted. Remember, these are all practiced behaviors and if you aren't up to meeting a lot of people, or the content of your exchanges is not fruitful, don't worry—you will improve as you go along and gain confidence.

Work the Room Spatially

Introduce yourself to the person or persons sitting next to you, at your table, etc. At a break or any program pause that there may be, introduce yourself to someone who appears open, friendly, and is just standing around with no one to talk to. If there are special people that you intend to meet with or do business with in the future, try to introduce yourself, slip them a card, and say you will be calling them. It could be that simple.

Introduce yourself to someone at the coffee or refreshment station, especially if the person is just standing around. If the person is going to a table that has an extra seat, take this as an opportunity to sit down and ease into a short conversation.

Avoid introducing yourself to people in the bathroom. I have always thought that the bathroom was a boundary, at least to privacy, so give people a few moments to freshen up and rest without having to be "on."

Work the Room According to the Host's Plan

If you are attending an event that has ice breaking and networking exercises built into the agenda or program, use these to your advantage. If you are in the position of having to stand up and address the group at large with a self-introduction, keep it brief. If you have a tendency to get stage fright, take a sip of water just before you stand and look at the moderator, or some other kind face in the group.

At conferences, take advantage of any networking breakfast or lunch, and don't worry if they are prescribed and you aren't in the group you prefer. All of this is helpful practice, even if the immediate contact is not presently someone you think you will engage with in the future. Also when you are at conferences, attend workshops, lectures, and plenary sessions that can help you meet, hear, and see the networks of people you want to contact.

If there is a choice (and there are usually *too many* conflicting choices) between a panel of funders and a panel of artists, I usually choose the funders, noting those artists with whom I will follow up later. Of course, you can do this in reverse, but I gravitate toward what will prepare me for grantseeking and so I usually opt for the funders' panel.

Work the Room Randomly

Have fun with networking—you're an artist. For example, in working a room choose to meet everyone wearing orange, or who is ten years older or younger than you.

Introvert First Aid and the Nonconformist Approach

I understand that for some people all of this networking stuff is truly foreign, and you may not like it because you are shy or don't want

to engage with the established networks and groups. Proceed with the idea that you are developing a new side to your personality that will help you in grantseeking. Think of it as a switch or a mode that you turn on for certain situations. If you feel nervous about speaking in public settings, you can try taking a class or attending Toastmasters meetings. These are excellent ways to give you the skills to make you feel more confident.

Trying to identify why you are reticent can be helpful, but I wouldn't spend too much time analyzing it. Accept it as a strength in that it helps you focus inward toward your art, and know that you can tweak and reframe the situations to your own benefit. Over time, if you incrementally increase the places and situations for you to be more public, social, and visible about your art, you will desensitize any fear, irritability, or annoyance you encounter when you have to be more extroverted.

If you are a nonconforming person, understand that your being different probably fuels your art and creativity. That said, there is a distinction between this and being obstinate or judgmental about established artists, critics, patrons, and funders. As you research and look at any of these entities to see whether they support artists like yourself, avoid getting worked up, adamant, or arrogant if they do not. Many grantseekers have far-reaching ideas, think outside of the box, and are abstract in their processes. The grantmakers may not have met an artist like you who can show them a competitive plan, application, and great work. You are here to educate funders and the establishment. It is part of your duty as an artist to show that your form of expression is one that has relevance.

In places where art is censored and political screens get placed over it, the challenge to educate will be greater. Depending on where you are, this can be quite restrictive. One can't show nude photography in many countries, because it is a cultural taboo. But if you are living in North America, you have a wide breadth to express yourself. You can voice your differences and try to educate your peers and the decision-makers.

☙ THE GRANTS ZONE

Networking and increasing your contacts in the community is a key step in preparing for grantseeking.

Ninety percent of all grants that are made involve personal contact. Get out there, make contacts, network, and meet people.

Avoid making yourself a nuisance in meeting grantmakers.

⌑ GRANTSEEKER'S DOS AND DON'TS

Do be aware of the agenda and purposes for a public forum or meeting and introduce yourself appropriately.

Don't launch into a solicitation and pitching conversation with funders at public meetings where this is not the focus. That is inappropriate.

Do remember that funders have their antennae up and want to meet you, and find out more about you, too, so don't forget to follow up when you should. Telling a funder you will follow up by giving him a call and failing to do so is not a good practice.

CHAPTER SIX

Increasing the Prospects for Success

Knowledge is of two kinds. We know a subject ourselves, or we know where we can find information on it.

—SAMUEL JOHNSON

Finding grant dollars can seem like finding the proverbial needle in a haystack, and my aim is to help you do just that in this chapter. At the very least, I will help you zero in closer to where you might look and by doing so you will increase your prospects for overall success.

The previous chapters have helped prepare you in many ways. Hopefully, you have been active with the exercises, and with increased networks finding grant dollars will be much easier. If you have skipped to this section of the book, you are still in luck.

Finding a good prospect is an important step. It's like finding a good publisher, gallery, or place to show your work. There is a natural "fit" and little work in making the match. The narrative that follows will describe the most common ways to find grant resources. You will be well on your way to getting a grant after you understand this chapter and the key elements of researching prospects.

We will also use our creativity to identify ways to find the more elusive and perhaps uncommon sources for funds and grants. This chapter is not a prerequisite to writing a grant application; however, without good prospects you won't really have an audience to present your case for receiving grant support.

I can't cheerlead enough for prospect research, because it is a fascinating social subscience in the field of philanthropy and I personally

love this work. I think you will agree that adopting my special blend of entrepreneurship, curiosity, and tenacity will help you find that needle in the haystack, or better yet that nugget of gold. You'll be looking in the right places, and that makes all the difference.

❧ DEVELOPING STRATEGIC PARTNERS

As we get into this, I know my vernacular gets pretty basic and I talk about grantmakers, funders, and patrons as "prospects," because they are that. But, of course, they are more than that. I don't want to lose sight of what we are trying to accomplish by merely learning the ABCs of prospect research. By creating networks with people, organizations, and the collaborators that you identify, you are in essence developing strategic partnerships that will hopefully be long-lasting and support you throughout your career.

Prospects are the means to the end. The end result is to develop sound partnerships that help you exchange ideas, leverage these ideas, and increase your opportunities for projects, grants, and visibility. A prospect may look good on paper, in that your research will show that the prospect indeed supports individual artists, but you may not get the grant when you apply. The reasons for grant declines will be discussed in chapter 11, but right now the main point is to try to get you to think more openly about prospects and to know that you must adopt the long view.

Can a prospect who basically turns you down become a strategic partner and helper in some other way? The answer is yes, and this chapter will help you understand new ways of thinking and developing partnerships.

❧ THE ABCs OF PROSPECT RESEARCH

Prospect research is a highly developed area of fundraising, and today there are many professionals who spend countless hours at the courthouse or library finding out very specific information about wealthy individuals, foundations, corporations, or other community grantmakers.

Fundraising for individuals and nonprofit organizations can be a complex business. Grants from foundations make up a good portion

of charitable support, but the best way to raise money is through private donations from individuals. Large nonprofits rely on this more than they do grants, and so the need for a good "prospector" is underscored. By adapting the skills of a good prospector for individual donation, we can research organizations and foundations with the same thorough approach.

I am always amazed at the wealth of American society and even more so in the way information is available about such wealth. I attended a conference in the 1980s and in one of the sessions I witnessed a demonstration of how prospectors gather their information. They hunt and look for public records, including birth and death notices, notices about probated wills, and the sale of estates. In one instance, a prospector was monitoring the transition of a large company selling off assets in a company merger. Because it was a public company, the information was easily accessible and so when the merger actually happened, it was apparent that the founder and former CEO of the company had made a sizeable profit. In this demonstration, the public shares and all of the profits were shown via computer projection to the audience.

If you are a fundraiser and have a worthy cause, knowing that someone has just come into a lot of money is advantageous. In this case, the story goes that a representative of the former CEO's high school alma mater paid a visit shortly after the sale and through a series of formal requests received a very large donation, which in essence built an entire new high school. Of course, most of us will not be running out to our city or county government office to look at someone's public records for background information such as this, but we can do research to position ourselves advantageously.

Prospect research is a vital tool in fundraising and philanthropy. For our purposes, we will focus on foundation and corporate prospects who give directly to individuals. We will also rely on those prospects who support individual artists through fiscal agents and organizations that have 501(c)(3) status.

Fiscal Agency and Sponsorships

In chapter 1, we discussed how history has influenced philanthropy and how it can be burdensome and complicated for foundations to give to individuals. Most grants are given to organizations that are

tax-exempt, or 501(c)(3). This designation is an exclusive one, and if you don't have it, all is not lost. You only need to find a "fiscal agent" or an organization that acts as your sponsor. And you may not have to look too far, since many foundations set up regranting programs, as was previously mentioned. They make large grants that establish programs like SASE's Emerging Artists Grants and The Loft's Mentorship Program for Writers in Minnesota.

Some foundations leverage their grants with public dollars, such as the Metro Regional Arts Council (MRAC) in Minnesota where the McKnight Foundation regrants dollars for capital grants and organizational development grants through MRAC. These can provide great support for the needs of artists in any career phase, and I mention them here to promote your thinking outside of the traditional box.

Warm-Up Exercise: Redefining You and Your Project

Before we go searching for where the grant dollars are, I want you to complete the following warm-up exercise, which will help you take the blinders off, and get you thinking broadly. Even though your goal in the research process is to obtain a good match, in doing so you will need to come up with key concepts and words that can help categorize the type of grantmaker you want to find. I want you to have as many opportunities as possible, so instead of focusing in narrowly to define yourself and your project, this exercise will help you redefine yourself, thereby increasing the number of potential prospects.

Grant research with the foundation directories is somewhat like using a search engine on the Internet. Thinking of keywords, terms, and ways to label your needs will be very helpful.

Exercise

Identify all of the obvious keywords within the following project description: "I will attend the SplitRock Lighthouse Artist Retreat for Photographers and Writers during the summer sabbatical."

Obvious keywords are: artists, retreat, photographers, and writers. You have identified four ways that you can research grant support for artists, retreats, photographers, and writers. To expand the number of possibilities, let's analyze and think about what we have that may not be apparent, especially if you are a first-time grantseeker.

For the First-Time Grantseeker

To get at the less obvious, let's look more closely at the above project description example and think of other considerations that can provide greater search opportunities:

* **Sabbaticals:** These may be a fundable area; however, they are usually formal sabbaticals that occur over a long period of time. If you aren't finding much in the way of short-term sabbatical support, look at the next keyword.
* **Continuing education:** If you are attending the retreat to further your education, this keyword may apply. Funders differ in how they support continuing education, from those who prefer formal education to those who allow for learning outside of an academic venue.
* **Individual artist:** It is implied here, but you could overlook the obvious.
* **Peer learning:** Another keyword, depending on the focus and purpose of the workshop.
* **Career development:** This is a broad category that opens up a lot of possibilities, depending on your needs and the funder's focus.
* **Types of support:** There will be many keywords here, as you may need support for travel and study, to finish and complete a work in progress, or entrance fees. It could also be considered a special project if you are working on something collaboratively, and if the workshops are geared toward the technical sides of creativity; say you are working with an arts organization and the sessions at this retreat are meant to build an organization's capacity, then you could add capacity building, technical support, and organizational development as keywords.
* **Planning:** Another keyword, if this is the main focus of the retreat.

Conventional Methods for Prospect Research: Reference, Phone, Internet, and Annual Reports

This is one of my favorite aspects of grantseeking, and I can hardly wait to indoctrinate you into the mystery solving of prospect research. We will investigate two main areas: private support and public support. The conventional methods for researching grant prospects are references, phone, the Internet and annual reports. The research methods for these are similar but some of the rocks we will look under are very different.

❧ IDENTIFYING PRIVATE SUPPORT PROSPECTS

Private support comes from private foundations and corporate giving programs that have raised their monies through bequests, estates, and trusts.

The annual report and grant guidelines are the two main pieces of information that you are trying to obtain to determine your "fit." The annual report is the document that explains each foundation's history and giving preference. The grant guidelines are often a separate document that gives the finite details of its programs and describes the application process. Application forms, when they are used, may also be a separate document, and so when you are researching and obtaining these items, it is important to be specific in asking for what you want. As mentioned early on, some foundations are idiosyncratic and may not automatically send you copies of everything unless you specify your needs.

Naturally, Web sites and Web pages offer much of this information and we will include it as a research method. That said, it is important to note that this industry is still reliant on print materials, and not all foundations have Web sites nor do these give you all the information you may require.

What I am suggesting in your research methods is a multilayer approach that should meet the needs of most artists reading this. Your research tools will include library and reference materials, Web review, telephone calls, and gathering support materials that can give you the missing clues in the mystery of finding good prospects.

❧ LIBRARY RESEARCH

In this land of plenty, we not only have wealth, but a wealth of knowledge that helps us understand it. In the United States, there are many research centers for philanthropy. The most widely known is the Foundation Center. We will focus on it, as it is the most comprehensive research entity. It established the Collection for Philanthropy, which is hosted in five regions across the United States and is located in libraries in New York, Washington, Atlanta, Cleveland, and San Francisco. In addition, it hosts another 212 cooperating collections in all fifty states, as well as in Puerto Rico and six territories.

The collections offer invaluable tools that include a variety of resources. Most major cities will have some semblance of a complete collection of reference materials. These materials include guidebooks, case studies, and other grantseeking books, but mainly include directories that present information about each foundation. There are a variety of directories categorizing grants for arts, individuals, humanities, education, health, and many other subjects. In addition, there are directories and reference materials categorized under types of support. For instance, there is a directory for capitol grants, for general operating, and special projects. However, some libraries may be limited to one or two of the directories.

The Foundation Center Directory

The standard industry directories are from the two largest entities collecting and publishing philanthropic data: the Taft Group and the Foundation Center. Both have similar information and publish many of the same taxonomies. Becoming familiar with these directories will be vital in finding good prospects, so let's look more closely at the Foundation Center's directory and do a short exercise in library research.

There are specific directories for many of the subjects that are categorized by the Foundation Center. For our purposes, we will look in the general directory and in the "grants to individuals" directory, which has over 6,000 entries. That is 6,000 entries, not prospects. Grants to individuals include support for artists, medical situations, special needs, competitions, scholarships, fellowships, and one last category I call "grants of the obscure." These grants are very unique and have requirements that are all over the map, literally. For instance, the funder may have a requirement that you must be a family member of an employee of Red Advertising Company, or live in Racine County, or have a specific ethnic heritage. It is worth the time to look at these, as the requirements for eligibility are unique.

I especially love the research aspect of fundraising. Maybe it is the challenge of finding "a treasure" among the stacks of books at the library. Book research can provide quiet downtime amid the sometimes-frenzied scene of grantseeking. For me, going to the library was a mix of chaos and order. The parking spaces in front of the library were all metered and on a very short timer, and because I lived in Minnesota at the time, it seemed I always picked one of the four nicest days that one could have while living in the land of ten thousand

icebergs . . . I mean "lakes." I made a game of it: how many prospects could I find in the short meter time I had at the library? Later in my fundraising career, I had my own copy of the directory, but taking it to bed was not popular with my spouse, so I still made a game of finding as many prospects in, say, one hour's time.

One of the main reasons why I like the directory is because there are a number of user-friendly indexes that can be cross-referenced to provide you with more prospects. As you begin your research in the subject index, you will note how they have categorized and labeled certain areas in philanthropy. After nearly fifty years, this taxonomy may be showing its age, as some of the subject labels are quite dated. Terms like "handicapped" and "aged" are not contemporary and reflect the origins of the database and the times they were created. Nowadays, we say "seniors" and "elders," instead of "aged." And instead of the pejorative term of "handicapped," which is derived from a beggar with a cap in hand, we use more respectful terms like disabled or challenged. Unfortunately, we aren't here to change the taxonomy, but note that the way you name your cause may need to conform to a less-than-contemporary terminology.

Methods for Doing Research with Directories

Turning to the subject index in the big general directory, use the subjects and labels you defined earlier in the warm-up exercise. For example, under the subject of "arts," you will see a list of foundation names categorized by state. Look up the foundations in the state where you live. Note all of the foundation names but more importantly, note the cite numbers next to the name. If you are doing this quickly, all you need is the number to have a peek at the funder's profile. Then go to that cite number and check out the narrative profile of that foundation. It will have a lot of info in very small type, so bring your reading glasses. If you are really in a hurry, you can make copies of all these profiles and study them later. Or you can do a quick analysis and decide whether they are a potential fit. To make the determination that they are a fit or not, analyze the following information:

* **Types of support:** Note special project, general operating, fellowships, etc.
* **Areas of interest:** Note all references to art, and any reference to your particular discipline of art. Also, pay attention to any of the

periphery ideas we have floated that will help you expand the number of prospects, like art education, human services, civic, and youth.

* **Limitations:** Some people look at this first, because it could cancel any chance for individual support, especially if it says, "no grants to individuals." Don't despair, and remember that you can align yourself with a nonprofit organization that will act as your fiscal agent or sponsor, thereby getting your foot in the door.
* **Assets:** I used to look at this first and was actually taught to do so early in my prospecting career. The assets section of the profile shows how much a foundation has in total, and the number of grants it gives out annually, the high grant, and the low. Choosing prospects that could give a minimum of $10,000 was one way to weed some out, as the total project budget I worked with back then was at least $100,000. Doing the math, we can choose to chase a lot of small grants or fewer large ones. It all depends on your budget and ability. For collaborative projects, medium to large grantors are needed but don't overlook the small grants for your own needs. A grant of even $1,000 can do a lot for an artist.
* **Deadlines:** Another key area to note. Of course, it helps to have a timeline and to know how long you have to prepare an application. I would even suggest setting up a schedule once you clarify and validate all of your deadlines.
* **Contact name:** Basic information to know when you call or try to set up a visit with them.
* **Approach:** A great field, because it actually tells you the funder's preference—whether it is by telephone, in writing, etc.

Expand Your Search Geographically

All right, so you've looked at the basic information under the subject index, finding the cite numbers of the foundation and then their profiles. You have discerned that some may be a good fit. But these are all in your home state, and it is important to expand your search geographically. Continue to look in the index and choose those states that are in close proximity. This is important, since you may have the opportunity to travel to a neighboring state for a foundation-hosted event. It could be part of your networking process or optimistically as part of an interview after your application has been received.

Foundations give regionally, so expanding your search to neighboring states will ensure that you don't miss important regional grants.

We haven't exhausted our geographic possibilities, especially with the handy-dandy Foundation Directory. I said I love this work, and it's basically because these tools are very helpful in looking for grants geographically. It's a logical process to look regionally and focus on neighboring states, but you can even look nationally, as some funders have no geographic limitation. And with the Foundation Directory, you only have to look at the print on the page to determine this—all funders who give nationally are in bold type. It's pretty easy to add more prospects to your list, since all fifty states are available to you.

Of course, you may not have the luxury of a large budget to travel around and meet all the funders you have identified in all fifty states, but you may be able to give them a call once you decide they are a solid prospect. With paper and pen, check various indexes and begin making a list of potential prospects. Cross-referencing will take some time; be tenacious in creating a large list of prospects.

It is not uncommon these days to attend a conference or some professional-related event, and spend a few extra days networking and trying to meet funders in that area. Being located in the Twin Cities area while working at foundations, I knew of many organization representatives who "came to the Cities" once a month just for these kinds of inquiry meetings.

Researchers' Bliss: Annual Report and Grant Guidelines

Once you have a sizeable list of prospects, you need to clarify the information by checking the foundation's annual report and grant guidelines. Many of these will be at the library, so you can have a quick look, even make a copy while you are there. Then it is best to follow up with a call and/or write to get your own copy of these. And again, some are available on the Internet.

In my five-year turn at a large nonprofit, I recall how my first few days on the job were sheer bliss. I not only had my own small office in which to write (this versus a cubicle), but there were at least four large file cabinets full of information about funders. I found information from A to Z on just about every major foundation in the country. I was in research bliss, and heaven was having annual reports and grant guidelines that were up to date.

As you begin collecting annual reports, guidelines, and information about the foundations that may be a good match, you can start creating your own mini-reference library. I highly recommend creating files for each and every prospect you discover.

Other References in the Library

Aside from the directories and the annual reports, the library hosts much more as part of these cooperating collections. The following resources will help "round out" your research efforts and point you toward a good prospect.

Microfiche Copies of Tax Form 990

Microfiche may seem a bit antiquated, but I offer it here, since libraries run the gamut in the breadth and scope of their resources, and some collections may include these. The Tax Form 990 is the official tax form of the foundation you are researching. The foundation must list all of the grants that it has made in that year. Even though you have other resources, the information may not list the grantees, although most foundations will have this in their annual reports. You may need to go back a year or two, and the 990s that are on microfiche file are usually a year or two old. Now, you're really researching, because once you start with the microfiche there's no turning back.

Periodicals

Periodicals are excellent resources for gaining an up-to-date view of philanthropy. There are quite a few, but two that I highly recommend are *Nonprofit Times* and *The Chronicle of Philanthropy*. The latter is especially comprehensive and reads nearly like a newspaper, because it has a journalistic style. It also presents the many facets of philanthropy and combines information on both grantseeking and grantmaking. This periodical blends well the need for philanthropy, its impact, and processes. You will get an interesting read concerning communities that have made great interventions into some of their issues and problems. It is also comprehensive in that it presents information for fundraising of all types: from the grassroots spaghetti dinner to planned-giving strategies. It includes a professional section on

career placements and job listings. I can't say enough about it, because I appreciate the approach and style that it is written in, which differs from many other periodicals.

The World Wide Web of Research

The Internet is a vital component of the philanthropy collection, and we will take a closer look at our access points. As part of the collection, you will find that most libraries have a computer terminal either in the section where the philanthropy collection is housed (usually the sociology department) and/or they will have a main area for online research.

Of course, if you have your own computer you can do this research in the comfort of your own home. There have been a number of occasions when I've sat in my pajamas armed with morning coffee to do my prospect research.

As mentioned earlier, private philanthropy is still quite dependent on standard application methods; yet the Web is gaining some ground. In 2003, approximately 81 percent of the top 100 foundations were using Web sites to present their information. An additional 1,600 of the 59,000 independent foundations hosted Web sites. It is a good sign, but the gap between newly formed foundations—about 8,100 in the last few years—and those actually having Web-based information is quite wide.

You will find the information somewhat inconsistent, with some foundations giving full service—that is, annual reports, guidelines, grants listings, and newsletters, and others that provide a home page with basic information.

Free Online Searching

Similar to the scenario with book and reference materials, online research can be a lot of referencing and cross-referencing. Initially, you will need to conduct a broader search of major portal and hub sites that can help you link into foundation Web sites that meet your needs.

Starting from a hub or entry point, like the database on the Foundation Center's Web page (*www.fdncenter.org*), go to the "Find Funders" section of the Web site. The "Get Started" pages are also a good place to begin.

Searching Grantmakers' Web Sites

The Foundation Center's Web site offers links to the 990s for many of the foundations you may be researching. The 990 is the IRS tax form that a foundation must file and it contains the names of organizations that have received funds. This is a helpful cross-reference as you can see if there are organizations similar to yours and the amount that they received in grants.

The best resource that you want to view online is the actual Web site for the foundation. If you know their name then using your search engine, type it in and voila! you should be able to go directly to the site if they have one.

If you don't know the name of a particular foundation then the use of the Foundation Center's Web site to find names of foundations by state under their "Find Funders" section can be helpful. This will give you a good start in cross-referencing foundations by searching each of the foundations that come up in the state search.

Just the Beginning

Remember, your search has just begun as you are restricted to those funders who have some sort of Web presence.

Unless you have the information from the Foundation Center's printed directory, one of their CD-ROMs (which is available for purchase online), or an online subscription to their database, your research will be limited. Online searches will give you a good start, but you will need to be inventive and combine the book and online research to have more complete information.

Important Links

Once you have identified a good pool of prospects, you can expand your search through the links that are provided in most Web sites. During my work in two foundations, I assisted in the concept design and editing of text on their Web sites and ensured the inclusion of helpful links to other organizations. A resource list of the most popular links is included in the appended information.

I am very hopeful that you will get the research bug. In nearly twenty years of teaching grantseeking classes, I have had very few students who reported back that they had immediately started researching, found

a good prospect, and followed through. I remember one new nonprofit in particular, the Osiris Organization, whose mission is helping to mentor youth offenders and avoid recidivism. It was very tenacious with its research and grantsmanship, and garnered many grants and contracts. So smile when you drive by the library. It will be your next hangout; just bring plenty of meter change.

✐ PHONE RESEARCH

Before we discuss public funding and the ways to research this, let's look at one last item for private funding, which gets us out of the library, at least for a while. Let's look at phone methods. Phone research is done as a follow-up to your effort in the library and on the Internet. As mentioned earlier, some foundations prefer a phone call approach, and most of those that prefer a written approach for any formal request will allow a call to obtain the annual report and guidelines.

This part of grantseeking offers you the opportunity to begin the process of introductions, meetings, and idea exchange. It's a fun and exciting part of fundraising, because it gives you the opportunity to approach foundation and corporate staff on a more personal basis. That said, I always maintain a professional manner in the context of a genuine and friendly disposition. I divide my phone research into three types of calls:

1. Calls to request an annual report and guidelines for proposals.
2. Calls to introduce myself and set up a meeting.
3. Calls to clarify researched information and even "pitch" a program idea.

All Calls Build Credibility

Matching the right foundation with your interests will assist you down the road as you develop a rapport with the staff and board of directors. Any call or contact with a foundation marks the beginning of a phase in which you are building credibility. Remember to be as professional as possible and present your best, even if you are calling to ask for guidelines or annual reports. And yes, even when you have to leave a message on someone's voice mail, you are building credibility,

so speak clearly, slowly, and don't mutter. Do your calling when you are alert and awake, not while you are having your morning coffee and waking up.

I know we all get nervous sometimes and each of us has a trigger for extra nerves, so be aware of this and try practicing what you are going to say. If you are not a natural at this, you will be over time; it is all a matter of practice

The following sample calls will help you in your initial approach. Many of you may be very comfortable with the first two call types, yet the third challenges even the most experienced development officer.

Sample Call to Obtain an Annual Report and Guidelines

This request may be directed to a person, or you may be routed to an automated service that will ask you to leave a message with your contact information. In either case, be direct and to the point with your request. Stand up if it makes you feel more confident, and speak clearly.

> **Opener:** Hello, this is Ellen Liberatori. I am a writer interested in learning about your grants program and would like to obtain a copy of your annual report and guidelines for proposals.

Speaking to a secretary or receptionist to request guidelines may be the protocol, but don't be surprised if when you call you end up speaking directly with a decision-maker. One time while I was a grantwriter for a nonprofit, I called the Dr. Scholl Foundation and was surprised when Dr. Scholl's brother answered the phone. He was very pleasant, joked with me when he realized he caught me off guard, and promised to send the information. As stated before, foundations vary greatly and some have staff and others do not. Be aware that you may be speaking with the director or someone close to the decision-making circle.

Sample Call to Introduce Yourself and Set Up a Meeting

Again, this is straight and to the point. Even though this call features you speaking directly with the appropriate person, don't be surprised if you need to talk with a secretary or program assistant to make the appointment. Treat all staff with the same professional

manner; they are an integral part of the foundation. Avoid making judgments about titles.

> **Opener:** Hello, this is Ellen Liberatori. I am poet interested in your grant program. I have thoroughly reviewed your guidelines and I am at the point of making an application, but there are some areas that I would like to clarify with you. Plus, I would like to meet with you briefly to introduce myself further. Would a short, say, forty-five-minute meeting next Monday work with your schedule?

Assertive Versus Nuisance

Taking a more assertive posture, the goal of this call is to get an appointment but not at the risk of being a nuisance. Suggesting a time and date as I have in the sample is assertive. If you are told a meeting is not possible and you insist, you are being a nuisance. I can recount many anecdotes of would-be-applicants who wanted my time prior to their applying, but because of the sheer numbers of these, I had to give phone interviews. It is amazing how many people would insist that I meet them face to face. It is true that a different impression can be made in person, but you need to exercise wisdom here and allow the staff person to do what he or she can.

Sample Call to Introduce You and Your Work or to Clarify and "Pitch" an Idea

If you are applying for a fellowship grant, the following script gives you one way to talk about yourself and your work. If you are representing an organization and have a special project or program to fund, the call will focus on describing it. You will summarize the main goals of the program and you will ask the staff person directly if they would entertain a certain grant amount. It is all clarifying information, but since you are really asking them if the project and the amount of money you need has merit it is like "pitching" and selling an idea.

Sometimes when you call asking for clarification of the guidelines, you may be directed to an upcoming community information meeting where all of your questions can be answered, so go with the flow and make a note to attend. As with the other types of calls, be clear and succinct.

Opener: Hello, this is Ellen Liberatori. I am a writer considering applying for a fellowship. May I speak with a program officer to clarify some of the foundation's guidelines?

If you are connected to a program officer—either there is no informational meeting or for some reason you can't attend—try to proceed in the following manner:

When connected: Hello, Mr. Lindberg, this is Ellen Liberatori. I'm calling to clarify the guidelines for art fellowships with you. It states here that the foundation supports mid-career artists, but it doesn't really define what that is. I am a poet who has been producing and publishing for about fifteen years and have a sizeable collection. I have published a few poems in *The King's English and Community Connection* and I was also a finalist in the Gonomad Travel Memoir Competition, but I am not widely published.

At this point, allow the conversation to flow naturally, and listen without interrupting. It is perfectly normal and helpful to "boast" a little, if you are so inclined and this can be done subtly to avoid appearing arrogant. For instance, mention the places you have been published, exhibited, or where you have performed, especially if these were very competitive. Talk about yourself, but don't forget to take notes and clarify what is important for you to know. Avoid reading the guidelines over the phone to the program officer, who obviously knows them quite well. You will have studied the information ahead of time, and this phone meeting is really to see whether what you have to present is appropriate.

As we discussed earlier, it is key to have an idea of what your career plans are and your future goals for your work and your focus. Discuss your goals before the end of the conversation and try to ask the following:

I know the process of decision-making is lengthy, and a complete analysis of my portfolio would need to be done, but from what I have described to you thus far, does it sound like I am a competitive applicant and would you see it as appropriate for me to apply at this time?

The answer you receive will most likely be indirect, but a good program officer will have an opinion that can be stated diplomatically about the competitiveness of your applying in the next grant round.

This phone call may be a bit more advanced along a continuum and depends on your knowledge of the foundation and your ability to articulate your goals in a way that connects them to what the foundation is looking for. Don't try to search for a particular angle that you can use in presenting yourself and your work. I spent twenty years as a grantwriter looking for the right angle or way to get in; then I realized that being direct was the best way. It's best to be brief and to speak to someone who knows the program interests of the foundation and who can help you in determining whether it is appropriate to apply.

The Runaround

I want to address "the runaround" here, as we have touched upon a part of philanthropy that gives us all a headache. Being the ultimate optimist, I have presented this role-play in such a way that shows a good-mannered applicant and good-mannered program officer. Oftentimes, no matter how direct you are, no matter how articulate you are, the reality is that the foundation staff can't, won't, or are too shy to say yes or no on the phone. Mind you, the question was whether you should apply, not whether you can have a grant.

So you get off the phone with an evasive staff person, and you immediately go to your corner with the Charlie Brown cloud over your head, sulking that you have just gotten "the runaround."

Try to understand something here. Foundation staff don't mean to be mysterious, evasive, or to give you a runaround; they simply don't know in most cases and aren't skilled enough to tell you so. And like any arena, there are a few who are downright incompetent and yet they still don't mean to give you the runaround. They are simply ignorant of the process and what impact their responses have on the entire process. We will talk more about this in chapter 11, but for now don't take it personally and move on to the next prospect.

⚿ IDENTIFYING PUBLIC SUPPORT PROSPECTS

We are ready to go on to the other side of prospect research, which will help us find grant monies amid public sources. Public monies are generally those that come from the government, and under that rubric they trickle down from the federal level to the state, county, and city level. There are a few main sources that will help you locate grant

notices, and so in many ways this is an easier mode of research. Finding public sources for grants is easiest done with the Internet, but we will review traditional research methods, too.

For public funding resources, we can imagine a funnel where all the monies get funneled from the federal government down to state, county, and city levels. Pointing ourselves in the direction of federal resources should help us begin our search. The library and the Internet will be our main points of entry, and although there are large depositories for government documents, we will most likely rely on Internet sources for much of our research. To best understand this, let's start where it all begins: Congress and its work.

The Federal Register

The first and foremost resource for federal grant notices and competitions is the *Federal Register*, which is a pulp-paper booklet printed every day that Congress is in session. The *Federal Register* is the official daily publication for rules, proposed rules, and notices of federal agencies and organizations, as well as executive orders and other presidential documents. It presents all of the activities of that day through the various governmental departments and special committees.

I have monitored the *Federal Register* for clients, as it presents any and all pertinent information related to rule- and law-making. For instance, while working with a rehab facility, colleagues and I would look for all notices, rules, and legislative information for the Americans with Disabilities Act. I would simply look in the table of contents, since there would be a heading in bold face with the words "Americans with Disabilities Act" and I could then read about the latest activity and progress on it.

The *Federal Register* also includes meetings notices, the daily presidential proclamations, and even an endangered species notice for the latest flora, fauna, or animal that has been designated to be protected.

Collections of the *Federal Register* and other government documents have been available through the Federal Depository Libraries for over 140 years. Nowadays, there is a depository housed in just about every state and the territories, and you will usually find them at the library in the government publications section.

Prior to September 2003 you could actually visit a government bookstore to purchase any government publication. These days, the only government bookstore that has remained open is the one located

in Washington, D.C. You can, however, purchase any government publication online. But since most of the information you need is for quick research purposes, you probably won't need to purchase special notices or forms anyway. Besides, you can search the Federal Registrar for free at the Web site of the U.S. Government Printing Office (*www.gpoaccess.gov*). Simply click on the "Federal Register" link in the "Executive Resources" menu. You can even sign up to receive the daily Federal Register table of contents via e-mail for free.

Public Resources and Grants on the Web

Eons ago, before we had the World Wide Web, there were small virtual bulletin boards, hosted by the federal government, and even though they were pretty basic, they had the monopoly on providing access to information.

Even today, the federal government outpaces the private sector when it comes to online services for grant notices and applications. The following is a list of publications and Web sites that are useful in seeking government funding:

* *Grants.gov* is a comprehensive site that calls itself "THE single access point for over 1,000 grant programs offered by the twenty-seven federal grantmaking agencies." Managed by the U.S. Department of Health and Human Services, it offers users "full service electronic grant administration" with guidelines and grant applications available online. You can search by agency, category, or browse the available grant opportunities.
* *FirstGov.gov* is a government Web site that provides the public with easy, one-stop access to all online federal government resources, including government benefits and grant information. The "For Businesses and Nonprofits" menu from the Federal Register Web site (*www.gpoaccess.gov/fr/about.html*) includes links to federal Web sites and information about grant programs, by cabinet department and federal agency.
* The Catalog of Federal Domestic Assistance (*www.cfda.gov*) is a searchable database of information about federal assistance programs.
* The National Endowment for the Arts (*www.nea.gov*) supports all areas of the arts.
* The National Endowment for the Humanities (*www.neh.gov*) supports all areas of the humanities.

* The Community of Science (COS) Funded Research Database (*www.cos.com*) allows you to search grants awarded by the National Institutes of Health (NIH), National Science Foundation (NSF), United States Department of Agriculture (USDA), Small Business Innovation Research (SBIR), and the Medical Research Council (MRC) in a variety of ways. You can search grants by keyword, geography, institutional recipient, award amount, date, agency, investigator, departments, and more. Free registration is required.

* The Institute of Museum and Library Services (*www.imls.gov*) supports all areas of the arts and humanities.

Easy Access

Access to public grants has always been very good, in my opinion, and my interaction with government staff has always been very helpful. Nowadays, access couldn't be easier with the Internet and instead of chasing around for public grant opportunities, you can simply put your name on an e-mail list and the grant notice will come directly to you.

State, County, and City Resources

Since much of our federal monies get trickled down to a local level, it is important to do the same amount of research within your state. Most states have similar registers that abstract rule-making, laws, and grant availability, so the research process is similar if not duplicative. The only difference may be in the names of the various departments, since each state in its sovereignty may call a department something close to but different from that on a federal level. For instance, instead of the Department of Education you might have the Department for Children and Family Learning. Be inquisitive with this and you will find what you need.

County and city resources may not be as straightforward, and in all your research methods for public sector grants these areas are unintentionally elusive. One helpful hint is to check the Sunday paper in the "Legal Notices" section of the classifieds. Since all public grant competitions have to have public notice, city and county administrators place small notices in the paper. All you have to do is check.

Also, networking will help you with these prospects. There is usually a city arts council, and it would be prudent to call, stop by the

office, and get as much information as possible. Some of these are as developed as the federal application process, so you can be placed on an e-mail list to receive grant notices and updates.

✑ CREATIVE PROSPECTING IS LIKE PANNING FOR GOLD

I want to leave you with one last brainstorm of ideas, which involves thinking like an entrepreneur. It involves looking at the ways your art project connects with the community, and the idea of sponsorship and cause-related marketing.

Similar to research for grants, you can divide your project into categories that represent potential commercial marketing. Here's an example: I worked with a filmmaker who needed to raise money to produce a short film. Aside from traditional grant sources, which at the time were few, we identified the main symbols in her storyline for possible sponsorships. For instance, the story had a senior, a cat, and a birthday cake as some of its primary subjects. So we approached a large pet supplier, a well-known bakery supplier, and a corporation that developed senior communities. In addition, we looked at film suppliers, like Kodak, and even the camera makers. Many of these have charitable giving programs that include what is called "in-kind support." This is nonmonetary support, given in the form of products and services through the marketing and public relations divisions of corporations. While I was the director of a corporate foundation, I gave away hundreds of thousands of dollars annually in products, and in some cases this was more appropriate than a grant.

In the case of the film, it took a couple of years to gain focus, money, and in-kind support. I moved on to other fundraising projects after the initial fundraising efforts, but the director and producers did eventually garner support from a variety of sources and the film was nominated for an Academy Award.

✑ A MATCH MADE IN HEAVEN

Working in philanthropy and finding strategic partners, grantors, and supporters sometimes feels like courtship and marriage. Prospect research is like finding the match made in heaven. It may seem tedious at times, but a good match is, in my estimation, key in this whole

process. After a few times at the library, a few annual reports, phone calls, and meetings, you'll be ready to start writing your proposal.

THE GRANTS ZONE

Getting grants depends on the partnerships that you are able to develop through sound prospect research.

Applying for grants is 80 percent planning, research, and networking, and the remaining 20 percent is writing and developing the application.

GRANTSEEKER'S DOS AND DON'TS

Do read and familiarize yourself with a foundation's profile, its interests, and the best ways to approach it.

Do be assertive in meeting the foundation, but avoid being a nuisance.

Don't waste your time and the foundation staff's time by sending applications to places that are not a match—no scattershot approaches here.

Do have your ideas, plans, and dreams formulated so you can begin discussing them at the opportune time.

CHAPTER SEVEN

Writing the Grant Application

*If a man will begin with uncertainties, he shall end in doubts;
but if he will be content to begin with doubts, he shall end in
certainties.*

—FRANCIS BACON, ADVANCEMENT OF LEARNING

The moment you have been waiting for has finally arrived. I know some of you flipped the pages directly to this chapter, wanting to write your application first. You can catch up when you need to, and for those who have followed along you can review the information when questions come up, as they are bound to when you are learning something new.

❧ GRANTWRITING IS LIKE A JOURNEY

This chapter will help you prepare and write a grant application. We will review the various types and their differences. You've come prepared to write, and even if you don't feel prepared, the exercises will gently tease it out of you. We will look specifically at two main types of grant applications for artists. These include the application for a travel and study grant and a fellowship application.

In the process, we will study and analyze actual grant guidelines and the many pieces that are required for a successful send-off. Even though this chapter may prove to be somewhat technical, I promise it

will be fun and worthwhile to proceed through it all. Think of it as a mini-workshop, and give yourself enough time to complete the writing exercises. Finally, I will present the lifecycle of a grant application process, from beginning to end.

Success in this game is really about getting the application to the office of the foundation. This is all you can control. The rest is something you don't have control over, so once it is mailed, no amount of worry will help make the outcome any better or quicker. A grant judge once told me after nearly all was said and done, "Relax, and enjoy yourself." This is definitely analogous to a journey, since there are many steps to getting grants. At first, all of it can be overwhelming, but I have loved this work all my life, and it has become second nature. It will for you, too, so hang in there! Now the real fun begins.

✎ A DIFFERENT LANGUAGE

I said it before: foundations speak a language all their own, and sometimes translating it is difficult. The language of grant guidelines runs the gamut from seemingly clear to vague.

Also, as I know from my experience as a former grant reviewer and designer of guidelines, application forms, and information, you can be clear as the ring of a bell and still have people get it mixed up. Two factors come into play here: applicants don't pay attention and are too flighty in preparing their information, and some disregard instructions. We will address both in this chapter.

The following narrative will help you understand the language of foundations and will help you read between the lines of what sometimes seems to be a very elusive process.

✎ UNDERSTANDING GUIDELINES

Grant guidelines are written in a variety of styles. Some simply state the foundation's general interests, and some offer detailed descriptions of every step of the grantmaking process. Let's look at a foundation that provides fellowship awards and an arts agency that regrants foundation monies through a blend of monetary awards and technical assistance.

The examples that I am using for this discussion come from my home state of Minnesota, where some of the leading grantmakers for

supporting individual artists exist. We will look at the fellowship guidelines of the Bush Foundation, which grants its monies directly, and the McKnight Foundation, which regrants its fellowship monies through an arts agency. We will also look specifically at the Jerome Foundation for its great travel and study program. These and others are truly angels in disguise, and their grant programs have been running for many years. This makes them well-versed in the ways of helping an artist develop.

The guidelines that I am going to showcase are very specific and as the adage says, the devil is in the details. But I don't want you to get scared off, frustrated, or, on the flip side, cavalier about it. Think of it all as great because these details will help you prepare an application that is stellar, competitive, and successful.

Taking a closer look at guideline components from the Bush Foundation, let's dissect and analyze some of the items and consider the specifics for eligibility and selection. The following is directly quoted from the foundation's guidelines:

GRANT CATEGORIES

The artist program makes awards in eight categories, which rotate on a two-year cycle. For 2006, the categories are: Visual Arts: Two-Dimensional, Visual Arts: Three-Dimensional, Choreography, Multimedia, Performance Art/Storytelling Traditional and Folk Arts

ELIGIBILITY

Residence: Applicants must be U.S. citizens or permanent residents and residents of Minnesota, North Dakota, South Dakota or one of the following twenty-six counties of northwestern Wisconsin (Ashland, Barron, Bayfield, Buffalo, Burnett, Chippewa, Douglas, Dunn, Eau Claire, Florence, Forest, Iron, La Crosse, Lincoln, Oneida, Pepin, Pierce, Polk, Price, Rusk, St. Croix, Sawyer, Taylor, Trempealeau, Vilas, and Washburn) and must have lived in this funding region for at least twelve of the thirty-six months preceding the application deadline.

Age: Applicants must be twenty-five years or older at the time of the application deadline.

Past recipients: Former Bush Artist Fellows who have submitted a final report are welcome to reapply *five years after the completion* of their previous fellowship. No more than two former fellows a year will receive fellowships.

Ineligible: Artists are not eligible to apply if they are a student enrolled full- or part-time in a degree-granting program after July 1, 2006; a director or staff member of the Bush Foundation; or a spouse, parent, child, or grandchild of a director or staff member of the foundation.

Dissection and Translation

These sections of the guidelines are fairly straightforward and easy to understand. However, the "Grant Categories" section does bring up a question in my mind. If the foundation funds eight categories in two-year rotations, what are the other categories, since only five are listed here? The answer may help alleviate any concern or anxiety you have when you don't see other art forms mentioned like literary arts, photography, or music composition. In looking further at other sections of the Web site and annual report, you would find that it funds the other categories in alternate years, which is a common practice with these kinds of grants. If you are an artist in one of those disciplines you must wait for completion of the grant cycle. The wait is not that long; you may need more time to meet the minimum requirements to apply, so that is a good thing.

In looking at the "Eligibility" section, a few questions arise for me, only because what is stated is somewhat open-ended. The questions that I want to clarify are related to the performance art category. I might have an art form that isn't listed here, and so I would need to determine whether the category is restricted to the five areas listed. Further reading of the foundation's entire guidelines and Web site would give me the clarity and the answer I need, but a question to staff could help clarify this, too.

The "Residence" section is defined in location and included the minimum length of residence to be considered. And the rest is very clear except for the "Age" section, which doesn't have an upward limit. The question I have then is, does the foundation have a limit related to age? If not, as an applicant I have an opportunity to read between the lines for other information.

Reading between the Lines

If there is no limit on age, you have to understand that the competitive pool for these grants includes people of nearly all ages. Your peers may be people much younger or older than you. And the relevance of this says a lot about the foundation's openness, but it is also a harbinger for you as an applicant, since it may make the process fairly competitive. Here's what I mean. These grant programs attract a lot of attention because they offer great opportunities and the grant size is substantial. But given the age range here, you can surmise that there will be senior artists with a fair amount of experience who can show a career's worth of work. You may not be at that level, but do not let this deter you and make think that your application won't be considered. On the contrary, an individual's art matures at different times, and so the only message to take here in reading between the lines is to be as competitive as possible by having a strong application.

The other factor to consider is really what I believe is happening here. The foundation is removing the age limit at the senior level to allow for the late bloomer: the writer, painter, or sculptor who started his career when he was fifty or more and finally had the time and discipline to focus on creativity. This again says something to you about the caliber of this foundation and its awareness of what it takes to be an artist.

A Closer Look at Guidelines about Criteria and the Selection/Review Process

The "Criteria" and the "Selection/Review Process" notes in guidelines are very important sections to study and analyze. Sometimes a foundation will "weigh" a criteria by giving it a point value, you get seventy points out of one hundred for how well you match their idea for having a strong vision, perseverance, and creativity. The examples given here do not have specific "weighted" or points value to the criteria, but like most foundations, this one lists a criterion that you need to study, since some of your application narrative will need to reflect this directly. We will focus on public granting entities in the next chapter, but note here that many public funders use weighted criteria, which scores points for specific criteria.

The two areas, criteria and selection process, are often blurred and the terms are used interchangeably. Let's study examples of both to see

why. The first is a foundation that provides artist fellowships and uses a criteria statement, in addition to a selection process statement.

FOUNDATION CRITERIA STATEMENT

The fellowship program supports artists whose work reflects any of the regions' diverse geographical, racial, cultural, and aesthetic communities. Artists may be at any stage of their life's work from early to mature. Among the qualities we seek in a fellow are strong vision, creative energy, and perseverance. Panelists consider the artist's past endeavors and current work, the impact an art fellowship may have on the artist's life work and future directions, and the difference his art may make in the region.

FOUNDATION SELECTION PROCESS STATEMENT

Artist fellows are selected through a two-step process involving preliminary and final selection panels. The panels are composed primarily of working artists and some arts professionals such as curators, editors, and critics. New panelists are named each year; none are residents of our funding region. The names of the panelists will be announced after the selections are complete. Separate preliminary panels are convened for each application category to review application materials and select finalists. If the number of applications in any category seems excessive, applications may be prescreened by current or past panelists. All applicants will be notified of their status by letter after the preliminary panels meet. Please do not call the office for this information. Final selection of fellows is made by an interdisciplinary panel composed of one member from each of the preliminary panels and one additional panelist. The final panelists are selected on the basis of their knowledge and experience in all the categories being considered as well as their expertise in their own field. The final panel reviews each finalist's initial application materials and the additional materials described below. Finalists will be notified of the results by mail. When notified of their status, finalists will be asked to provide additional information.

This next example is a Selection Process Statement from a regranting agency supporting playwrights.

REGRANTING AGENCY'S STATEMENT FOR SELECTION PROCESS

Each application will be independently screened for eligibility, then read and evaluated by a panel of Minnesota Theater Artists. Finalists' applications will be further evaluated by the center's producing artistic director, in consultation with a committee of local theater artists. Selection is based on artistic excellence, potential, and commitment, and is guided by the core values written in the center's mission statement. [These state]. . . nurturing artists' excellence and new visions of the theater; fostering playwright initiative and leadership; protecting cultural pluralism; discovering emerging artists; advocating for playwrights and their work; connecting playwrights with audiences; and developing a community for new work.

Analysis of the Three Statements

Before we look at these statements, there is one caveat to remember: we do not have an exact comparison between these examples. The first two examples of foundations I chose to showcase provide a monetary award, and the regranting agency provides a monetary award along with placement in a special working lab and production of the work. Even though the grants are a bit different, these three statements are great examples of how foundations describe their processes.

Each tells you the step-by-step approach to selection with having both preliminary and final stages in the review. Each talks about values and qualities of the recipients. These are in essence some of the criteria that they will use to make their decision, qualities like artistic excellence, potential, and commitment, as well as strong vision, creative energy, and perseverance.

It is important to note that the first statement talks about the societal landscape—that is, geographic, racial, cultural, and aesthetic qualities of the community as reflected in the artist's work. Similarly, the regranting agency defers to values stated in its mission, which are part of a societal backdrop to the core attributes that it also requires.

One more important thing to note is that the first statement includes a reference to the artist's past work and a very interesting remark about how the grant will in essence help the artist develop. This is inferred in the regranting agency's statement in that it uses a very important word in its lists of values: the verb "nurturing." From my past experience with these entities, I know this is one of their main functions, and yet they state this in different ways.

Finally, they are similar in that their statements mention an important aspect of getting the grants that we discussed earlier. If you recall, your application will be more competitive if it adds to the relevance of the community, as is seen in the statement, "and the difference their art may make in the region."

Looking at the differences, there is one main item in contrast. The primary difference in these three entities is in the panelists and reviewers. The foundation and fellowship grantor uses panelists that are *not* local, whereas the regranting agency has a very local contingent to review the applicant. Although all three use panels and reviewer committees, the regranting agency specifically states that the process involves a screening "by the center's producing artistic director."

Although each uses a peer review, the fact that the foundation's process involves people outside of the immediate area as opposed to the local community is a major difference. The reasons are many, but some relate to the foundation's sense that panelists who were not local would be more objective, although this ignores the fact that artists often have far-reaching audiences.

Advantage or Disadvantage

Although I could act like a referee and "make the call," I won't express any opinion about the advantage or disadvantage of having a local versus national review committee. In previous chapters, while discussing the researching aspects of grantors, I said it was helpful to have grantors nearby, for general information meetings and networking. In the case of peer reviewers and judges for fellowships, initiating information meetings and meetings outside of the purview of the selection process may not be allowed. Lord knows I have paid the price for misunderstanding the boundary surrounding this issue. In one instance, a judge had to recuse himself after meeting with me because I asked for feedback about my previous and first attempt for a grant. I may have inadvertently caused my own disqualification, of sorts, by

interviewing a panelist before I applied. So be cautious and ask staff what is allowed before talking to judges outside of the review process.

Networking behavior may be deemed inappropriate, no matter how innocent or naïve your intention. Even if you are trying to understand a past failed attempt (as I was), it is best to avoid contact with judges altogether. These kinds of queries are best addressed to staff and not judges.

The advantage you would have if a local artist is a reviewer is that you can personally view his work if he has public exhibitions or performances. If he is part of the literati, access to books and magazine articles is not usually limited by geography, and so you could still familiarize yourself with the reviewer's work. Is this necessary? No. Is it helpful? Perhaps. But only in a general way, as it lets you know who the reviewer is and helps you see him more as a peer.

❧ READY TO WRITE YOUR FIRST GRANT APPLICATION?

What? You're not ready? You say that there are 101 other things you'd rather do? Oh, I understand. You don't like to write. Well, not to worry, this application process is really straightforward, and remember, you have your very own personal grantwriter helping you along the way.

❧ THE TRAVEL AND STUDY GRANT

Travel and study grants come in many forms, ranging from those associated with academic programs to those that are more independent and have no requirement for college work, graduate, or postgraduate focus. Finding the resources for these in general is relatively easy, through the traditional research methods we have described earlier. Web searches also provide a quick array of resources that will link you to many programs.

For our working purposes, we will focus on a relatively easy travel and study application that is available to the artist at large and is not directly involved in an academic program. I will again reference a foundation from my home state of Minnesota, the Jerome Foundation, named after Jerome J. Hill who was an artist and philanthropist.

The Jerome Foundation has provided small grants supporting emerging artists in a variety of ways, travel and study being one of

them. Here is a press release from their 2004 grant round, which will help you understand the context of these grants:

> The Jerome Foundation announces the 2004 Travel and Study Grant Program recipients. Thirty-three grants totaling $117,185, ranging in size from $620 to $5,000, were authorized. The Travel and Study Grant Program awards grants to independent artists and nonprofit arts administrators. Funds are authorized to support travel for the purpose of professional development. Grant categories are separated by geographic region (seven-county metropolitan area and Greater Minnesota) and artistic discipline (dance, theater, and visual arts). Three, three-person panels reviewed 215 applications in April. Jerome Foundation directors approved the panelists' recommendations.

Sample of Grants Made

Now let's look at a few of the recipients from that grant round. Pay close attention to the modes of study and not so much to the location of the artists' travel.

* **A Dancer.** She will travel to Hungary, Slovakia, and Czech Republic, and Berlin, Germany, to increase her expertise in Central and Eastern European modern/contemporary dance forms. She will meet with several Central European dance professionals. This investigation will inform her role as an international dance organizer preparing a Central European/Minneapolis Dance Exchange Project.
* **A Puppet Artist.** He will travel to Portland, Oregon, where he will spend seven days attending Sojourn Theatre's Summer Institute for adults working in theater, education, and community settings This workshop will inform his interest in community change through the use of puppetry.
* **A Visual Artist and Writer.** He will spend three weeks in Denver, Atlanta, and Pittsburgh to study the phenomenon of the neglected artist by focusing upon three unrecognized but skilled artists in these locations. These are talented visual artists who've worked for decades without attaining success. He intends to write about what he discovers in a series of critical essays/profiles and to explore what the social phenomenon of neglected artists may mean to the future

of cultural production in this country. He believes that these artists' efforts to continue producing despite their inability to make money to survive from their art reveals a glimpse of the creative soul of humanity, something he ever seeks to understand as a writer on art.

* **A Painter.** She will spend thirty-five days studying at the Florence Academy of Art in Italy. She will take two intensive, month-long drawing and painting courses, and attend weekly lectures, technical demonstrations, and additional drawing classes. Each student receives two critiques per day. She will visit specific collections, museums, and art centers. This travel and study experience is designed to expand her abilities and strengthen her technique. She is pushing toward increased self-confidence, a visual understanding that is subtle, and more precise powers of description.

* **A Potter.** He will spend three weeks in South Korea and Japan to learn more about the forms, kilns, and glazes of folk pottery. He's interested in the hand building and wood firing techniques used by the Onggi potters of Korea and the Mengei of Japan. He'll visit kiln sites in five different provinces in Korea, looking at design, construction materials, firing processes, firing materials, and the rhythm and routine of the annual production and firing cycles. He'll visit museums and the leading proponent of the Mengei Movement in Mashiko, Japan.

* **A Sculptor.** He will spend three weeks visiting large-scale outdoor sculpture venues and artists on a road trip exploring the nature of large-scale outdoor sculpture in America today. He'll visit and document—through photography and writing—major sculpture venues between Minnesota and the East Coast, and will meet with sculptors along the way. This information will feed his professional and aesthetic development, enable him to critically assess his strengths and weaknesses, and assist him in understanding the place of his own work within a broader context.

* **A Web Artist.** He will spend ten days at the Anderson Ranch Arts Center in Snowmass Village, Colorado. He will do research dealing with philosophies of imaging and notions of language and visualization, while at the same time undertaking a practical examination of digital imaging tools in light of photography's and image-making's history. He'll participate in a workshop titled *Web Animation for Artists* . . . focusing on the Web as an artistic medium. He'll also spend some time making new images while in the east Snowmass wilderness area.

What We Glean from These Samples

These are excellent samples of the kinds of travel and study programs that receive funding. Each of these gives some very important information and will help us in developing our own applications. Note that as much as each artist has traveled to a place, the focus is really on their study plan and how it relates to their artistic development and even to the greater community.

Also, all of these are written in a declarative style. Funders like to be the support cog in the wheel, and the most competitive applicants are those who have already secured their places and plans. The grant merely helps them do what they were already intending to do. And even though this is catch-22 in that most of us may be dependent on the grant, it does help you think about plans B or C if the grant doesn't come through. It also encourages you to seek multiple funding sources, especially as the overall budget for a plan may exceed the grant amount from one funder. As mentioned previously, grantors like very much that their grant leverages other grants, and so it is prudent to approach more than one funder.

The Travel and Study Guidelines

The following are the "Music, Theater, and Visual Arts" application guidelines for the Jerome Foundation's Travel and Study Grant Program for Literature, Film/Video, and Dance. We won't dissect them, as they are very informative and clear. To help you become more familiar with these, I have presented them here in their entirety. Also, these will prepare you for the writing exercises that follow in the "Application Requirements."

ELIGIBILITY

1. The Twin Cities portion of the program requires that applicants reside in the eleven-county metropolitan area at the time of application and have lived in Minnesota at least one year prior to the application deadline. Counties include Anoka, Carver, Dakota, Hennepin, Ramsey, Scott, Washington, Wright, Sherburne, Isanti, and Chisago. The New York City and Greater Minnesota portions of the program require that applicants

currently reside in the five boroughs of New York City or Greater Minnesota and have lived in those areas for at least one year prior to the application deadline.

2. Applicants must be emerging creative artists.

3. Applicants must complete the cover sheet and comply with all application requirements. Fax and e-mail submissions are not permitted. Incomplete applications will not be accepted.

4. Applicants may apply to only one discipline area and may submit no more than one proposal. Multidisciplinary artists should submit to the discipline area most closely aligned with their work. All panels will be prepared to review proposals that cross disciplines. If a proposal is declined, the applicant may submit the same request only one additional time in a subsequent year.

5. In order to be eligible for another grant, previous grant recipients must have completed and filed a final report on their trip. Individuals may not receive grants in consecutive years.

6. This program supports individuals, not organizations. Multiple-person partnerships may apply on one application form if the monies requested do not exceed $5,000.

7. Students in K–12 educational programs are not eligible for Jerome Foundation support. In general, individuals enrolled in undergraduate and graduate degree programs are not eligible, with one exception. If an artist enrolls in an undergraduate or graduate degree program or takes classes while maintaining a current and active professional practice of creating and presenting work to the public, she/he is eligible.

POLICIES

1. THE APPLICATION DEADLINE FOR THE 2006 TRAVEL AND STUDY GRANT PROGRAM IS JANUARY 13, 2006. Proposals must be postmarked on or before that date to be eligible. Applications postmarked January 14, 2006, or later will not be accepted. Proposals may be hand-delivered to the Jerome Foundation office on or before 4:30 P.M. on January 13, 2006.

2. Applicants will receive cards acknowledging receipt of their proposals. If there are questions about a proposal, a Foundation staff person will contact the applicant. The Foundation will

send a letter by early April 2006, notifying applicants of the decisions on their requests. No information on the panel's recommendations will be provided prior to the letter of notification.

3. Travel may be national or international. Travel must occur between May 1, 2006, and December 31, 2008. Applicants not awarded grants in 2006 may reapply in 2008 if the program is renewed.

4. This grant may not be used for touring, performances, appearances, exhibition expenses such as shipping, production of new work, and teaching.

5. In order to receive payment, recipients are required to submit an itinerary for the travel and study period, with confirmed schedules and proof of travel at least two weeks prior to departure.

6. Grants of up to $1,500 will be awarded for short-term travel of three to six days. Grants of up to $5,000 will be awarded for trips of one week or longer. Applicants may use grants for extended travel and study if supplementary resources are available.

7. Recipients agree, by contract, to file a narrative report within one month of completion of the travel and study grant project.

8. Purchase of equipment is not an eligible expense. Expenses may include such items as daycare, limited purchase of necessary materials, and an appropriate amount of lost income due to absence from work for required expenses such as housing payments and utilities.

APPLICATION REQUIREMENTS

The following are the requirements for putting the application together. The Jerome Foundation requests narrative information for three questions that summarize your plan, a résumé, and then a few work samples. In addition, it has an application form that acts as a cover sheet and includes the budget you would create, and a helpful checklist so you don't forget any of the items required for the application.

The information that follows is stated directly from the foundation's requirements. Included is the "Tips" section. Review these and then move on to the first writing exercise for these travel and study grants.

THE NARRATIVE SECTION

PLEASE DO NOT STAPLE PAGES TOGETHER OR PLACE IN FOLDERS OR BINDERS. PAPER CLIPS ARE ACCEPTABLE.

1. Describe in detail the purpose of the proposed trip, what you plan to investigate, and why you have selected the cities, organizations, and people you plan to visit. Describe how the travel and study project will affect your professional work, being as specific as possible about your expectations. If appropriate, indicate how the travel and study project will affect the organization at which you work. Recommended length is one to three pages.

2. List the groups, organizations, productions, exhibitions, performances, festivals, institutes, and names (with titles) of individuals you intend to see. Specify their locations. Indicate whether you have contacted them and received positive responses to your proposed visit. Attach copies of any confirmation letters.

3. Attach a current résumé.

4. If your study trip is supported in part by other grants or income, specify their source, and provide specific information on which expenses those contributed funds will cover, and any restrictions on those monies.

WORK SAMPLES

Submit work samples representing your current interests and potential linkages to the proposed trip. You are encouraged to submit materials that document more than one piece of work. Please do not place multiple work samples on the same tape; submit separate cued tapes for each sample. Limit written materials to ten double-spaced pages with at least one-inch margins, and video, film, audio, and computer disc materials to ten minutes. If submitting samples in more than one format, proportionately reduce the number submitted. Identify your role in the work samples. Provide preferred viewing order of samples.

LITERATURE: manuscripts, audiocassettes, videotapes, etc.
FILM/VIDEO: videotapes, DVDs, CDs, script excerpts, story-boards, etc.
DANCE: videotapes, DVDs, photographs, etc.
AUDIO AND VIDEOTAPES MUST BE CUED. VIDEOTAPES MUST BE VHS FORMAT. COMPUTER-GENERATED CDs/DVDs ACCEPTED.
Complete Application Cover Sheet.
OPTIONAL:
You may submit a ONE-PAGE statement describing your aesthetic philosophy and creative process, as additional information for the panel to review.
Persons needing communication accommodations such as sign-language interpretation, TTY operator-assisted inquiries, transla-tion services, alternative formats for print materials, etc., are encouraged to contact Foundation staff for assistance.

TIPS SECTION

* Be as specific as possible about expenses. If necessary, attach a separate explanation sheet and summarize on the cover sheet.
* The discipline categories of visual arts and literature are, by far, the most competitive because they draw the largest num-bers of applicants.
* The optional statement describing aesthetic philosophy and creative process is often a valuable addition to a proposal.
* If attending a seminar, workshop, or conference described in a brochure or on a Web site, please send a copy of the brochure or printed information from the Web site.
* Proposals to attend the opening of an exhibition or perfor-mance of your work are rarely supported if that is the only purpose for the trip. If this purpose is one small part of a larger trip focused on study/experiential learning/research, it stands a better chance of being seriously considered.

Whew! Some of you are thinking, wow! This is a reality check, and the money doesn't just fall from the trees. This *is* a process where you have to pay attention and follow the directions. Certainly, it is

formidable even though there are really only four questions to the application. Don't let any of this scare you. Foundations like the Jerome Foundation host informational meetings, as well as personal meetings to help prospective applicants.

I will coach you through writing a draft for the first and primary requirement in the Jerome application. As for the résumé requirement, you can attach what you already have.

Since you were paying attention, I'm sure you noted the suggestion to respond to the "optional" item listed after the section on work samples. In chapter 3, we had a mini-workshop on writing the artist statement with a focus on the aesthetic and that is what is being referred to here. Yours is already completed, and this is a good demonstration of how some pieces of grantwriting can be reviewed and reused.

Three Steps to Completing the Application

Applications for individual grants are typically unique. While Common Grant Forms and application processes do exist, these are usually for organizational grants. For instance, in Minnesota, more than thirty funders share a Common Grant Form. Even though this has yet to be something grantseekers for individual support will find, we can approach our fundraising in similar fashion.

Preparing the travel and study grant is a simple three-step process, which certainly involves drafting and writing a number of responses to the funder's requests or requirements, but the overall process is straightforward.

Step One: Formulate Your Travel Plan

Within this context and the above requirements, travel is restricted to attending a conference, workshop, or special study program, as well as travel for independent research or interviewing. This is not a holiday, respite, or adventure. These grants are restricted for travel pertinent to something related to your artwork. And unfortunately, it is not travel to do an exhibition in a new location. As is seen in the samples, it could be travel for a working retreat, or for independent study that included interviewing and learning from master artists.

So you have the parameters for what kind of travel is allowed. Now you need to identify the place, make contact, and arrange for your attendance.

Step Two: Draft a Description of Your Plan

Using the requirement as stated in the application guidelines, let's push ahead: "Describe in detail the purpose of the proposed trip, what you plan to investigate, and why you have selected the cities, organizations, and people you plan to visit."

This requirement is broken down well enough and gives you specific information to draft a response. Try to draft three paragraphs that say what you want to do, focusing on you as an artist. A few introductory sentences will do for this requirement, so you can be brief; you will elaborate further in subsequent paragraphs. Introduce yourself by your art form, and follow with the place you will be traveling to, with a short description of your plan.

We can start with basics and describe where and what we are attending. For example:

> I am a dulcimer musician, and I will travel to Tennessee and North Carolina for a three-prong self-designed study program. The first part will be to attend the Tennessee Appalachian Cloggers Annual Forum from October 10–15, where I will participate in a special workshop for dulcimer players. The second part of the program is to spend ten days in Ashland, North Carolina, attending an annual conference for folk musicians. The third part of the program is integrated into the conference, including composition classes that I will attend daily, so at the end of the study program I will have one new composition, which will be used in a master's class at the Homestead Pickin' Parlor where I teach hammer dulcimer to intermediate-level artists.

Notice that I have not launched into why this particular place was chosen, only the where I will go and what I will do. The next part of the requirement gives greater detail about your choices for the overall plan. The second sentence in the requirement specifically says, "Describe how the travel and study project will affect your professional work, being as specific as possible about your expectations."

Approach this section as clearly as you can, taking some time to develop and design a plan or piece of a plan that will help you advance yourself in your art. Knowing what you lack will be helpful, because this description is about what you need, what your strengths are, and

what would support and fill any gaps or weakness you see in your development. Here's what I mean:

> I have designed this plan focusing on the venue and the special classes that are offered at the Cloggers Forum and the Conference. My approach to dulcimer work to date has been academic and technical. Even with my seven combined years of study, practice, and teaching, I lack the necessary peer and mentor aspects that support Appalachian traditional music and arts learning. Although my current composition ability and mastery level is progressing, it has not yet been informed by the true Appalachian tradition that is the hallmark of this style of folk music. My study and learning will gain greater depth, and my playing will finally achieve an organic quality that can only be attained through instruction in folk tradition. I also chose these venues because they are organized in a fairly intensive manner, maximizing the time on task. My hope is that I will come away with a deeper and profound understanding of the core of one of America's root music genres. Participating in a primarily oral and folk tradition also keeps that tradition alive and intact.

In this requirement they also stated that they want you to indicate, "if appropriate . . . how the travel and study project will affect the organization at which you work." This part is not mandatory, as they say "if appropriate," but it is helpful to use the grant to its full capacity and support the organization that you work with if it is germane to your art.

This was already mentioned in the introductory sentences, but I would elaborate here and reiterate some of what you have stated:

> My work as a dulcimer teacher would be informed through an oral tradition of folk music that is a vital part of the style and modalities to teach hammer dulcimer. My students [*tell them the annual number of people*] would have the benefit of this and would help keep the tradition of this specialized genre alive.

There you have it—one very basic example of the ways and means of writing up a description of your plan. It is important to note that in other grant requests you may only have a requirement that states, "Please describe your plan." They may not be as helpful as the Jerome Foundation in telling you specifically what you need to cover in your

response. This exercise will help in your future attempts and will at least get you started. Remember, when you tell them what your travel and study plan is, describe the place, time, and duration. Tell them your motivations for this as it relates to your artistic development, your artwork, and the community.

Now let's look at the "optional" item. It's really like the frosting on the cake, and we all know how that distinguishes a good cake from a mediocre one. The guidelines say, "You may submit a one-page statement describing your aesthetic philosophy and creative process, as additional information for the panel to review."

I highly recommend providing "optional" information in any grant request, for two reasons: 1) I am competitive and know other applicants will "skip it," which gives me greater audience time, and 2) these optional items give a reviewer unique information to consider in granting an award.

Step Three: It's Out the Door

To get your travel study application out the door, this foundation, and most others, will have a cover form to use and a budget requirement, and will sometimes request references. These are the usual attachments, and we will have a comprehensive discussion of grant application attachments in chapter 10, but note here that a complete application will be the narrative and attachments. Reiterating from the above, pay attention to any checklist they provide, which many require as a completed attachment, and you are ready to get it out the door.

It's appropriate to do a rain dance, a hat dance, any celebration that acknowledges that YOU HAVE DONE IT! It's the first notch on your fundraising belt, and you are really set now. Primed for the next step? The BIG grant—fellowships, special project grants, and residencies—here we go!

☞ FELLOWSHIPS, PROJECT GRANTS, AND RESIDENCIES

Grant size is a relative matter, and any amount is really helpful. The above travel and study grant provides as much as $5,000, which in grant terms is a good-sized award. But some of you know from your prospect research that there are fellowships, project grants, and residencies that award tens of thousands of grant dollars. As you move into

this area, remember that grant size isn't what it is about. A big grant is nice, but never look a gift horse in the mouth, as the old adage goes.

As you have also discovered through your research, preparing the request and application for a big grant is more complex in that you have more pieces to put together. These grants also involve greater planning, and as mentioned earlier, allow you to take new directions in your journey of developing your art.

The bigger grants come through fellowship programs, special projects grants that are affiliated through a fiscal sponsor, and residencies. Fellowships and residencies tend to have capped awards, which can range from $10,000 to $100,000. The midrange and typical award is between $20,000 and $50,000. My past attempts at artist grants ranged from $2,000 to $10,000. As mentioned earlier, I also applied for a leadership fellowship, which was very involved and the grant request was approximately $130,000.

As a finalist in some of these competitions you have to understand the value of a means to an end. The application and review process is only the means. In the case of my big fellowship plan, I didn't get the grant, but the process was so rich in self-reflection and planning that it was an invaluable experience. Remember this when you feel any doubt through these processes.

The Arts Fellowship

For our purposes, we will work through a fellowship application of the Bush Foundation in Minnesota, since it is one of the leading funders for artists in the country. We reviewed, dissected, and analyzed the selection process and the criteria for the Bush Foundation's fellowships.

Let's prime the pump to get our blood flowing and look at some examples of who has received grants from the Bush Foundation. These can inspire you to begin thinking of how fellowships can be used.

* **A Writer.** He writes essays that explore relationships between people and their physical environments. He has received fellowships from the Wisconsin Arts Board, the Iowa Writers' Workshop and the University of Minnesota, where he recently received his PhD. His essays have appeared in such publications as *The American Scholar* and *The North American Review*. The writer is interested in "how culture and the natural world shape one another."

* **A Poet.** She was a finalist for the Minnesota Book Award. She has an MFA from the University of Arkansas and was a Fulbright

fellow to the Netherlands. She has held residencies at the Poetry Center of Chicago and the Anderson Center for Interdisciplinary Studies; her work has appeared in magazines like *The American Scholar* and *The Iowa Review*. "A central theme of art and myth is exile, and we are all exiles from the past," she writes. "I care about the ways history and memory interact."

* **A Composer.** He is currently the composer-in-residence for Kantorei in Denver. He was also the composer-in-residence for the Rose Ensemble in Minneapolis for the 2004–2005 season and a 2003 winner of the Chanticleer Composer Competition in San Francisco. A graduate of Minnesota State University in Mankato, he says, "I try to write about 'eternal' moments of ideas, which are experienced by everyone. In doing so, I strive to find the essence of beauty, which often contains simplicity and balance."

* **A Filmmaker.** She has begun work on a video about the lives of South Dakota rural women and the rural diaspora. Her first documentary, *this black soil*, also about rural people, has received honors at various festivals around the country. She says, "I am committed to bringing art and social change together, to use my work to explore issues of race, class, and gender, and push boundaries to open up the documentary vernacular to include a feminine aesthetic that includes not only stories that are rarely told, but the way in which we tell these stories."

These are only a few of the fifteen artists who were selected in the 2005 grant year. The fifteen fellows were selected from a field of more than 500 applicants by a panel of nationally known artists and curators. Each fellow received $44,000 over a twelve- to twenty-four-month period. These award notices describe the artists, their work, artistic focus, and some detail of the project they are currently working on. Unlike the travel and study examples, little detail about their actual plan is presented. Yet, as is seen here, these grants do help the artists focus on their primary discipline of art, and it is their work that is supported and celebrated.

Application Requirements

I particularly like the "form" application because it tends to be brief and less belabored. It does have a disadvantage in that you must have a computer to fill out a PDF format of the form. Given that all

funders are not equal, some still use forms that are not in a PDF file and so you must go to the local library or copy center and use the old fashioned, but reliable and sturdy, typewriter.

The following is a list of the various components to the applications, along with helpful hints as to how and what to write for each of these.

Ten Easy Pieces

I am alluding to the title of an old movie in this subtitle, and I do wish it were five instead ten, but these requirements are pretty straightforward. Remember that these are grants—not handouts—so you have to do a little bit of work. The good news is, you won't have to write heaps and heaps, because you are working with a form. You will need to be judicious in what you write, since you will have limited space.

In fact, there is a special note on margins, typeface, and so on, and you shouldn't ever try getting by with something different. I am guilty as charged for trying to "cheat" on these requirements, and it is probably all MY fault that foundations now state emphatically the preferred margin and font size. My penance for this youthful folly came when I was a grantmaker reading hundreds of proposals with tiny words that filled the whole page. Even though I once used a smaller font on an application, it isn't fair play. The reviewer commented on this and I could have been disqualified. So do as you are asked and make it easy for someone to actually read your application.

A Cover Sheet

This has basic information about the category you are applying to and all of the basic contact information. It has many boxes to check, for the types of grant you are applying for, your discipline, gender, and other basic facts. After you have completed this, make sure you haven't missed any of the places to fill in.

Accomplishments

This appears first and is a great start in that you basically list all your accomplishments. A critical issue with these will be to fit what

you have within the space limit of their requirements. I once inserted a table within the page, which helped economize the space I had. And it was noticed! In fact, the preliminary judge referred to it, noting that the presentation of a table demonstrated to her that I was organized, which certainly could be deduced.

If you are a beginning artist with few credits to your experience, you may be hard-pressed to stretch your accomplishments. In one case where I was helping a filmmaker fill out an application, she was clearly transitioning from a brand-new beginner to a more serious artist. She had basically filmed a commercial, and so when we mentioned it we gave it a more concentrated description, identifying what she had focused on and how this inspired her to go forward. I don't actually recommend padding your experiences. If you are a beginner, you need to get out and produce, so that when you have amassed some work and credits you can apply for a grant and be competitive.

Funders are looking especially for such things as performances, commissions, exhibitions, collections, residencies, tours, community work, collaborations, employment, training, fellowships, honors, and awards. Clearly labeling these and putting them in chronological order helps tell your story. You only have one page to do this and it may not be easy to squeeze it all in. The funder gives instructions for prioritizing the "overflow" by stating that it is only a partial list. You know your field best, and so if you have accomplishments that are highly esteemed, prioritize your list in this manner. Remember, with many of these programs, the written application is just one layer of the process. Oftentimes, when you are a finalist they will ask whether you have more information to update your application, and you can offer more information about all of your accomplishments.

Truly, when guidelines prescribe a page limit you have to stick to it. Some funders discard anything over the limit, and they won't even look at what you have written on additional pages, so adhere strictly to their requirement.

The Artist Statement

We have seen this on the other applications and have worked on it, so we are well prepared. The examples of fellowship winners I gave earlier give smatterings of the artists' statements. The statement may be pretty personal, but overall it must make sense to the larger community.

Defining Your Style within the Artist's Statement: A Writing Exercise

When a funder asks for any piece of information, pay close attention to the order in which it lists the information in the request. For instance, the Bush Foundation's application says, "you may discuss your style, subject matter, working process, or other aspects of your work." These "lists" give important clues for writing your statement. You would conceivably have a section called "Artistic Style" or "My Style," another called "Themes and Subject Focus," or "Subject Matter of My Work," and a third section called "My Process" or "My Inner Workings." For our writing exercise, let's focus on the style section and review some of the examples I've created that can capture the essence of this very important and sometimes elusive artistic quality. Here's an example of a general statement:

> My poetry has a narrative style that gives the reader a storyline, a day in the life of a normal everyday occurrence, a microscope on the smallest details of observation.

You may want to consider describing your style through a comparative statement that contrasts your style with that of a well-known artist, perhaps one whom you have admired and/or has been a guiding mentor and influence in your work. For example:

> My work uses all of the psyche and aspects of personae, including the shadow self which was more prominent in my earlier career. These days, many read my poetry and see a wit and humor that is influenced by Billy Collins, the former poet laureate.

Another approach would be to relate your style to a well-known movement or school within your artistic discipline—for example, the cubist movement, realism, or postmodernism. It will be interesting to the reader to see how your work flows from or perhaps departs from that movement.

Finally, another way is to think about what you would say to a friend you haven't seen in many years. How can you explain your work in an accessible manner?

And don't worry about being baffling, stupendous, and fantastic in this statement; be as real and genuine as you can be. This is a true reflection of you, so make it real!

Fellowship Plan

The requirements ask you to describe the general directions you plan to pursue or specific activities you intend to undertake and to indicate how you plan to focus extended periods of time on your work as an artist. The limit is one page.

Here are a few considerations and ways to approach designing your plan:

* Reflect upon your work and identify gap areas of development. Identify the resources and learning that would help fill these gaps.
* Identify your focus area, whether it is a technique, a new direction, influences, or peer learning.
* Identify the outcomes, what you are trying to produce, and what the result will be at the end of your fellowship period. Remember, many programs allow six to twenty-four months, so think through the full period and back cast.

After you have worked with the above considerations, you are ready to draft your plan. An easy approach is to break it all down chronologically. Here is an example of a plan that involves a photographer who wants to create a forty-year retrospective of his work.

My fellowship plan will extend through a ten-month period. Fifty percent of this will be spent producing new images that will stem from environments and themes of previous work. I will spend five one-month sojourns to the places where some of my work was inspired and have chosen two new environments to push through new ideas.

I will use a digital format solely during this time and through it, capture color and light in new ways, giving my aesthetic an enhanced and evolved quality. Delving into the technical side of digital photography, I will also attend the Fuji Pix Conference in May of this year. Along these lines, I will be enrolled in an S2 Web forum, which allows for a global exchange with fine arts photographers.

The second half of the fellowship will be spent exhibiting in three major venues, with each venue having the opportunity to exhibit and collaborate with design centers in each place. These are for the purpose of hosting master-level workshops.

The fellowship culminates with the production of a retrospective show in the place of my work's origin, Paris, and in the production of a print book.

The above example is very basic, and although it isn't jam-packed with activities, it is focused around the specific need of that artist. You must strike a balance between the work shown and what you ask for in your plan. This example is competitive if the work of this photographer has a seasoned and masterful quality about it.

Recalling the levels of artistic development, try to choose and design a plan that reflects where you are in your development. Obviously, in this example, after forty years it is appropriate to think about developing a retrospective of one's work. Also, in this particular discipline the technical aspects of creating have changed and this photographer is delving into new methods through the use of a digital process.

Of course, this is fictitious but it gives you an idea of how you can approach designing your own plan.

Other Requirements

The final three requirements for this application form are the additional pieces of information: the list of your work samples and two references. These are fairly straightforward, and the only area you need to pay closer attention to is the work sample section. Let's have a careful look at the example below and what the foundation's expectations are for presenting your work samples. Note the requirements are very detailed so you must follow directions.

The Work Samples List

The form states, "List your submitted work, following the instructions. Give additional instructions, if appropriate, for presentation of your work to the panel. Please see the guidelines for additional information appropriate to the category in which you are applying." This just means, depending on your art form, the panel needs help to view it best. You will be sending slides or videotape, as we discussed in the prepping for portfolio section, and here is how this funder requires they be prepared:

Slides: List up to twenty slides with title of piece, date completed, materials used, and dimensions. Please list all works

chronologically, beginning with your earliest work. The numbers on the slides must correspond with the numbers on the list.

Videotapes, audiotapes, CDs, and DVDs: List the title of each work, date completed, length (if an excerpt, please note both the length of the excerpt and the total piece), where and when performed, number of performers and names of principal performers, designers, and composers. Be sure tapes and disks are clearly labeled as described in the guidelines. For video and audiotapes, please note cue marks if there is more than one piece on the tape.

Additional materials for traditional and folk artists: For any printed materials showing images of your work, please list the title or description of the piece, date completed, materials used, and dimensions on the reverse. The numbers on the samples must correspond with the numbers on the list.

There you have all of the pieces for this application, along with many helpful hints, a few examples, and a writing exercise. If you stay focused on each section separately and avoid being overwhelmed by all the micro-steps, it really is straightforward. And fairly said, this is a process but you have made a lot of progress and the mystery of it all is gone, given the specifics that I have provided.

ESTIMATING AND CREATING A BUDGET

To estimate and create a budget, I have chosen a basic one, using the Jerome Foundation's requirements. This is probably a smaller budget than that used for a fellowship applications but it will illustrate how to create budgets. The example here has very basic line items that are the categories for the kinds of costs and items you could encounter in a travel and study venture. The following descriptions clarify each of the line items and the specific way in which these are used in a budget:

* **Transportation:** This is the cost of an air, train, or bus ticket to get you to your destination. If you are driving yourself, be as exact as possible in estimating the mileage costs. A way to help with this is to use an online calculator through Mapquest or some other Internet travel planner. Then place a quick call to

the foundation staff and ask what the accepted per mile reimbursement is, and multiply this by your round-trip mileage. There are standard limits on some of these costs, so trying to get in the range will make your request more competitive.

* **Lodging:** These are the costs for room and board. Your plans may include a travel package that combines lodging and meals into one price. If yours is a self-designed program, estimate an average cost of a hotel per night; your food costs would come out of your per diem. Go with average, not high or low. Five-star lodging will usually break a budget, so try to make estimates within the grant budget.

* **Materials:** These are costs related to supplies you will use in the course of implementing your travel and study plan. This does not usually include equipment like computers or software, and any kind of hardware tool. Check with foundations on this, as they are pretty clear about what they allow.

* **Fees:** These are entrance fees for a conference, workshop, retreat, or whatever the venue you may attend.

* **Per diem:** This is a per day stipend that compensates you for your time and attendance and is used for the ancillary costs not covered in any of the other line items such as food, taxis, buses, subways, and other daily miscellaneous expenses. Again, be exact and estimate what these costs would actually be. Also, in the same telephone call that you make to the foundation staff, when you inquire about various parts of the application, you can ask what the range is.

Other costs are anything not listed that would pertain to the travel and study plan. Check to see whether phone costs could be included in this and whether you could charge the budget one long-distance call per day.

Sample of Worksheet for Budget

The following is an example of a worksheet to help you create a budget for your project. This is the budget form used with the Jerome Foundation travel and study grant application. Give it a quick review, and begin working on your own budget.

BUDGET: PLEASE BE AS SPECIFIC AS POSSIBLE.

Applicants are not required to secure supplementary funds; however, if personal monies, donations, fellowships, or other grants will be used for the travel and study project, they must be included in this budget.

	Brief description	Request	Supplementary funds**	Total
Transportation				
Lodging				
Materials				
Fees				
Per diem*				
Other				
TOTAL				

* Per diem includes food, taxi, bus, and other daily miscellaneous expenses, with a $1,500 limit for travel of three to six days and a $5,000 limit for travel of one week or longer.

** Please list source(s) of supplementary funds (if any):

A Word on Budget Totals

Grant awards have ranges, limits, and set amounts. This is what they will provide, but it doesn't mean your budget will be the exact amount of the grant. It is highly unlikely that you would draft an authentic budget that would be the exact amount allowed with a funder who has two grant categories, one for $1,500 and the second for $5,000. Creating budgets that conform exactly to the upper or lower levels allowable demonstrates to the funder that you may not be estimating things as they really are, but that you are trying to pad, skimp, or guess on the budget.

Your budget amount could exceed either end of the awards here, and that is why the funder asks whether you have supplementary support or grants. If you have a budget of near $5,000 and you have obtained another small grant of $1,000, it would make your request more competitive because you only need to ask for a $4,000 grant. Sure, the top

end allowed is $5,000 but grantors want to fund as many artists as possible. Your ability to understand this and try to get other funding signals to them that you realize they are not the only bank in town.

❧ ONLINE CONSIDERATIONS

As mentioned earlier, there are a few foundations whose entire process is online, but some, like the following, use their Web sites for items such as eligibility worksheets and budget worksheets.

Below are the eligibility questions posed online for the travel and study grant from the Jerome Foundation. These are presented on the Web site as part of the guidelines for grants. It realizes that people scan this information relatively quickly and may miss some of the eligibility description.

Examples of Qualifying Questions from an Online Worksheet

1. Are you a resident of one of the five boroughs of New York City or the State of Minnesota?
2. Are you an emerging creative artist originating work in the following art forms? Dance, literature (poetry, fiction, creative nonfiction, spoken word), media (film and video), music, theater, visual arts.
3. Do you have a plan to travel somewhere in the country or in the world to study, research and/or seek professional development?

These questions are very straightforward, and as you see there can be no fudging. You are either a resident who is an emerging artist and have a plan for travel and study, or you are not. It is very simple but amazing how many people will apply despite being ineligible.

❧ THE LIFE CYCLE OF APPLYING FOR A GRANT

Before we end this chapter, I want you to see an actual timeline for applying for a fellowship grant. As you will see, the planning and research involved in these is substantial and in this example the entire process nearly took two years' time. I might add that many of us will

have been "thinking" about applying for some time, even years prior to the actual application so the process can be quite long.

Spring:
* Obtain guidelines for the fellowship program.
* Attend an informational meeting hosted by the foundation and listen to a panel of grantees who received awards.
* Begin to research options for the fellowship plan.
* Research past grantees and people who had received grants for similar plans.

Summer:
* Conduct at least three interviews of past grantees whose awards for fellowship plans were similar to my goals and plan.
* Conduct another half dozen or more interviews with colleagues, mentors, friends, advisors, and peers who know your talents to determine the feasibility of application and chances of success.
* Meet with the foundation staff to interview them regarding competitiveness, weaknesses, and strengths of your proposed plan.

Early Autumn:
* Begin drafting the application.
* Begin the process for fellowship plan placements, venues, and new learning opportunities.
* Secure the guiding assistance of master-level experts to act as advisors, mentors, and career guides.
* After one month of writing and editing, submit the application.

Late Autumn:
* Receive notification of preliminary judging for first round.

Winter:
* Submit additional information if requested and apprise the foundation staff of updates and changes.

Spring:
* Provide additional specific information about your plan as requested by the funder.

Conclusion

Yes, it is a lot of work, and it can be very disappointing if you are not successful in winning the grant. Yet when I think of the process, its depth and the richness I gained in meeting the many people who were very willing to help me, well, that is priceless. After analyzing myself in mid-career, I know more about myself and my abilities. I had reached a milestone in my life, and the application process was a jumping-off point. The final judging process was also enlightening for me, and I felt honored to be part of such a stellar group of people. And even though I didn't attend Harvard, which was one of the goals of my plan, I met some amazing people, including David Gergen, who has continued to guide and encourage me in my career aspirations.

Some people believe that if you dream of something, it has a chance to happen and can become reality. I believe the process opened me up to thinking about my future in unlimited ways. I wanted to end up more informed and to work with a nongovernmental organization (or nonprofit, as they are called in the United States) in a developing country—and I wanted to write. Fours years later, I find myself doing that and more in Cairo. Getting here via another formal degree and a job didn't pan out, but the fact that I opened myself up to the ideas made the opportunities more apparent when they did arise. In the world of grants, I have come to understand that even though you may make plans that totally change your life, you do live to breathe another day, even if you do not receive the grant. After all the planning and preparation for a fellowship, you may find yourself in a completely different place relative to your vision and future. That is the wonder of the journey and some of what life holds; you can try again.

There you have it! All of the necessary application information and exercises have helped you complete or at least start your own application. Before you move on to the next chapter where we look at public grant applications, don't forget these simple and helpful hints.

✑ THE GRANTS ZONE

Drafting one grant application can give you enough information to draft a second or a third.

Funders want grant applications that are creative but fit within formats that prescribe specific directions.

Don't get nervous or give up because the instructions for applying for a grant seem long-winded. Give yourself enough time to do the work properly and you will enjoy the outcome and success of having written your very own application.

✎ BOARD PET PEEVES

Applicants who use the "mass mailing" approach in sending out applications basically copy the information for one to send to another. I know I've said that you can transport sections from one grant application to another, but the difference is that you use some information and customize it to the next application. Sections in applications, like the artist statement, may not change that much, so you can reuse them, but other pieces will need to be adapted.

Receiving applications where the grantseeker has not followed the directions related to page limits, font size, or word counts.

Prospective applicants who don't make good use of informational meetings hosted by funders.

CHAPTER EIGHT

The Public Grant Application

People sometimes inquire what form of government
is suitable for an artist to live. The form of government
that is most suitable to the artist is no government
at all.

—OSCAR WILDE

I don't think Mr. Wilde would agree with the position I present in this chapter about government grants and the public sector. Just as we have seen in applying for private grants, you will find the public sector as helpful, with abundant opportunities.

This chapter will provide you with information about some of the primary funders for the arts in the public sector, these being the National Endowment for the Arts (NEA) and your state and local arts councils. You may find that the methods are similar in both public and private arenas, but I want to point out the nuances and differences within public grant applications.

We will look at the three levels of government—federal, state, and city—and discern the best ways to access grant dollars in these fairly competitive arenas. We will look retrospectively at the NEA and its current four-goal strategic plan. Then our main focus will be on one of the grant programs. You will have more opportunities to write various pieces of grant applications, and the writing exercises will prepare you well for your first public grant application.

✍ THE NATIONAL ENDOWMENT FOR THE ARTS

We looked at the various ways to help us locate federal and state grants in chapter 6. If you didn't identify the National Endowment for the Arts as one of the premier funders for grants for individual artists, you can add it to your list. The NEA has many grant programs, some of which are for the more established mid-career artist but the organization can be on your "radar" for future use.

Given the change in political administrations and decreases in federal appropriations, the NEA has had its share of funding challenges. Despite these challenges, I am here to say that the NEA is still alive and kicking. In fiscal year 2004, it awarded over 2,100 grants (totaling $100 million) to individual artists, schools, arts organizations, and communities in all fifty states and six U.S. territories.

The National Foundation on the Arts and the Humanities Act established the NEA when it was passed by Congress and signed into law by President Johnson in 1965. It states, "While no government can call a great artist or scholar into existence, it is necessary and appropriate for the federal government to help create and sustain not only a climate encouraging freedom of thought, imagination, and inquiry, but also the material conditions facilitating the release of this creative talent." On September 29 of that year, the National Endowment for the Arts, a new public agency, was created "to strengthen the artistic life of this country."

Between 1965 and 2000, the government's thirty-five-year public investment in the arts paid tremendous dividends. Since 1965, the NEA has awarded more than 111,000 grants to arts organizations and artists. The number of state and jurisdictional arts agencies has grown from five to fifty-six. Local arts agencies now number over 4,000, up from 400. Nonprofit theaters have grown from 56 to 340, symphony orchestras have nearly doubled in number from 980 to 1,800, and opera companies have multiplied from 27 to 113. And the first grant to the American Ballet Theatre, in 1965, was a harbinger for dance companies, which have multiplied nearly eighteen-fold since then.

NEA Strategic Plan 2003–2008

You can see the illuminating influence the NEA has had on American society. Its primary agenda has not changed, although funding has seesawed over time. The NEA's public service mandate

states that it "[continues] through its commitment to fostering American creativity and investing in our living cultural heritage. By supporting artistic excellence, forging partnerships, building more livable communities, promoting lifelong arts education, and improving access to the arts for all citizens, the agency strengthens American democracy at its core."

The NEA, like any government entity or private foundation, has "Le Grand Plan" which helps it strategically focus on priority areas that are deemed to be the main focus of its vision and mission.

The following is the NEA's four-part plan. Given the agency's history, I think you may agree that it seems quite doable:

THE NEA VISION

A nation in which artistic excellence is celebrated, supported, and available to all.

ITS MISSION

The National Endowment for the Arts enriches our nation and its diverse cultural heritage by supporting works of artistic excellence, advancing learning in the arts, and strengthening the arts in communities throughout the country.

GOALS

1. Artistic Creativity and Preservation: To encourage and support artistic creativity and preserve our diverse cultural heritage.
2. Learning in the Arts: To advance learning in the arts.
3. Access to the Arts: To make the arts more widely available in communities throughout the country.
4. Partnerships for the Arts: To develop and maintain partnerships that advance the mission of the National Endowment for the Arts.

A Multidisciplinary Approach

Although the NEA may not be on the top of your list of funders to approach, as your work may not be at that level, I want to review its

process so you are familiar with a public agency's application. There are many grant programs under its umbrella, and for our purposes we will look at Fellowship programs.

The NEA makes direct awards to individuals only through its Literature Fellowships, Jazz Masters Fellowships, and National Heritage Fellowships in the Folk & Traditional Arts. This may seem limiting, yet NEA funding support is available in many nonprofit organizations, schools, and state and regional programs through fiscal agency and sponsorship. The following encompass the reach of all its funding, including individual and organizational grants as demonstrated through all the disciplines listed:

• Arts Education	• Literature	• Presenting
• Dance	• Multidisciplinary	• State and Regional
• Design	• Museums	• Theater
• Film/Radio/Television	• Music	• Visual Arts
• Folk & Traditional Arts	• Musical Theater	
• Local Arts Agencies	• Opera	

◦ᵔ THE NEA FELLOWSHIP PROGRAM APPLICATION

Let's look at the literature category for NEA grants. The PDF for this grant application is twenty-six pages long. I tell you this with a smile because you only have two pages of an actual form to complete and of that, you have limited space to explain and describe your fellowship plans. The fellowships for the Literature category are divided further and it is the Creative Writing Fellowships that we will discuss here. These grants are $20,000 awards. The review process greatly depends on your previous published work and the plan for your career advancement. The work samples that you submit are limited in both the poetry and creative nonfiction (prose or essays) categories of the Creative Writing Fellowships. Don't be scared off by the strict eligibility requirement that you must have published or exhibited work. Of course, many readers will already have this. Those of you who are just starting out can look to the NEA as a future resource, to be approached after you've gone further down the road of your artistic career.

Let's look at a few of the particulars and have a go at another writing exercise. This is how the NEA describes its grants in the literary category: "Fellowships in prose (fiction and creative nonfiction) or poetry are available to published creative writers of exceptional talent. Fellowships enable recipients to set aside time for writing, research, travel, and general career advancement. This program operates on a two-year cycle with fellowships in prose available in FY 2006 and fellowships in poetry available in FY 2007. Individuals may apply only once each year."

The NEA has many instructions and sections describing its exclusions, limitations, and deadlines; a very specific requirement for eligibility; and similar to some private funders, a worksheet or checklist that is an integral part of the application. I have included the NEA eligibility requirements below, because I want you to see how specific these requirements are and "lead the cheer" for you to work your art and craft in a focused way. These awards are great, but you will need other supplemental monies. Again, these grants are very straightforward; they help, reward, and support the mid-career artist.

Eligibility for the NEA Grants in Literature

Here's what the eligibility requirements state (note these are specifically dated as they pertain only to current fiscal year 2006 awards). Check their Web site for the most up-to-date grant cycle:

Creative writers who meet the publication requirements that are listed below are eligible to apply.

Applicants must be citizens or permanent residents of the United States. See "How to Prepare and Submit an Application" for the documentation that is required to demonstrate eligibility. Ineligible applications will be rejected.

An individual may submit only one application per year. Multiple applications will be rejected. You may not apply for a Creative Writing Fellowship and a Translation Project in the same year. You are not eligible to apply if you have received two or more Creative Writing or Translation Fellowships (in poetry, fiction, creative nonfiction, belles-lettres, or for translation) from the National Endowment for the Arts.

In addition, you may not apply in Prose if you have received any Arts Endowment Creative Writing or Translation Fellowship since October 1, 1996 (FY 1997). You may not apply in Poetry if

you have received any Arts Endowment Creative Writing or Translation Fellowship since October 1, 1997 (FY 1998).

Former grantees must have submitted acceptable Final Report packages by the due date(s) for all Arts Endowment award(s) previously received.

You are eligible to apply in Fiction if, between January 1, 1998, and March 1, 2005, you have had published at least five different short stories, works of short fiction, or excerpts from novels in two or more literary journals, anthologies, or publications which regularly include fiction as a portion of their format; *or* a volume of short fiction or a collection of short stories; *or* a novel or novella.

You are eligible to apply in Creative Nonfiction if, between January 1, 1998, and March 1, 2005, you have had published at least five different creative essays (such as personal essays, memoirs, etc.) in two or more literary journals, anthologies, or publications; *or* a volume of creative nonfiction.

You are eligible to apply in Poetry if, between January 1, 1999, and March 1, 2006, you have had published a volume of 48 or more pages of poetry; *or* twenty or more different poems or pages of poetry in five or more literary journals, anthologies, or publications which regularly include poetry as a portion of their format. Up to sixteen poems may be in a single volume of poetry of fewer than forty-eight pages. This volume, however, may count as only one of the required five places of publication.

Applicants may use online publications to establish up to fifty percent of their eligibility, provided that such publications have competitive selection processes and stated editorial policies.

You must apply in a specific literary form (i.e., fiction, creative nonfiction, or poetry). You must establish your eligibility in the form in which you apply. No exceptions will be made to the eligibility requirements. The following may not be used to establish eligibility:

* Self-publication including work that has appeared in a publication for which you are the editor, publisher, or staff
* Collaborative work
* Scholarly writing
* Instructional writing
* Journalism

* Book reviews
* Editorials/letters to the editor
* Interviews
* Student publications and publications which primarily print work by persons who are affiliated with a particular academic institution
* Vanity press publication—one that does any of the following: requires individual writers to pay for part or all of the publication costs; asks writers to buy or sell copies of the publication; publishes the work of anyone who subscribes to the publication or joins the organization through membership fees; publishes the work of anyone who buys an advertisement in the publication; or publishes work without competitive selection

Review and Translation

THAT, indeed, is how the eligibility requirements read for NEA writing grants. Note that each genre has publication requirements that are fairly recent, in that you can use publications that you have completed in the last seven years. Also note, in all eligibility requirements the items and situations that are excluded. Typically, you will see a cap on the number of times you can receive a grant, and both public and private funders have some restrictions. Some of the restrictions may be in the number of total grants you can receive, and some have waiting periods but will allow you to apply again.

The Procedure, Form, and Helpful Hints

The application procedure involves four simple but detailed steps:

1. **Application Acknowledgment Card and Application Checklist:** These are frequently used with applications from public sources, and as we discussed earlier, checklists are very commonly used in the private sector.
2. **Application Form:** These are the instructions about the form, the number of copies needed, and so on. The form has a few pages, the first of which uses boxes to check for "Yes" and "No" answers to such questions like, is this your first application? Have you received a previous grant? Which category of support are you applying for? It also addresses simple things like

legal name and citizenship. Further on in the application, there is a page with a large tabled section to summarize your education, publications, other fellowships, prizes, honors, and professional memberships.

3. **Manuscript Material:** These are the instructions for "work samples," and similar to those of the private funders we reviewed earlier, these instructions are specific and you should follow these exactly. Be prepared with NEA applications to send many copies of a manuscript or whatever materials you are submitting for review and eligibility.

4. **Proof of Eligibility:** As mentioned earlier, this is an important aspect of these grant competitions. For NEA applications you **must** submit proof of eligibility. The following detail describes what is required and gives you an idea of the formality of the process. As mentioned earlier, NEA is a great resource, yet is only advantageous if you are in your mid-career with some credits to your name.

Your application package must include proof of your eligibility. For each publication listed in "Summary of Publications" on the application form, send one clearly reproduced copy of each of the following:

a. Proof of publication (the title page or table of contents of the book or magazine). If a table of contents is used, highlight the page number on which your material begins.

b. Date of publication (the copyright page or other page with the publication date).

c. Proof of authorship (e.g., the front cover of a novel or a book of poems, the table of contents page, the first page of a story or poem).

Where applicable, highlight your name as it appears on any of the above. These copies cannot be returned; do not send originals.

The NEA Application and Being Computer-Savvy

The application form is available in a PDF file, and you can use your computer to fill it out. To access the form, you must have Adobe Acrobat or Acrobat Reader. The NEA Web site provides a link to

the Adobe Web site, where you can download the Reader for free. It's important to note that the free Adobe Acrobat Reader does not allow you to "save" your completed forms. You can use the Acrobat Approval program to save, but there is a charge for this software.

To get around the "save" problem with Acrobat Reader, you must complete the form in one sitting and print it out. Before you start to fill it out, ensure that you have all the correct, final information available. You will be unable to go back and retrieve or edit your information once you close the window containing the forms. You must print out the forms before you close the window or you will lose the information that you have entered. With multipage documents, you may want to proof-read and print each page as you complete it. Another option is to print the forms first, fill them out by hand, and ensure their accuracy before filling in the final forms on your computer and printing them out again.

You are allowed to use a typewriter (I know many writers who do) as long as you adhere to the typesetting and font requirements for the applications.

☙ THE APPLICATION FORM

The application form is basically two pages, with the first page full of boxes to check and fill out with your contact information, birth date, grant category that you are applying for, and the standard "certification," which is a statement that all government applications have to ensure the integrity of the information. A special note here about your name: if you use a pen name, stage name, or pseudonym, list your legal name first on all government documents and your alias in parentheses.

Then we have the second page, which has five items in large tables, and grids whereby you fill in the "white spaces" with your information.

Space IS the Final Frontier

Space and the page limitation given for most applications can be a challenge. Although I write fairly brief and concise applications these days, I went into many a battle with way too much armor and only weighted myself down with verbose writing.

Because space is such an important factor in applications, I have presented you with not one but two exercises to coach concise and

simple writing. The first exercise is one that I have used in the grantseeking classes that I taught for fifteen years, and the second is something customized from the NEA application. OK, get ready to be concise and prepare for the Battle of Lengthy Writing.

Writing Exercise One

In most applications, whether private or public, individual or artist, form or free narrative, you will undoubtedly be asked to describe your program. Let's try this exercise using the scenario that I have seen in many applications. Your instructions are to write a brief description of your project, including a title. (Use no more than twenty-two words.) For a change of pace, let this be a project that an organization would implement. This will help you think about and describe projects that support individual artists and could be implemented through a fiscal agent or an artist residency. Try to do this exercise without reading further, giving yourself some time to draft, write, and use the skills you have learned to date. Then check the examples and helpful hints.

Easy Ways to Write Concisely

Here is a quick writing workshop to help you develop those concise writing skills when dealing with limited spaces. To avoid writer's block and staring at the page, allow yourself to write anything at first. Until you are "trained" to write concisely, try writing without limiting the number of your words. Here are some other helpful hints:

Concise Writing Hint #1

In this assignment of a project description, try to write the who, what, and how. The where and why areas will be dealt with in other sections.

> I am a poet (the who), working with Arts Lab (the what), that focuses artists' creativity through a multidisciplinary peer group and a four-month intensive learning program (the how).

Notice the where and why are unnecessary for this very basic exercise of writing a project description. And depending on "what" it is, you can use many different nouns to describe the program. For instance, if

we think "learning program" isn't quite right, or snappy enough, we can use "production lab" or even "learning atelier." Remember, in word choices you aren't going for fancy. We don't use words that they won't understand; so using "atelier" is right on the edge. It is a recognizable term used in artists' circles and is appropriate here.

Concise Writing Hint #2

Write declarative sentences. These are the basic sentence structures we learned in grade school English. Use a subject (you or the project name), a verb (the action word), and the object (the activity).

I am a musician (the subject) composing (the verb) a jazz master's series (the object).

Concise Writing Hint #3

Don't put too many ideas in one sentence, thereby avoiding the run-on sentence.

I am a musician, composing a jazz master's series, which focuses on the musicality of Twin Cities jazz with the West Bank School of Music's Jazz Festival, which is a community festival celebrating the culture, art, and community of the Seward, Riverside, and Longfellow neighborhoods.

See, there *is* a lot there, at least half a dozen simple ideas. At first, you may write like this, which is actually okay. I even encourage it because you just want to get the ideas out without worrying about grammar, punctuation, and word counts. You will edit later, taking away ideas that are not germane to the central point or thought. Let's dissect that run-on sentence so you see what I mean:

* *Simple Idea One*: I am a musician, composing a jazz master's series
* *Simple Idea Two*: which focuses on the musicality of Twin Cities jazz
* *Simple Idea Three*: with the West Bank School of Music's Jazz Festival
* *Simple Idea Four*: which is a community festival celebrating the culture, art, and community
* *Simple Idea Five*: of the Seward, Riverside, and Longfellow neighborhoods

We have five main ideas in this sentence, which is overkill. So get the pen out and edit away. Simple Idea One is your introductory sentence, so leave it for now. Simple Idea Two goes first, since it is not really necessary information and is repetitive in that the communities with the Twin Cities are named in Simple Idea Five. Then look for other redundant phrases or ideas. Notice that Simple Idea Three says it is a festival; then Simple Idea Four repeats that it's a festival and describes it. Also notice that Simple Idea Four says, "community" then Simple Idea Five describes it. This is all very good information in the evolution of writing this simple sentence. Yet by editing it somewhat, you can have something that flows more smoothly and is not running on and on:

> I am a musician composing a jazz master series for the West Bank School of Music's Jazz Festival, which celebrates the art and culture of the Seward, Riverside, and Longfellow communities.

Concise Writing Hint #4

Write freely and edit without mercy. Pare down fat sentences, editing all the unnecessary adjectives and repetitious words or ideas. Look at the following three sentences, which go from fat to lean—twenty-nine words to sixteen—in no time flat:

> **Twenty-nine words:** I am a potter working with inner-city students on the project "Poetry Plates," which blends and integrates the clay making of plates, and the learning and creating of poems.
> **Twenty-three words:** "Poetry Plates" is an integrated learning project of pottery and poetry forms for inner-city youth.
> **Sixteen words:** "Poetry Plates" is an artist residency, teaching pottery and poetry forms to inner-city youth.

Avoid using jargon, and try to speak and write as simply as possible without fluff, verbosity, or ideas that are not germane to the central meaning.

> "Poetry Plates" is a mid-career artist residency that teaches inner-city youth the utility of poetry forms and expressions, while integrating the process for creating pottery.

Say what? The notion of a mid-career artist residency is misplaced here and can be mentioned elsewhere. Take out the words "utility, forms, and expressions" since these are overkill and unnecessary to define what is being taught. Also "while integrating" is indirect. The rewrite could be:

> "Poetry Plates" is a program that blends the art mediums of poetry and pottery. This is done through a six-week artist residency for inner-city youth.

Concise Writing Hint #5

Write sentences that makes sense and read smoothly. Read your work aloud, and if it doesn't sound smooth to your ear, you need to edit. Notice in the last example from Hint #4, not only do we have a "skinny" sentence but we have skinny words. Half of the words are monosyllabic and fall easy on the ear.

Now you ask, do you have to write like this? No, of course not. I am not asking you to write prose or poetry, but just making the point after reading hundreds of proposals in my day, that the simplest writing is the best writing.

Writing Exercise Two

Having warmed up the cerebral cortex, let's tackle this next exercise, which will in essence write the description of your fellowship plan. The description will only take about 150 words. The form does not state a word limit per se, only white space, which is like a road of white snow. You are driving/typing happily along, and suddenly you have a roadblock and are unable to go/write further. This is partly due to the use of the PDF format. Trust me on this, I've filled out this form myself, and the space allowed will only take about 150 words.

Since we are practicing writing concisely, this description will be a set of declarative statements, encompassing who, what, where, when, how, and a little bit of why. It will be our best exercise yet.

Step One

Write a sentence or two saying who you are. You can name your discipline, level in your career, or affiliations if these are relevant. It can be an introductory sentence and fairly straightforward.

Step Two

Write three declarative sentences, stating the obvious attributes of your plan. You are describing the "what" and the "where" of your plan. Does it involve focused time to complete or initiate new work? Will it involve focused study through a workshop, retreat, conference, or attendance in a program? Will it involve other study methods, such as researching book references, artist interviews, or artworks?

Step Three

In one or two sentences, describe how these activities support your development or how they are implemented to give you the result you want, which is to support you doing your art, advancing your career, or finding new skills, techniques or areas to explore.

My fellowship plan uses a three-prong approach, supporting my writing and mid-career advancement. One: I will be part of a multidisciplinary peer group in the Arts Lab, which is a four-month learning atelier focusing on producing new work. Two: I will pilot these new works in four communities hosting Spoken Art Forums, places where the art form originally emerged. Three: I will meet and interview a number of Spoken Word Artists at these forums, focusing on the roots, architecture, and forms of the spoken word and writing genres. This third prong will culminate in my coordinating and hosting a Writer's and Spoken Word Charrette with The Loft. Borrowing the Charrette concept from the architect's arena, a term used to describe the final, intense work effort expended by art and architecture students, my cohort and I will provide the intensive solution-driving environment needed to identify the concepts, structures, and challenges of an evolving art form. The Charrette will host over 100 spoken word artists and writers.

Dissecting the Example

In looking closer, you can see a fairly simple introduction basically stating that the plan as follows supports a writer in mid-career. Then, we have three sentences that focus on what and where. These give the basic elements of the plan, the methods for studying, working, and learning. The rest of the plan discusses more of what

and how, giving the reviewer an added bonus of what may result from this work—an arena (the Charette) for defining the state of spoken word forms as an evolving art in society. By using the Charette as a modality, it tells the reviewer that the artist is looking at the basic "architecture" of spoken word art, as a new and emerging art form.

Break Out the Champagne

I know I get carried away with celebration, but hey, you did it! This review of the NEA grant application has pushed you forward, and the exercises that you have completed have helped you gain a vast amount of information to apply to all your grantseeking endeavors.

Given that the NEA fellowships require established work, exhibits, and publications, let's look at another level of government funding that may be more accessible to the beginner and emerging artist.

☙ THE STATE ARTS BOARD AND ARTS COUNCIL

There is a state arts board or council in every state of the union and even six territories. These receive NEA monies along with local support through their state governments. I have reviewed a few of these: Minnesota, Ohio, New York, and California, to see how these states support artists. As you might imagine, arts funding comes in similar packages, and depending on the financial health of the state, one state might have more and better programs than another.

I included Minnesota because I know it personally, having lived there for more than twenty-five years. During this time I knew well the legacy of former Governors Arnie Carlson and Rudy Perpich, who made the arts one of the state's top priorities. In similar fashion, Ohio and New York have had leadership that invested well in sustainable arts programs. And, of course, you only need to read the newspapers and remember California's budget woes to know it has scaled back on its program.

Unique Funding

The following is a list of the different groups and programs supported by state arts boards and councils. Review these and let your mind trigger

new ways for you to plug yourself in. These come in many labels but the general categories supported are:

Individuals
Schools
Arts organizations
Communities of color
Cultural collaborations
Artist residencies
Artist registries
Apprenticeships
Heritage preservation
Public art

Many of the programs that provide support for individuals do so in fellowships, awards for lifetime achievements, and through honoraria positions, such as New York's State Poet and State Author. Also in the case of New York, individuals can only apply through organizations and so fiscal sponsorship is a mandatory requirement for some programs. And although state arts boards and councils provide support for every discipline, some focus unique programs for music, dance, and literature. For states that have a folk art tradition, we see apprenticeship programs and heritage preservation programs, meant to keep traditional styles of these art forms alive.

☞ MORE ABOUT ARTIST RESIDENCIES

There are two types of art residencies that I want you to add to your resource lists. The first is the residency that provides a place—usually quiet, beautiful, and serene—to do your work. These are like working retreats, and you apply for them as you would any grant or fellowship. They come in varying lengths of stay, and some provide a small food stipend, or room and board.

The second kind of residency is the one I have discussed briefly, in which you are employed or contracted to "reside" within a small community, school, or academic setting and are the guest artist. These are formalized programs in many communities. Arts organizations that support youth and art in school programs are high on many priority lists for state funders. One of my favorite ways of working, and gladly

one of the more popular granting programs, is the artist residency. In Minnesota, artist information and applications are reviewed and selected to be part of a state roster that advertises artists for hire. This roster is a juried catalog of individual or paired artists who demonstrate high artistic quality and the ability to teach students in grades K–12, a resource for schools interested in hosting artist residencies, and a marketing tool for teaching artists. Let's look at a couple of people who work in these residencies, to become aware of the great opportunities you shouldn't let pass by. The first example is a writer and poet, and the second is a singer and songwriter:

John Minczeski, Writer/Poet Residency

In residencies, I strive to deliver a sense of excitement and discovery in poetry, and give students poetry's ancient tools: metaphor and image. I have developed writing exercises to help students delve into memory, use their senses, or imagine what it feels like to be so close to a wild animal that they know what it's thinking. Other assignments include poems of praise, in which students explore themselves, their families, and the world. Each poem involves discovery, and each discovery is a surprise.

My recent book, *Circle Routes*, published in October 2001, won the Akron Poetry Prize. My poems appear in scores of journals, anthologies, and periodicals throughout the country. I have received fellowships from the Bush Foundation and the National Endowment for the Arts, and other grants and awards. My teaching experience, dating back to 1973, includes classes at The Loft, Macalester College, Saint Cloud State University, Warren Wilson College, and other organizations. I have been named the Edelstein-Keller Distinguished Writer in Residence at the University of Minnesota for the 2004–2005 school year.

Barb Tilsen, Folk, Ethnic-Inspired Musician

At the heart of my school residencies is the creative process. Whether we're writing songs together, making our own musical instruments, exploring songs through stories or arts projects, music feeds our spirits, connecting us in deep and universal ways. Self-expression and community connection form a strong dynamic, bringing a better understanding of ourselves, our world.

As a singer/songwriter, I've performed for all ages since 1971 and worked with children since 1985. My experience includes Minnesota Arts Education Partnerships, instructor/teaching artist with the West Bank School of Music, the Children's Theatre, SteppingStone Theatre, Intermedia Arts Minnesota, ArtStop, the Children's Museum, and arts residencies in schools and other programs. Highlights include residencies creating songs for community groups and directing my youth chorus at the Raptor Center bird releases. I coordinate the Peace Resources Project for Children's Music Network and received the Best Recording for Young Children Award in 2001. My songs appear in *Sing Out!* and other publications.

Residencies can be based on any part of the curriculum: Songwriting, "Make-it Shake-it" Instrument-Making Projects, Soundscapes/Storysongs, and Creative Musical Arts Projects (crankies, flip books, overhead art, musical slide shows). I also am open to developing new residency ideas. I have a special interest in peace, conflict resolution, anti-bias education, and the environment.

More Than a Residency

All of these artists describe what they do with a classroom of students. They provide information about programs and activities, samples, and ideas that can be commissioned for hire. More than that, they tell you who they really are through their work. They talk about their artistic process in ways that you can understand, and they include a list of awards, accomplishments, and special and personal interests.

We won't spend time writing one of these out, since they are pretty straightforward, but I wanted to give you an idea of the kinds of residencies that exist and those that are part of many state arts programming.

❧ EXAMPLES OF STATE FUNDING FOR INDIVIDUALS

Now, let's look at a few examples of individual artists receiving grants from state funders. Although it isn't the case across the board, grant size is smaller generally for these programs, since one of the main aims is to fund as many artists as possible. Here are a few examples,

again from my home state of Minnesota. Note, they are very specific and resonate with the focused tone of the fellowship plans we have worked on so far:

* **Dance:** $6,000–To create and present a new full-length performance, breaking down the walls between various dance forms and interweaving the elements of different dance genres. $3,000–to re-choreograph "Leonora's Dream" to be performed in two new locations.
* **Theater:** $4,400–To collaborate with an Australian composer and director, to co-create a new piece of musical theater that will explore the contrasts and similarities between Australia and the United States. $4,000–To research and conduct interviews for the play *The Partition Project*, set during anti-Sikh riots immediately after Indian Prime Minister Indira Gandhi's assassination. Pangea World Theater will host the workshop and performance when the script is completed.
* **Pottery:** $6,000–To acquire and install a large-scale "car kiln" with an adequate firing chamber that will allow her to experiment with imagery and scale.

SAME LEOPARD, DIFFERENT SPOTS

As you become more familiar with the requirements for applications, you will see the similarities between state and private funders. Even though each has its own language and calls things by different names, some aspects may seem similar. For instance, private funders host informational meetings to help answer questions about the application process. Public funders have similar meetings, but because public monies are sometimes viewed as contracts and not grants, a public entity might call these meetings "bidders' conferences." Same utility, same focus, only they use a different name.

PUBLIC FUNDERS, PUBLIC SERVANTS

Having applied for grants to both public and private entities, I don't know which seems easier. However, I can say something about public funders in that they take their role as public servants quite

seriously. As we round out our experience in accessing grant dollars, do not shortchange yourself by avoiding public grant opportunities because you have deemed them too bureaucratic.

My experience with staff in both federal- and state-operated programs has been stellar. I have met many administrators in some of the more popular departments like education, health and human services, housing and urban development, science, and, yes, the arts, and they have all been very helpful. This is your tax money at work, and when it comes to public monies distributed this way, it seems that both state and federal entities get it right.

ꙭ THE GRANTS ZONE

You have done a lot of work, so give yourself a pat on back! Hopefully, after the exercise, the public-grant arena doesn't seem so big and scary. Remember the following helpful hints: Grant applications are more standardized in public arenas; the eligibility requirements can be formidable; public grant applications rely on concise writing.

ꙭ BOARD PET PEEVES

In this case, instead of boards we have staff, juries, panels and peer reviewers. These are some of the things that drive them crazy: Incomplete plans that miss telling them how this helps you develop as an artist; plans that focus only on the means; writing and narrative that is too abstract.

CHAPTER NINE

Fiscal Agents and the Arts Organization Grant

You keep sending out these little paper boats and hope that someday one will come back laden with gold.

—GLEN HANSARD, SINGER/SONGWRITER

Having covered the basic treatise on grant applications from the private and public sectors, we will now delve into the processes for grants under fiscal agency and sponsorship. These opportunities are much more generic and have greater leeway in their overall structures, requirements, and even in the implementation of programs.

You will find a respite in this chapter, especially after reading the previous chapters that dealt with the directions that individuals follow when grantseeking for fellowships. This chapter will pick up the remaining pieces of the puzzle and help you understand the process for applications that do not have prescribed guidelines for presentation. Through study and analysis, we will look at the necessary components for a competitive application submitted by an arts organization. For all you fans of writing exercises, I will increase the practice time with new sections that will give you greater exposure to grantwriting.

I will present a standard format for the nonprescribed grant application and a Common Grant Form, which provides the "how-to" in

template form for developing an application. Both of these are used as a boilerplate, the first being an industry standard and the second one, used by fourteen states.

✑ MORE FUN TOOLS

This chapter also provides you with samples of letters of inquiry, which are used by funders to screen applicants before the submission of full proposals. We will go back to the basics and revisit our networking strategies, and discover ways to make them work for art collaborations and special art projects.

This chapter is chock-full of samples of grant applications and the thinking, writing, rewriting, and presenting of vital pieces of information with them. You will be fully prepared to write the arts organization grant request after reading this chapter. It will only take your energy to fuel the fire with your project ideas.

✑ SPARK INTO ACTION

All right! We have established that one of the more available resources for artists will be the grant given to arts organizations that work with individual artists. We have touched upon the fellowship programs and the programs that are regranted through arts organizations. Let's focus on grant sources that are open-ended and whose giving has little prescription or limitations, other than that they fund small arts programs through arts organizations. Let's spark into action with our networks and creative ideas.

✑ MAKING USE OF OUR NETWORKS

Remember that in chapter 5, we discussed the importance of networking and establishing contacts with many entities, including arts organizations. Let's review the scenario for conceptualizing those great art projects and finding the necessary partners and places to implement them.

This involves you mapping out your idea and identifying within your network those arts organizations that are conducive and like-minded to

your project. In calling around and making appointments to meet, greet, share, and brainstorm, have the following "package" ready to present and discuss.

✑ THE ARTIST COLLABORATION AND PITCH

Before pitching any idea or collaborative project, you have to identify those organizations with which you can partner. These will come in a couple of scenarios that I have included here: Those that use request for proposals publicize the need to find artists who will fit within an already-established project. For instance, an arts theater wants to hire ten artists to work on independent projects in a summer showcase. In this case, you submit a proposal to the theater for review and if selected, you are an artist for hire, or one who is commissioned to fit a specific artistic need.

Another scenario is that you know of an arts organization that you admire, and you want to partner with it. Perhaps you have seen its work, a seasonal installation, or community arts project that was inspiring and you want to align yourself with its creative energy. In one instance from my own experience, I was on the board of a small arts organization in St. Paul, and each summer it hosted many art projects engaging children and the community. This was an ongoing process, and the organization actively sought and successfully obtained grant support for these projects.

Coffee and Collaboration

In cases like these, it is a matter of having coffee with the director and pitching an idea for a project, using one of its already-established or past projects to compare and use as leverage. These coffee meetings seem informal but are about the "business of making art," and it is a good idea to leave a short one-page concept paper that the director can review and consider. This paper will describe the art project, who it serves, what it does, and the materials needed. This should also be combined with a short biographical sketch of your experience. This "package" resembles something like the description of the two artists profiled for artist residencies in chapter 8 and is fairly simple to write up and put together.

Artist and Grantwriter

Although you may have successfully established a great collaboration, the typical scenario you run across is that the funding to implement the project has not been obtained. Small- to middle-sized arts organizations typically run and operate with minimal administrative staff. It can be a luxury to find a community arts organization that also has its own grantwriter. Usually the art director will be spinning seven plates at a time and may only be able to focus precious grantwriting time on the organization's primary programs.

You can be a huge asset to any collaboration if you have grantwriting skills and can develop a proposal for the organization. With this rather common scenario in mind, let's look at the various pieces needed to write the special program proposal for an arts organization.

✒ PREP STEP

As is the case in philanthropy circles, the guideline and application formats for seeking program grants for arts organizations are quite varied. In this realm, many funders have the "Prep Step" in which they ask that you send a letter of inquiry first for consideration. This helps both you and them in saving the time and effort of a lengthy proposal. A letter of one to three pages quickly tells them whether what you have in mind fits with their giving interest.

Naturally, foundations may have specific requirements for these, but I have presented a general example of how you can approach this step. There are a few schools of thought in how to prepare a letter of inquiry. I am going to present three samples of these, demonstrating the most popular approaches. I have my own personal favorite, of course, which I will share as we go along.

Letter One: The Formal and Longer Version

This letter is an abbreviated proposal really, with particularities that get coached in any basic grantwriting class. It is usually coached that you write an introductory paragraph that relates to some recent contact you have made with the funder. This is a helpful starting

point, and given your methods for networking with foundation staff it isn't a bad idea to refer to a recent conversation you may have had. But the caveat here is that it isn't necessary. You may not have had the luxury of a meeting and even if you have, it may not be that remarkable, so in that case, it may be pointless to reference it all. Use common sense here.

The main body of the letter carries three pieces of information: the short introduction of the organization, a very abbreviated needs statement, and a description of the program. A closing paragraph is made with a formal request, or what is sometimes called the "ask" among development professionals. Written formally it specifically states the amount of grant support needed, and the consideration to send in a full proposal.

This longer version can be about three pages. The sample here is not that long, and note that I prefer the more straightforward style and approach:

Dear Grantmaker:

Thank you for our recent chat at the Philanthropy Conference where you were kind enough to visit with me at the grantseekers roundtable session. Your comments and feedback about the Arts Lab Project were poignant and helpful. The Board of Directors of the Arts Lab is aware that the Foundation distributes a number of grants for peer learning and audience development.

The Arts Lab Project has enjoyed significant growth within the last three years. Last year, we launched two new programs and have attracted ten new arts organizations to collaborate with in various projects totaling $300,000. Our staff has doubled its efforts to nurture these new collaborators, and we are now well-positioned for the next vital steps.

I am pleased to write to you about a project that I believe will be of interest to the Foundation. The Arts Lab Project is seeking $150,000 over three years to expand its very successful peer-learning lab, which builds organizational capacity for small arts organizations. Our efforts to date have assisted thirty-seven arts organizations in strategic planning, financial management, and fundraising, which has helped these organizations garner new grants totaling $250,000.

[Insert further Project description here, which could be as long as two pages of narrative.]

The Arts Lab Project has received a $100,000 challenge grant, and we would like to formally approach the Foundation for a $50,000 grant toward this challenging goal.

We look forward to your consideration of our request and the opportunity to submit a formal proposal for your review. We will be pleased to submit additional information at your request. Please do not hesitate to contact me at 333–555–3333.

Sincerely,

[Your Signature]

Letter Two: The Shorter, More Direct Approach

I prefer this version of the three because it is brief, concise, gives enough information, and avoids superficial remarks. As a grantmaker, I liked reading these letters the most because they asserted what they needed in an open fashion.

The introduction of this version differs primarily from the first in that it bypasses any remark about collegial association or meetings and gets directly to the point by stating the request or "ask" up front. I know some people are having protocol attacks because you have gone directly to the matter at hand and mentioned "money" up front. But this style and approach is still professional, and works well when you consider that program staff read hundreds of proposals and letters per year.

As a result, this version repeats the "ask" a second time in the closing paragraph, which may seem repetitive but ensures that the request is not missed and takes into consideration the quick scanning read by the busy program officer.

The main body of this letter also includes information about the applying organization, the need for the program, and the activity or program description, but everything is really abbreviated. Notice that in the first paragraph, I describe how the proposed project would support with the foundation's goals. The information was gleaned from GTH Foundation information and guidelines but *not* parroted here.

Dear Mr. Lindberg:

The Africa Institute seeks support of $100,000 from the GTH Foundation for a special project entitled "Learning through Arts and Sports." We are grateful for past support from the GTH Foundation, for the demonstration phase of this project, and hope that this new request for scale-up funds will be of similar interest. We believe this project is very much aligned with the Foundation's goals to protect human rights through education, especially for those who have not had access to any form of study, literacy training, sports, or artistic expression.

Our organization, established in 2000, is serving the coastal area of Benin with the following services: health education, literacy programs, and special programs for girls. Recently, we were honored by the Women's Foundation for modeling and piloting a program that reaches girls who are in nearly "invisible" rural areas. The scale-up project for which we request funds will serve an additional 600 girls in the community. The project will operate over a period of two years, and the $100,000 grant will establish ten new clusters of programming, train-the-trainer programs, and help to establish new attitudes toward girls' learning, playing sports, and having artistic expression.

We would like to submit a full proposal with additional information for your further review.

Sincerely,

[Your Signature]

Letter Three: The Abbreviated Letter

This third version is the most abbreviated of the three types and basically is more of a letter of intent, which is used in some arenas. Here is an example of what I mean:

Dear Foundation Rep:

This letter is submitted by the Arts Lab to announce our intention to apply for a Technical Assistance Grant. The Arts Lab is a cadre of thirty-seven arts organizations that have collaborated for the purpose of peer learning, organizational development, and

capacity building. Project plans to use a grant of $30,000 would assist in hiring a trainer for our new curriculum and practicum. We have the necessary application forms and requirements, and await your request for further information.

Sincerely,

[Your Signature]

❧ REQUEST FOR A FULL PROPOSAL

OK, now you've sent out the letter of inquiry and the funder writes back saying it is interested in further consideration of this request. As mentioned earlier, some will have very specific requirements to follow. Others will not. The following information will help you understand the best ways to present your proposal, using an industry standard.

Many private foundations and corporations do not use any particular format for many of the proposals for arts organizations, and so you are on your own. Actually, it's not that bad and I have always relied upon an industry favorite that is short (five to seven pages long) concise, and compelling. I call this the generic format and have used it 90 percent of the time. My "all-time favorite" boilerplate or proposal format includes the following sections:

* Summary
* Introduction
* Problem or needs statement
* Methods (goals, objectives, action plan, timeline, evaluation)
* Future funding
* Request
* Budget

Even though this is a general standard, which can be used endlessly, I know some of you more creative writers may want to use your own format, but I caution you about this. You may like to write and enjoy being creative, but remember to keep it simple. It goes without saying that you must read the instructions and guidelines to apply to

a funder and determine whether using a generic proposal is appropriate. If funders have particular sections that they want addressed in a proposal, follow their directive and don't use a generic approach. For instance, some will require that you give information about the history of your organization. Even though this is included in the introduction section of a generic narrative, label the section—as they require—"history and background." This will help the reader feel comfortable with your proposal and find the necessary information that he has asked you to submit.

Here are the basic elements to my favorite proposal format, flushed out with key ideas to help you write each section with ease:

Summary

The summary is a brief synopsis of your proposal. It says in a nutshell who you are and what the need is; it introduces the solution and includes a dollar amount. It is sometimes called the "Executive Summary" or "Abstract." In a generic format, it is between half a page and a full page in length. In grant application forms, you will have approximately two paragraphs worth of space to *summarize* your request.

This is the first piece of the proposal that is read and thus your first opportunity to interest the reader. In a board meeting, the summary or parts of it may be the only piece that is read, and oftentimes it stands alone.

Helpful Hint #1

To gain the reader's attention, use language that is simple and free of jargon. If you attempt to align yourself with the funder's interest, do so in a genuine way, without pulling statements from its guidelines.

Helpful Hint #2

Many writers of proposals are taught that the summary is the last piece written. Even though it appears first, many believe that you cannot write this part unless you have done all the other parts first. When I started writing proposals, I found it very helpful to write the summary first. This helped to focus the proposal and also helped program developers and myself fine-tune a project.

Introduction

This tells the reader who is applying for funds. This is important and needs to be stated very distinctly when fiscal agents, partnerships, or collaborations are formed. An introduction can include the history of the organization, information about the services or programs you operate, information about your constituency (in numbers and description), your mission, goals, and objectives.

It brags. The introduction establishes the credibility of the organization through statements that are accountable and can be supported. It introduces the project or specific program that you are pitching.

It is brief. In a five- to seven-page proposal you don't have the page length to go on and on about the organization. You want to be brief and get directly to the project you are focusing on in the request.

Mission Statement

The introduction includes your mission statement for the organization, which can be a nice segue for the next section. The introduction, with mission statement, is concise enough to fit on three-quarters of a page to one page. I have seen mission statements that were very long, but the best are said in one breath and written in one sentence with a limit of twenty-one words.

Statement of Need

The "Problem Statement" or "Statement of Need" documents the needs of the community, the situation that is presenting a challenge or opportunity to the community. It describes the problem in a larger sense and is not usually about the challenges facing the organization— that is, not enough program support.

This statement of need is a strong part of the proposal. It must be compelling but not overly dramatic or negative. Demographic information can come in handy here, and summarized statistics help validate a statement.

Sometimes showing the scope of a problem or need by using national statistics can be helpful to a reviewer in understanding the problem. If you talk about the problem on a large scale, make sure you bring it home by telling how the problem affects your local community.

Remember to focus the problem on the constituency that you serve and not your organization. It is appropriate to talk about some internal aspects of your organizational need in reference to that of your clients, but you have to be careful. For instance, if you need to expand a program, you focus on the underserved people in the community as they relate to the program. In doing this, you may mention that space, staff, schedules, or whatever are barriers to being able to properly serve your clients, but don't focus on that as the problem.

This section can be up to two pages long. In federal proposals, it may be several pages long, but for private foundations, try to keep it short.

Helpful Hint #3

In the earlier days of grantmaking and grantseeking, writers and program developers were taught to *really* emphasize the problem or needs statement of the proposal. This section of the proposal would oftentimes win the grant. Nowadays, a balance between the needs statement and the methods or solution part of the proposal must be achieved.

Unfortunately, we are still dealing with some of the same societal issues and problems that we had thirty years ago (i.e., homelessness, drug abuse and addiction, illiteracy, and poverty), and so emphasizing these without sound strategies for improvement will not win the grant. In the final analysis, ask yourself—is this problem manageable?

Methods: Goals and Objectives

These get very confusing. Maybe this will help. A goal can be bigger than life. It can be very general and lofty, and sometimes it is stated in vague terms. For example:

The goal of the Children's Music Program is to improve the self-esteem of children.

The goal of the City Band Program is to reduce gang and street fighting.

These are great goals, as they are stated in general enough terms, but because of that, they are not very good objectives. Objectives are measurable statements of action that help a funder determine the

impact that can be made on a particular problem. Objectives begin to set up measures and structures in a proposal, which will ultimately evaluate the effectiveness of the project. Objectives are the accountabilities for the project. They tell the funder who will benefit, how, and when. Objectives also tell a funder how realistic your project is and whether or not you have done adequate planning.

Here is an example:

> The City Band Program will serve forty-five teens at the Teen Center through a blend of music instruction, practice, and "jam sessions" held every night of the week and especially on the weekends.

Helpful Hint #4

Aggressive goals and objectives aren't necessarily the key to winning a grant. Sometimes, depending on the problem, a little change or difference is a lot, so I caution you when proposing objectives that may seem ambitious but are, in fact, unrealistic.

Example of Goals, Objectives, and Methods

To clarify this section on goals, objectives, and methods, the following narrative gives a clear example of these and how they may appear in a proposal:

The long-term goals of the Youth Academy are to:

* Teach young people to fully utilize their skills
* Improve their study habits, and math and verbal skills
* Develop leadership and social responsibility;
* Improve school and scholastic test performance
* Motivate the students to excel in academic pursuits

These broadly described goals will be accomplished through the following objectives:

1. The Academy will serve a total of seventy-five children (grades 1–8) and youth (grades 9–12) from September 2007 through August 2008.

2. Each of the one hundred students will improve one grade level for every twenty hours of computer-assisted instruction.
3. The graduation rate of students attending the Youth Academy will be approximately 90 percent compared with the current rate of 40 percent in Washington DC schools.
4. Students will show an increase of one hundred points (over the national average) and three hundred points (over the average for minorities) in the Scholastic Aptitude Test.

METHODS

The goals and objectives of The Youth Academy are achieved by advising, counseling, and teaching youth to fully utilize their skills, abilities, and aptitudes.

Improved study habits and math and verbal skills also add to the success of the student.

State-of-the-art equipment and learning techniques, coupled with one-on-one instruction make this program truly unique.

Action Plan

The plan of action is a separate section that is sometimes written as part of the methods. In this standard format, the action plan is optional when the goals and objectives are clearly stated and the funder does not request a separate action plan. Action plans are very helpful program development tools and don't always need to be shown as part of the proposal. Typically, these include a description of each step with a timeline. In some federal proposals for organizations, you may be required to chart your timeline as in a Pert or Gant Chart, but generally speaking, in proposals to private funders you can describe this briefly. The general scope of the program will determine how lengthy you need to be with this. For instance, if you are proposing a project that has national significance or is implemented in multiple phases, whether it is for a public funder or a private one, a more elaborate timeline and action plan are helpful.

Action plans are sometimes called methods, program strategies, or solutions. Label them in the narrative with the name that is listed in the guidelines for proposals from the funder. If there isn't a particular name, action plan will suffice.

After you've planned and written, double-check to see that your methods will actually have a chance of bringing about the proposed results. I know of an organization that wanted to increase self-sufficiency for single mothers, and the proposed method was to teach the mothers how to balance a checkbook. The notion was that if they could manage their checkbooks better, they could be more self-sufficient and provide for themselves. The underlying problem was, of course, generational poverty and a lack of education—so I'm not really sure how balancing a checkbook was going to help.

Key Staff

Information about the people who run the program would be appropriate to describe at this point. Biographical sketches of about two paragraphs are sufficient for the concisely written proposal. A full résumé or CV can also be attached when allowed or requested.

Evaluation

Here is another area in which to excel. Try to make this section as strong as possible. The evaluation of a program helps to determine:

* Whether you are effective
* Whether you've achieved what you set out to achieve
* Strong points
* Weak points

Some funders will hire a consultant to do an outside evaluation or will have their own staff work with you to do the evaluation. This is especially true for large grants or initiatives that are attempting to make breakthroughs. But since most grants are on a smaller scale, you and your organization are your own evaluators. The more specific your checks and balances (namely goals and objectives) are, the easier it will be to determine in a concrete way how the program was a success.

The evaluation section describes the tools and methods that will help you *know* the program was great—or not. This could be describing

the use of consumer feedback that may be obtained from program participants. It can also include the following:

* Focus groups
* Surveys
* Reports
* Staff meetings and program debriefings

Staff meetings and program debriefings are some of the easiest tools that you can use to show a funder that you plan to monitor the activity of the program and grant. It is an often-overlooked item because it is so routine, and some organizations may not deem it to be an evaluative method, but it is when you think of the basic ways we need to track progress in organizations.

Policy of No Surprises

Planning for the evaluation is typically done with high expectations. This is good as a general standard, but be prepared for the possibility of a program going off course. (Nah, that couldn't happen, could it?)

It's important that you understand that funders want to know the good and the bad. So when you say you will provide them "with timely reports," think about that carefully. And if your program does run off course, inform the funder as it is happening. Surprises at the end of the grant year put your credibility at risk, and any hopes of future or continued funding may be diminished.

The Budget

In this standard format of a proposal, the budget will be up to one page and may be even less depending on the number of line items presented. It will either be incorporated into the narrative if it is brief or presented in an attachment. Where you present it depends on the instruction of the funder and budget's length. If no instruction is given and it is only a few line items, I usually integrate it into the narrative. If it is a full page or so, then attach it with the other necessary documentation.

Budgets are the tattletales of the proposals we write. Since they are projections, experience (or a lack thereof) can show up. "Guesstimates"

for salary amounts on particular positions or equipment costs are not advised. Sometimes, this may seem necessary, especially when a deadline is approaching, but as a general rule you'll need to be as precise as you can in determining budget costs.

The Three Bears

I mean budgets. For many grantseekers, budgets do seem like bears, big, tough, and scary. Three different budgets are commonly presented in a grant application for an organization. These are the organization's projected budget for the year, the project or program budget, and an accounting or financial statement of expense and revenue. The first two often have similar line items, with project budgets having smaller totals.

Financial statements of expense and revenue are more like financial reports that show the organization's actual account of its income and expenses. These financial statements are fairly routine, but in my experience they were always a sticking point for many grantwriters and staff. There is also a 990 form, which is a tax statement submitted by all nonprofits and foundations to the IRS. These give the statement of accounts and show the actual expenses and revenue as they were spent and accrued throughout the year. These are not projected budgets like those used for programs and organizations. There is no estimating with a 990; these are the actual expenses and revenues as they were accounted for in the year. The 990 is often used interchangeably with the financial statement, since it gives the funder a report of your accounts.

Once you get into drafting these, the bear of budgeting won't come in estimating costs but in estimating the revenue sources to offset these. Budgets should be logical enough to allow anyone to understand how and why something costs what it costs. They also have to be realistic about how you are going to raise the monies to operate them. Budgeting is one of my favorite parts of grantwriting, but I know for many it can be a bit of a headache. Once you develop your first budget, the rest will seem easy, and this information will empower you to be as clear as possible.

The Program Budget

As an artist/grantwriter, you will probably focus most of your energy on developing the program budget. The organizational budget and

financial statement should already be in place and would have been developed by the executive director, financial person, or committee of an organization. Let's look at the following items and their descriptions to understand the line items that are often used in developing program budgets.

* **Salaries and benefits:** These are the costs related to any staff members or employees who work on the project.
* **Professional fees:** These are secondary costs related to professional services that are charged to the projects, like accounting, bookkeeping, legal, etc. These could also be the costs for contracted services of an independent artist who is hired to do program activities. The difference between these and salaries is that these are not typically full-time permanent positions with the organization.
* **Supplies:** These are costs related to program supplies, any artist supplies, etc.
* **Equipment:** These are costs related to the bigger ticket items in an organization like computers, furniture, and office equipment. Because they tend to have an organizational use beyond a project, it can be difficult to make the case for charging them to one project budget. It will depend on the situation, and you will most likely discuss these needs with the foundation staff before you apply. For example, if you are a music school and need more instruments to make a program accessible, you may be able to include some of these costs in the budget. However, if you have a small $10,000 project it would be difficult to justify, say an additional $2,000–3,000 for a computer, copy machine, or in the case of the music school, a new piano.

 Equipment needs are typically a separate category of support, and it is more appropriate to look for funders who want to cover these kinds of needs. Please avoid the temptation to "slip in" a large equipment need in a budget without first checking it out.
* **Printing:** These are costs related to the printing of materials for the project and can include photocopies.
* **Occupancy:** This is the cost for space, rentals, and even utilities, if these costs are not broken out specifically in other line items. To fairly charge a budget for space needs, you have to determine how much of your current space is used in the

program, and with a few calculations determine the cost in relationship to your overall rent and occupancy costs. Project costs for occupancy will end up being a fraction of your total rent paid in the year.

* **Phone:** These are similar to occupancy costs, and to fairly charge the program budget you will need to figure the fraction of the total cost for the organization.

* **Postage:** These are usually direct costs to a project related to any mailings you send out, program notices, surveys, invitations, and so on.

* **Travel:** These are the direct costs of mileage for staff and contractors who are involved in the program.

* **Administrative overhead:** This item is one that provides a bit of a challenge. Many midsize to large organizations will charge a program a percentage of the overall costs to cover all of the indirect costs related to the program. It's best to try to determine the exact costs of these as we did with occupancy, phone, and so on, instead of taking percentages. If you use a percentage across the board, the acceptable range is 5–30 percent; in recent years, I have seen the typical range to be 13–15 percent.

Funders and donors do not like to see these kinds of line items. Any budget item that cannot be explained is suspect. You may not intend to "pad" budgets, but because the budgeting process is generally disliked, you may not take the time and effort to be precise. Also, it is sometimes difficult to forecast a future need and cost, and so program staff will ensure that the budget covers the actual costs by adding line items that will cover the unknown. Being proactive is a good practice for budgeting, but guesstimating is frowned upon. I mean, think about it: if every applicant increased its budget with 20 percent administrative charges that can't be validated, the available grant dollars would be diminished overall.

As a program officer, I was a bit of a "stickler" about budgets and in a coaching and informative way, I tried to help applicants understand the best practices for developing budgets. If you are not precise and cannot answer questions about how you arrived at a particular amount or what a line item means, you may be asked to revise the budget downward. Worse yet, you may be passed over for an applicant who estimates costs more precisely and conservatively.

* **Other/miscellaneous:** Another catchall area, which is allowed with limitation since most funders realize there will be some underestimating with budget items. A comfortable amount here is usually $500–$1,000, depending on the size of the budget.

The Budget Narrative

After you have completed the program budget, you will also submit a budget narrative that describes and clarifies each line item. Budget narratives explain each line item, or in simpler presentations, explain only those items that are large or items in a budget that may cause question or concern. The narrative tells the funder how you arrived at the amount listed in the line item.

Future Funding

In this section, you are asked to tell the foundation about your fundraising plan for the project. It is a good idea to mention that you have received other support if that is the case or which funders you intend to approach for support. This section can refer to your long-range plan if your plan includes some development strategy that pertains to the project. For instance, if in three years your organization decides to use a national direct mail appeal that anticipates an increase in contributions, you should mention it here.

Some foundations will ask for a three-year projected budget, including revenue projections. This, along with the budgets that we have already discussed, is included in the attachments and is not part of this section of the narrative.

Request

Aside from attachments to the proposal, you are almost finished. The request is a simple paragraph of two or three sentences that formally requests the dollar amount of the grant. It is sometimes referred to as the "ask," and I repeat this three times in a proposal— once in the first paragraph of the cover letter, a second time in the Executive Summary, and a third time at the end of the proposal in the request section.

These are the necessary components used in a standard format for grant applications for art organizations. This will give you a great start to an application process that doesn't have prescribed requirements.

☞ THE COMMON GRANT FORM

Now let's look at a format using a Common Grant Form, one of the great helpers to you in your grantwriting endeavors. As I have mentioned earlier, some foundations have adopted common grant applications and standardized practices for their grant application process. The following is a list of funders across the United States who use generic formats.

* Associated Grantmakers Inc.
* Association of Baltimore Area Grantmakers
* Connecticut Council for Philanthropy
* Council of Michigan Foundations
* Delaware Valley Grantmakers
* Donors Forum of Chicago
* Grantmakers of Western Pennsylvania
* Minnesota Common Grant Form
* National Network of Grantmakers
* New York/New Jersey Area Common Application Form
* Philanthropy Northwest
* Rochester Grantmaker Forum
* Washington Regional Association of Grantmakers
* Wisconsin Common Application Form

Let's look at the Common Grant Form used in Minnesota and the requirements for the narrative section. I have provided specific coaching hints on each section and a few more writing exercises. Don't get overwhelmed with the comprehensive nature of it, just go section by section and approach it incrementally. Remember, these are great opportunities because after you prepare these boilerplate formats, you only have to redraft certain sections to customize the proposal for other funders.

There are three main sections for this format, and in each section much detail is provided. This is very helpful because it gives you a great outline for how to write the proposal. For our practice purposes, the examples used will come from a variety of proposals and samples that I have written. For our general role-play, we will use the scenario of an art organization (a music school) that is requesting support for its summer youth program.

The first section of the Common Grant Form introduces the organization in all its finery. This section "presents" the organization

to the funder and provides the basic facts of who you are. This section is one of those that, once written, will need little revising and customization to be used again. It is a standard section and helps alleviate the rewriting burden.

Organizational Information

A. Brief summary of organizational history, including the date your organization was established
B. Brief summary of the organization's mission and goals
C. Brief description of the organization's current programs or activities, including any service statistics and strengths or accomplishments. Please highlight new or different activities, if any, for your organization
D. Your organization's relationship with other organizations working with similar missions (What is your organization's role relative to these organizations?)
E. Number of board members, full-time paid staff, part-time paid staff, and volunteers
F. Additional information required by each individual funder

Example

The following example comes from a bona fide proposal that garnered much attention and grant support. It is too long to include in its entirety, since this particular proposal was not as brief as those I've preached for you to write. There are exceptions to any rule, but important to note here are the ways in which the Common Grant Form Requirement above are used to tell the story. Let's look at a few examples for the requirements A, C, D, and F:

The following text relates to requirement A under "Organization Information" of the Common Grant Form:

WEST BANK SCHOOL OF MUSIC: HISTORY, PROGRAM, AND STRUCTURE

West Bank School of Music (WBSM) celebrates a thirty-one-year tradition (inc. 1970) that sets it apart as a unique music force in the Twin Cities community. Known for its high-quality, affordable, and

customized approach to musical instruction, WBSM plans for the future with great accomplishment, new opportunities, and projects.

Celebrating our history is really about celebrating the community. Steve Antenucci, executive director of Theater in the Round, states it well in the following quote from our thirtieth year Anniversary Book, "At the time [1970], many people hoped that the presence of arts organizations would help turn the neighborhood around. In the years that followed, WBSM attracted more than 15,000 students, working under 300 faculty members. The School and Theater in the Round were joined by other theaters, music and performing groups—the neighborhood kept its character while developing one of the highest concentrations of arts groups in the country Now it has become commonplace to try to revitalize neighborhoods by introducing arts groups to an area. All the more reason to celebrate today in thanking the West Bank School of Music for its thirty years of service to the community—in helping make the West Bank and the Twin Cities a better place."

When dealing with requirement C (brief description of activities), it is best to try to give information along with the idea that the organization is unique. Instead of just using lists of program names, I also put this heading in bold type and described the context of the programs. Also note in the example below that there is an emphasis on describing the population served. This is because the funder has a particular interest in this issue:

PROGRAM CONTEXT, UNIQUENESS, AND EVALUATION

WBSM provides a supportive, purposeful artistic environment for students whose needs don't fit the kinds of instruction offered commercially or through schools focused in the classical tradition. Our uniqueness is demonstrated in the American styles of Folk, Blues, Bluegrass and Jazz music and learning that is focused on at the School. Our offerings are affordable (most competitive private instruction rate in town) and accessible to a wide range of people.

We have qualitative evaluation modes currently that provide feedback about students' interaction with faculty for private instruction and class settings. The outreach and collaborative programs receive external evaluations, and these have been very positive and helpful in developing current programs. Feedback and observations in all settings demonstrate positive learning experiences, based on the mainstay of individualized attention and customization. Quarterly debriefings with faculty occur to process our current course. We plan to revamp our evaluation processes, to establish more metrics and broaden the scope to obtain more audience feedback.

UNIQUENESS THROUGH THE POPULATION SERVED, AND ART PARTNERS

Students are attracted to the creative environment that the diversity of music brings. They crave an environment that allows them to learn in an open setting that does not mandate learning style or rigueur. As a result, WBSM brings music to approximately 450 people annually from all walks of life, from children of eighteen months to retirees, from immigrant Americans and university students, to plumbers, secretaries, doctors, and lawyers. We feel that the contribution of personal contact and the diversity it produces makes WBSM a special place for musicians of all calibers.

WBSM serves the Twin Cities area and is centered in the Cedar-Riverside neighborhood. The neighborhoods that are most served are predominantly located in South Minneapolis, Seward, Longfellow, and Powderhorn, to name a few. Our teachers report that students *do* sing and play the blues in the suburbs, and we draw students from many outlying western suburbs, including Minnetonka and Plymouth. A smaller percentage of students and faculty come from St. Paul. Our constituency is diverse, non-traditional, and although we serve people from all socio-economic backgrounds, it is the product and focus on American styles of music that draws these diverse people together in community. Although we have drawn students from as far away as Moorhead and Hutchinson, our core group is the "urban musician."

We pride ourselves in serving both artist (emerging artists included) and learner with 90 percent of faculty performing professionally. Currently, we have a 70/30 percent mix of adult learners to youth learners. The common thread with our constituency is that we attract students who need a non-conventional, less pressured learning environment. WBSM is uniquely positioned to serve the emerging musician and artist through its Ensemble Program, which trains and supports the creativity of new talent. In addition, we serve the emerging teacher and have a process that allows for artists to become mentors and new teachers.

Gender is well balanced, and we are pleased with the growing level of diverse students, faculty, and board members that we attract. Because of our diversity and our faculty's talents, we are able to offer music instruction for some instruments in Spanish, Russian, Italian, and Norwegian. Through our performances, we serve an additional 500–600 people and community venues are also inclusive and include: Capitol City Pride in Mears Park, Hiawatha Park Neighborhood Barbeque, Pepitos Restaurant, First Universalist Church, the Federal Reserve Bank Public Concert, Lake Harriet Band Shell, Augsburg College Auditorium, and Cedarfest.

Requirement D asks you to describe your organization's relationship with other organizations working with similar missions. Here's an example:

PEERS AND OTHER ARTS ORGANIZATIONS

WBSM has longstanding relationships with many musical and arts institutions in the Twin Cities. We receive and make appropriate referrals to like organizations, as well as share expertise, through our Board of Directors and instructors, with other institutions. Some of these include MacPhail Center for the Arts, Augsburg Music Department, Art Start, Twin Tone Records, Homestead Pickin' Parlor, the University of Minnesota, and the American Composers Forum. These partnerships are vital to the School, as its artistic vision is created within the community and guided through these peer relations.

And finally let's look at an example of how to deal with requirement F, additional information required by the funder. This funder was concerned with access to the arts and arts programming.

ACCESS AND INCREASING PARTICIPATION

WBSM is a diverse organization with people of color, gay and lesbian, and people with disabilities represented on our board of directors, faculty, and student groups. The School is proud that it has achieved much toward diversity (60/40 percent white to non-white), as *this was an intentional strategic goal established in 1996 when the current director came on board.* As open as the School was, it did not represent in all of its levels of operations the diversity that is a core value. Because of this work and experience, WBSM has been invited to be a part of much collaboration serving communities of color.

The culture of the organization reflects diversity through the ways it operates and the freedom it allows for artists, teachers, and students to express their talents without pressure to "fit in a box." WBSM is the only music organization that has placement in the Gay/Lesbian Yellow Pages and although we have worked hard to achieve our diversity, we are continuing to address this area, that is, attracting younger teachers and students and offering music instruction to non-English speakers. Our current mailing list reaches over 12,000 households with 25,000 names to draw from.

Our mainstay and purpose is to provide an affordable experience, and we are accessible to many people because *we offer the most competitive private instruction rate in the Twin Cities and because we tailor instruction to their needs.* Discounted tickets are offered at performances, and the School is on a major bus route. But more than that, WBSM accommodates people with disabilities with instructors who teach in their homes and or with techniques that accommodate the sight-impaired and learning-challenged student. Likewise, we accommodate faculty with disabilities by making referrals with students who are able to go to the instructor's studio. As part of the strategic plan completed in 1999, we have addressed

the issue of accessible space and parking at our facility and through renovating the building, we will make it wheelchair-accessible.

✍ WINNING POINTS TO GRANTWRITING

Looking back over this successful grant application, notice that in the very first paragraph, I establish the organization's history and immediately begin to build credibility by the choice of words—that is, "unique music force," and in the second sentence, "high quality, affordable" to describe WBSM's program. This funder also is very keen about arts access and who is served, so these sections are bolded out with the subtitles of "Uniqueness Through Populations Served, and Arts Partners" and "Access and Increasing Participation." Note that for the headings, I did not use a basic reiteration of the Common Grant Form requirement in the actual proposal (I only added them for you as a reminder of what had to be addressed.) The use of bolded headings will help focus the reader, but as in these examples it can also highlight some very good strengths about the organization.

The Use of Quotations

A couple things for you to note about the use of quotations: In general, they are great attention-getting tools in a proposal narrative. They break up the discourse, and when you use great quotes you enhance the narrative. In my earlier days in learning how to write proposals, I was always encouraged to use quotes. Yet I didn't really see the need and most often didn't want to use them unless they were really pertinent to the narrative. It wasn't until later in my grantwriting career that I actually began to use them, and even then I did so sparingly.

The quote under "West Bank School of Music: History, Program, and Structure" is from a local stakeholder and not from a famous person, leader, or literary genius, which in my opinion makes it quite poignant. Using quotations sometimes seems superfluous to me, even though in most grantwriting classes you will be told to try and use them. When I use quotes I do so to pinpoint a theme or to set a tone, as I have done at the beginning of the chapters in this guidebook. Otherwise, I think quotes can be unnecessary.

Oftentimes when I was reading proposals, it seemed that the quote just sat there staring at me without relevance to the narrative. Quotes presented like this really do not function well and demonstrate a writing style that is poorly integrated.

But getting back to the quote in the example, it works beautifully because it talks about the history of this music school, and more importantly to a funder, it reflects well the relevance of this organization to the community.

And one last thing that may not seem apparent; because the quote talks about a place, and how the school has anchored a particular area, it gives the reader a lot of information. It says that the location of the school has been somehow improved and "revitalized"—a great word choice—and it really helps build credibility for the school.

Further Analysis of the First Section

Even though this Common Grant Form presents information using an A, B, C outline format, it may not always be necessary to set it up like this on the page. In preparing applications for funders who use common forms, it is a good idea to call and ask whether they adhere to the form exactly. Oftentimes, as long as you use the subheadings and address each item in your narrative, you will have covered all your bases. In this case, I give them more than enough of the information listed in the outline through headings and subheadings that are bolded out.

Also note that after the section describing program activities, the one entitled "Program Context" gives a much more enhanced description of the quality of the programs. It mentions evaluation and shows the funder that staff members pay attention and are forward-thinking in their program implementation. Notice that the example gives basic information, which is always couched in the message that "we have taken great care to know our community and serve it well."

Places to Excel

In the introduction, as you describe history, mission, and program, you have a great opportunity to describe the community you serve. In the example given, much narrative is spent in helping the

funder understand the people served. How you describe them is important, and tells the funder how broadly you think and the scope of your reach. As you see here, this section includes some demographic details that describe the range of people served and their backgrounds. The subheadings of constituency, volunteers, peers, and arts organizations are part of the narrative describing "Population Served." This tells the funder that the consumer is more than a one-dimensional entity.

A second place to "show off" in your narrative is in describing any thoughts, plans, and efforts to increase access to your programs. Increasing access to the arts is a fundamental priority for most funders supporting arts organizations. Any discussion or work around this is very good and bodes well for you.

Don't Forget to Count Them

And finally in the section that discusses the governing body, staff, and key people who will operate the program, you can really excel and demonstrate strong capacity. You might want to go through this in a hierarchical way, starting with frontline staff and going up through the ranks to the Board. Since volunteerism is a central part of most nonprofits and is highly esteemed in America and with foundations, don't forget to count your volunteers.

☞ THE MIDDLE SECTION AND PURPOSE STATEMENT OF THE COMMON GRANT FORM

The middle section or second part of this Common Grant Form includes a choice of two modes for application, which are really helpful. They provide an outline for requests focusing on general operating support and those focusing on all other proposal types. The two most prevalent "other" types for organizations are project support and capital support.

General operating grants are the most-sought-after grants for organizations, because this support comes without any restriction. These grants can support and pay for all the indirect costs that may be difficult to calculate for a project request. These grants pay for the lights, phone, and administrative needs of an agency. They help offset midyear slumps and project deficits, and are the gravy of grants.

Writing to request grants for these is like any other. The availability for these ebbs and flows, depending on the economy and a funder's priority. In times where funders want to pinpoint their giving toward exact solutions and problems, they may not be apt to give out general operating support, so you may find limited prospects for this. Even though the mantra for grantseekers may be "gen-op support, gen-op support," each foundation has its own set of priorities and interests. Gen-op support has certainly dwindled across the board, but some foundations still provide it.

The second category of grant request is also a highly used mode in fundraising, and this is where the individual artist can plug in with the organization. As mentioned earlier, you can either be part of an already-existing program or preplan with the art director to gain the funding necessary to hire you to launch a special project.

Using our scenario for the music school, the following components are required for the special project grant request. Review these and then get ready for a writing exercise.

II. Purpose of the Grant
 * General operating proposals: Complete Section A below and move to Part III – Evaluation.
 * All other proposals: Complete Section B below and move to Part III – Evaluation.

A. General Operating Proposals
1. The opportunity, challenges, issues or need currently facing your organization.
2. Overall goal(s) of the organization for the funding period.
3. Objectives or ways in which you will meet the goal(s).
4. Activities and who will carry out these activities.
5. Time frame in which this will take place.
6. Long-term funding strategies.
7. Additional information regarding general operating proposals required by each individual funder.

B. All Other Proposals
1. Situation
 a. The opportunity, challenges, issue, or need and the community that your proposal addresses.

 b. How that focus was determined and who was involved in that decision-making process.

 2. Activities

 a. Overall goal(s) regarding the situation described above.

 b. Objectives or ways in which you will meet the goal(s).

 c. Specific activities for which you are seeking funding.

 d. Who will carry out those activities.

 e. Time frame in which this will take place.

 f. How the proposed activities will benefit the community in which they will occur, being as clear as you can about the impact you expect to have.

 g. Long-term strategies (if applicable) for sustaining this effort.

Writing Exercise for the Statement of Need

You will need to tell a bit of "your story" in setting up this section of the Common Grant Form. You can take it from the perspective of describing the situation, the challenge or problem, or the opportunity. When faced with this "writing assignment" on a Common Grant Form, relax into it, because in most instances, they tell you exactly how to go about writing this piece. For instance, here it states, "The opportunity, challenges, issue, or need and the community that your proposal addresses."

Using our scenario of a music school wanting to host a summer youth program, write a statement of need that helps the funder understand the purpose of the grant. Start by outlining ideas and let these questions trigger your writing concepts.

Trigger Questions and Answers to Help You Write

What are the priority needs for the community and music school, and how can I plug myself in?

* Teachers and students at the school would like a summer program but don't have the program monies to offer it to an economically challenged community free of charge.

* The summer is a great time for kids to explore and try out new pursuits like making music and playing an instrument.
* The school serves kids through private lessons during the regular school year and could help them stay focused during the summer break.
* The school has always provided the most economical alternative in music instruction, and part of its mission is to increase access to musical arts to an underserved community.

As an artist, songwriter, and music teacher, how can I help the school implement a program?

* Design a summer music day camp that runs for only one week.
* Design a summer music program that runs through the summer.
* Find two other teachers to collaborate with me.
* Be available to the school director to develop the program and meet with potential funders and partners.

We are ready to write, given that we have identified the community's needs and how we may plug ourselves in. Now, in the role-play of you as songwriter, teacher, and grantwriter, compose a short paragraph that tells the funder that you have partnered with the music school to implement a summer program, and you will be addressing the needs that you identified in the above list.

Even though this is a role-play situation, try to write something and even make up statistics and scenarios to support your premise to the funder. That premise is: Through planning and assessment, we have identified the need to provide musical programming through the summer to youth grades 7 to 9 who do not have access to musical instruction.

Remember, we are only addressing the "A" and "B" parts of the Common Grant Form's middle section, "Purpose of the Grant." Here is the replay in case you need another reminder: Describe the opportunity, challenges, issue or need, and the community that your proposal addresses. Describe how that focus was determined and who was involved in that decision-making process.

Here are a couple of examples written in different styles. This will help you see how you can customize one description into another and see the different approaches to writing this piece.

Statement of Need and Purpose of the Grant #1

WBSM requests $5,000 from the Great Foundation to implement a music enrichment program for forty-five underserved youth in three communities. Monies will be used for direct programming, planning, and curriculum development.

NEED FOR THE PROGRAM

Through the assessments, analysis, and focus groups that were part of the strategic plan, we have determined the need for an increase in youth programming. The following groups have been identified as groups who are underserved and/or who have contacted the School for collaboration:

* At-risk students in the Daytons Bluff neighborhood (they requested voice, violin, and music enrichment)
* Students who are home-schooled and whose parents or home teacher need community support to fulfill the arts and cultural aspects of their students' learning
* Teens and youth in grades 7–12

Our hope is to implement this program and reach out to greater numbers of youth who otherwise would not have the opportunity to access music programs. The project will serve youth who wouldn't normally be able to afford to study or "play" with music.

Statement of Need and Purpose of the Grant #2

NEED FOR THE PROGRAM: THE SITUATION/ OPPORTUNITY

WBSM has had a phenomenal year with many new developments. Through our strategic planning process, we have assessed a need to deepen our commitment to youth programming. In 1999, we obtained grant monies from the Minneapolis Arts Commission to pilot a new program serving at-risk youth at the Hennepin County Home School. In addition, we acquired

scholarship monies for young adults and will be able for the first time in the School's history, to bring music instruction to students who are not able to pay.

Programming in early musical development of children in grades K–6 and youth grades 7–9 are areas on which we have focused our new curriculum. Our hope is to implement this program and reach out to greater numbers of children who otherwise would not have the opportunity to access music programs. The project described below will serve youth who wouldn't normally be able to afford to study or "play" with music.

Through the proposed program, WBSM will serve forty-five children and youth living in the Daytons Bluff neighborhood of St. Paul. Ninety percent of these participants are Hmong and are economically disadvantaged. The project was designed with youth input. All participants will be girls, and many may have challenges with English and academics. East Side youth and Asian youth are currently at risk of gang involvement, to which this program would be a preventive. At the very least, it would give these kids the opportunity to explore musical expression.

Comparing the Two Examples

These examples are similar in their main message, which tells the funder that indeed thought, assessment, and planning has been put into developing this program. The first example is very concise and through the use of bullets identifies the core group of people to be served. If there was a funder who specifically served any of these groups, youth, at-risk youth, home-schooled students, and so on, this could be a perfect fit.

These examples give pertinent information about the number of youth who will be served. It's a very helpful piece of information to tell the funder that the request of $5,000 will serve forty-five students. Funders and program developers do the math, and they'll know that this program costs the funder approximately $111 per student. Ask yourself, are the costs effective? In this case, the answer is yes. It is largely dependent upon the activities and what the outcomes are, and these must balance overall with the need of the program. You can make a judgment on the effectiveness

of this grant and how far-reaching the impact on the community would be.

Each of the examples are compelling but in different ways. The first example demonstrates a compelling need by the listing of underserved youth. The second example is compelling and provides an added consideration. In the last paragraph, it mentions that this group is at risk of gang involvement, which compels the reader further by realizing that this program would be a helpful intervention.

A Great Set-Up

The problem statement is set up in such a way that it draws the reader in with a compelling rationale that isn't too dramatic. When we talk about the needs and problems in society, it is one thing to paint a realistic picture and to catalyze a funder into action, but it is another thing to paint a picture that is so dire and negative that any solution would be hard pressed to work. The key is to find a balance in how you present these needs and to set up naturally the next section. It's like you are saying here is this problem, and sound the horns, here is the solution to save the day.

As you may notice, we are still in the middle section of the Common Grant Form, describing the solutions and activities of the grant. Let's look at a sample description for the activities for this request:

ACTIVITIES

To meet the identified need and request for youth programming, the West Bank School of Music will launch a special music program for youth in grades K–6 and 7–9. Through interactive songs, musical games, and hands-on experience, the program will focus on developing musical concepts and musician skills. For youth in grades K–6, we will introduce the families of musical instruments, make percussion instruments, and provide song creation in instrument/voice.

For youth in grades 7–9, we will host a four-day camping experience on Bay Lake in Northern Minnesota. Music theory, practice, and play will be integrated with the outdoor camping experience.

PROJECT GOALS

Goal 1: Reach out to underserved children and youth in grades K–6 and 7–9 in the Daytons Bluff neighborhood of St. Paul.

Goal 2: Create and implement a diversified marketing and outreach plan that embraces the organization's values in reaching new audiences of underserved families, individuals, and students, and increase visibility in communities of color.

Goal 3: Write youth music curriculum that can be disseminated/replicated with a variety of youth groups.

OBJECTIVES/TIMELINE: AUGUST 2007 THROUGH AUGUST 2008

Implement Pre-Project Planning with faculty experts in working with targeted age group. August–September 2007.

Create curriculum. January–March 2008

Recruit students by collaborating with Portage for Youth (they will provide access to the greatest number of Hmong youth in need) and/or advertise, market, and reach out to family communities through special notices in *Parent* magazine, and other family venues. March–June 2008

Host the summer program serving twenty to thirty students in grades K–6 and ten to fifteen students in grades 7–9. July 2008

Encourage adult and peer mentoring through the program assistants working with the music teachers. July 2008

Evaluate program activities and outcomes and write youth music curriculum. September–December 2008

KEY PEOPLE WHO WILL CARRY OUT THESE GOALS AND AVAILABLE RESOURCES

The Arts Director has an eclectic background that blends the skills of administration with her own creative expression in poetry and prose. She will work with the lead teacher and singer/songwriter, who has over twenty years experience creating youth music programs.

Quantified Effects

Most funders (and their grant applications) will require that you identify goals and objectives, about which we have talked in previous narratives. Some also require that you identify your outcomes and/or the impacts of these methods and activities. As you will see in this next section, which deals with evaluation, you will have a great opportunity to really dig down into the core of program development, showing the results and outcomes.

⚜ THE THIRD SECTION OF THE COMMON GRANT FORM

The third section of the Common Grant Form follows a thread from activities, goals, objectives, outcomes, and impacts to how you will measure and see these impacts. Here is what the form requirements state:

III. EVALUATION
 A. Please describe your criteria for success. What do you want to happen as a result of your activities?
 B. How will you measure these changes?
 C. Who will be involved in evaluating this work (staff, board, constituents, community, consultants)?
 D. What will you do with your evaluation results?

Responding to these four questions will take a bit of thinking. Standard answers for describing the evaluation process typically focus on the methods of evaluation and who will help evaluate the efficacy of a project—the "B" and "C" of this third section. These are the easier pieces to think about and write, but this format pushes us to think in a broader, deeper way about evaluating a program. Let's look closely at the concepts of criteria, results, and result distribution or dissemination, which are presented in A and D of the "Evaluation" section.

The Evaluation and Outcomes Grantmakers Usually See

The following is an example of what grantmakers usually see in response to this section. Like the budgeting aspects of grantwriting,

evaluation has people running into the hills mostly because they don't understand it.

> For our scenario of a summer music camp, here are some outcomes that may be relevant:
> Increase the number of students who will pursue creative development in music study.
> Increase the number of students who can express their talents comfortably singing or performing musically with their peers.

As you can see, the example is written in general terms. Sometimes this will be the case, as it may be difficult to quantify your activities. Yet you are striving to quantify your *effects*. As is requested through the questions in this section, you need to tell a funder more than this. You need to quantify your results. Some of you ask, but how? Let's see if this helps and makes sense.

How to Quantify the Impact

In the example that we have been working with, where you are introducing music to a new group of youth, a way to quantify this would be to identify the number of people there are in any given client or consumer group that you are working with. Then identify a fair estimate of the number of people who will be affected by this. For instance, in this case approximately forty-five children will be introduced to music. So that is one quantified result. But it is only the first layer of program impact; try to think deeper and see where it leads.

You may ask, of the forty-five children, how many will choose to study music long term, since that would be an interesting outcome. Also, if you recall, this program was a diversion from teens getting into trouble, and thus it would provide an outlet for them. You could identify a reasonable estimate of how this could lead to a decrease in delinquent behavior, if you choose to identify the number of police calls made to this neighborhood, and/or the numbers of altercations and incidents of youth misbehavior.

Rethinking/Rewriting the Outcomes

Let's use quantifiable methods to rethink our outcomes, to make the impacts as relevant as possible to the community. With the idea

that this program will prevent teens from doing harm to themselves and the community, you could rewrite the following:

> There will be a 25 percent decrease in the number of police-involved incidents related to youth for this neighborhood.
>
> This youth group will report 100 percent of its participants to be free of any altercation, delinquency, or youth crisis during the project period.

These outcomes relate to the larger community and address some of the problems and needs related to youth at risk. Outcomes that focus on a societal problem blended with those that focus on the musical aspects of the youths' learning would be more holistic. So the outcomes would look something like this:

> All participants will report that the program has been fun, and the introduction to musical play has benefited their lives.
>
> Additionally, of the youth participating, 10–25 percent will make goals to pursue ongoing music study and instruction.
>
> There will be a 25–75 percent decrease in the number of police-involved incidents related to youth for this neighborhood.
>
> This youth group will report 100 percent of its participants to be free of any altercation, delinquency, or youth crisis during the project period.

The Rest of Our Evaluation Assignment

So with the results and outcomes we have rewritten, you have the core of what the impacts could be. You have answered part of the "A" of this third section. We have not yet addressed the other questions but have done the very necessary work of quantifying our success. Given how we have thought about this project in our rewriting exercise, let's address the rest of the assignment, then analyze it a bit. Here's an example of how it may be presented.

PROGRAM CRITERIA

The criteria that we have selected for these programs are generally the criteria we work with to determine the success and

relevance to our mission, which is to provide high-quality musical instruction, to allow people to develop their musical talents, and specifically for this special group of youth, to engage them in constructive pursuits.

EVALUATION METHODS AND DISSEMINATION

We will measure these outcomes throughout the program and gather statistics related to neighborhood delinquency, and so on, from the police at the beginning of the program, mid-program, and end of the program. We will also have a blind survey of our participants at similar program junctures to monitor ongoing progress. To disseminate our program results, we will provide the funder with a standard report, but we will work within the neighborhood association to publicize the projected successful outcomes as they relate to a secure neighborhood and secure youth. Finally, program effectiveness, as demonstrated through participants' abilities, will be showcased at the end of the session through a youth-organized cabaret, which will culminate and celebrate students' musical talents.

What These Outcomes Mean to an Artist

As an artist collaborating with an arts organization, you can see the impact of your work on the broader community. Facilitating arts learning, appreciation, and sharing provides opportunities to intervene in society in very helpful ways. As you can see in the examples, not only will you be able to create art, but also you will be able to create positive change in the lives of people. The impact of "your" art in collaboration with the larger community has a profound effect on that community, and more importantly, the human condition.

ᕫ CONCLUDING THE COMMON GRANT FORM

Yes, indeed, this example of an evaluation process will get noticed. It may cause questions to come up from the funder—especially the aspects of delinquency, etc. In any program where behavior changes are made, unless you are doing psychological exams and intensive

surveying, your best bet is to look outside for statistics and creative ways to measure your outcomes. Any real engagement with funders about program development, goals, objectives, and the outcomes that affect a community is the heart of grantmaking. It is more than seeking and giving grants, it really is about making positive changes in communities.

At this point, your narrative work is pretty complete. Give yourself a pat on the back, and take a short break. You can even reflect and think about how great this process really is, and that once you plug into a community, grants really can be just around the corner.

In the "finishing" of the proposal, you only need to gather a few attachments and send off your packet of information. Let's move on to the next chapter for the finished product and get a few tips on how to present it in the best light.

❧ THE GRANTS ZONE

Grant applications that have open formats still do best with brief and concise writing.

Organizational grantseeking holds great promise and provides many opportunities, so try to find alignment with peer art groups.

The outcomes, evaluation, and ways to determine your efficacy are important aspects in arts support.

❧ BOARD PET PEEVES

Too many attachments included with the proposal.
The applicant doesn't follow instructions for submission.
The applicant expects the Board to overlook a sloppy application.

CHAPTER TEN

The Completed Grant Proposal

> To me, art in order to be truly great must, like the beauty of Nature, be universal in its appeal. It must be simple in its presentation and direct in its expression, like the language of Nature.
>
> —MOHANDIS GHANDI

With the work of the last chapter, hopefully you feel well versed in grantseeking and grantwriting. Now that you understand the more generic and standard grant application used with fiscal agents and art organizations, you will be able to think of countless projects for possible funding.

If you think of the grant application as a gift, by going through this process, you have chosen and prepared the ideal present. Now all you need is the giftwrapping and proper packaging. This chapter helps you put the final touches on the proposal and will review all the bits and pieces for a great presentation. I will provide a standard list of needed attachments and a "grand over the top" list. These will all be defined and explained with helpful hints on how to obtain some of them.

The packaging of your application *is* very important, so we will also focus on the final look and aesthetics of the grant application. We will engage in a discussion about the ways to present the nonprescriptive and generic proposal, and inside tips that will guide you along the way. I will explain how to obtain an "early read" by the funder and how the use of white space will help the grantseeker prepare the final product. You will know the best ways to "wrap" these

projects up and send them out the door. Let's get started on making these pretty packages.

↪ THE ATTACHMENTS OF A PROPOSAL

In the beginning of my grantwriting career, I often read a periodical called the *Chronicles of Philanthropy*. I mentioned it earlier, and it was and still is a good read about the inner and outer workings of philanthropy. It is written like a newspaper, complete with great cartoons that poke a bit of fun at what is sometimes a subject taken too seriously. One of my favorites was a cartoon of a boardroom scene, with suited men and coiffed women sitting around a long conference table. In front of each person was a stack of proposals. At the head of the table was a bespectacled board trustee, with the extended cartoon word bubble coming from his mouth, "All right, how about we cut it short and fund every proposal that uses three or less attachments."

With grant review, anything is possible, and the cartoon takes a shot at one of the trends seen in grantwriting, which is to attach nearly everything, including the kitchen sink for the funder to consider. The following list will help you send the appropriate attachments; it will describe what they are and even where to find some of them since they may seem elusive. Below is a list of standard attachments:

* **The Letter of Tax-Exempt Status:** Every organization has in its possession a letter from the IRS that states it is, indeed, an organization that is tax-exempted.
* **List of Board of Directors:** This is a list of the names and offices held by your board members. Some funders ask for the members' business association.
* **The Budgets and Financial Statements:** We talked about these earlier, unless the project budget is only a half-page or so, then it will fit nicely into the narrative. The other budgets are a combination of financial statements and budgets—that is, a three-year (the past year, the present year, and the next year) trend budget and narrative will be attached along with the year-to-date actual accounting of the financial position for the organization. As mentioned in our narrative about budgets, some funders require the IRS 990 form that your organization files, which shows your actuals and grants received.

* **The Audit:** An official audited statement by an accountant who is outside your organization is oftentimes requested. Audits provide good financial information but are not required in the United States if the nonprofit organization has an operating budget less than $25,000.

* **Biographical Sketches:** Attach a page of short biographical information about the people who will operate the program.

* **Charity Review Letter:** In some states, you must register with the State Attorney General's Office or a Charities Review Office. This registration is another verification that you are indeed a nonprofit and acting accordingly. This involves a nominal fee paid annually; a letter from the state office will arrive and this is your legal registration.

* **A Statement of Agreement:** This is a statement that is signed by the chief officers of the board and may include the following statements:

 * A statement endorsing the proposal and agreeing that the organization will assume the full responsibilities involved in the proper fiscal management of and accounting for any grant received, and will make certain that any reports required by the Foundation are submitted on time.

 * A statement to submit regularly and on time such progress evaluations and financial reports as are requested by the Foundation. The Foundation requests semiannual evaluation and financial reports, and may request additional reports if appropriate.

 * A statement that no part of the grant from the Foundation will be used to support propaganda for or in opposition to legislation, either enacted or proposed, or used for campaigning for or against any candidate for public office, or to employ or compensate for such activities. The agency will not use this grant for the purpose of funding what is perceived to be grassroots lobbying under the revised Internal Revenue Code of 1988. A statement that this proposal has been reviewed by the board of directors of the applicant organization or will be reviewed at a board meeting (provide the date of the board meeting).

 * A statement regarding the existence of a governing board that meets regularly. State the size of the board, frequency of meetings, and average numbers attending each meeting.

* **Fiscal Agency or Sponsorship Letter:** If this is a project using a fiscal sponsorship or a fiscal agent, a letter is submitted stating that the fiscal agent will take care of all the managerial and financial

responsibilities. The fiduciary responsibility for a project lies with the fiscal agent, and this letter is basically stating that he will provide the proper oversight and accounting for the grant. In the same way, all grants made for projects using a fiscal agent will be made directly to the sponsoring agency, and payments are then made to the artists involved. The National Endowment for the Arts' Web site has a sample of a fiscal agent's letter, which can help you in drafting one of these for authority signatures.

* **Project Support List:** A list of other funders who are supporting the project. If there is no other funding obtained for the project to date, at least provide a list of those funders you are in contact with and those pending requests. Some foundations request a list of all pending funders, approved, and those who have declined. I wouldn't automatically provide this unless it is requested, but I would always present information about the funders who are already supportive.

* **Work Samples:** As in the grant request for individuals, sometimes funders will request work samples for grants made to organizations. I mention it here because it would be included as part of the standard set of attachments showcasing the organization. I would submit these only if the funder requests them.

The Over-the-Top List of Attachments

The above list of attachments is pretty standard. Of course, there are instances where you may want and need to send more information. As a general rule, you can always elaborate and give more information about the staff and who will carry out the project. So if you aren't limited for space, and the project warrants it, send the full curriculum vitae.

The following are other embellishments that you can send, but double-check first to see that the funder is open to these:

* **Job Descriptions:** This is an embellishment, but if the project is brand new, some funders may request these. I wouldn't normally send a job description, but in standard proposals and Common Grant Form types I do include a section that covers the "key responsibilities" and who will implement them.

* **Consumer Satisfaction/Critique/Feedback:** In some cases, depending on the project, I will send some evidence of consumer feedback. For example, if this is a performance or exhibit and you have obtained feedback from the audience, you could compile quotes and statements in a one-page abstract. Make sure you give the proper heading so that

the funder will know what it is looking at. For example: "Audience Feedback," or "What People Say about Our Great Program" or even something as plain as "Participant Comments about the Program."

* **Evaluation Forms and Templates:** In some proposals, I have included the actual survey or evaluation methodology as an attachment, which is definitely over the top. This is really only appropriate when a funder needs a lot of information about your evaluation methods.

* **Copies of Past Program Reports:** When I was a grantmaker, I saw quite a few of these, and even though it was superfluous I didn't really mind, as I liked looking at results and outcomes. This is a personal and subjective thing, and not every funder out there has a quirk for reports, although it is safe to say, funders generally pay attention to outcomes.

* **Annual Reports and Program Brochures:** These are oftentimes pretty standard attachments, but I put it here since most funders do not list these in their checklist for attachments.

* **Press and Media Clips:** I worked with a great nonprofit organization in Washington, D.C., called the Freedom Youth Academy, which was and is a community-driven educational program with volunteer tutors. Even though it was grassroots in nature, it had the most amazing publicity, with coverage by every national magazine and periodical. So, of course, we included a small "P.R. kit" with abstracts, clips, and even a newsletter. It was a phenomenal program, and most small nonprofits will not have the luxury of the "positive buzz" generated from media P.R. But any press or media piece could be included here.

* **Newsletters:** Yes, these can also be included, especially if they are generated by your consumer base and show relevancy to the program. For instance, writing organizations that have literary journals and periodicals created by a cadre of community writers would be something special to showcase.

Don't Get Carried Away

We have listed most of the types of attachments that can be sent with grant applications. Remember our cartoon about too many attachments. Call ahead and ask the foundation staff if they allow many attachments beyond the standard list of what they request. Attachments won't help you make your case, nor do they ever help win the grant.

Think twice about sending videos of programs and organizations, especially when these are not on the funder's list of standard attachments.

❧ THE PARTICULARS OF PRESENTATION

The way in which you present your information has become more standardized as time goes on. Believe me, when you need to make ten or more copies of a proposal for a board meeting or some kind of review, everything gets concise. Here are a few standard rules, but make sure you follow the funder's request, in case it wants something unique. As you gain more grantwriting savvy, you will see these items described in many foundation guidelines under "dos and don'ts."

Do use white paper that is generally 8.5" × 11" in size.

Don't use colored paper. Don't submit "cut and paste" original documents.

Don't submit two-sided copies unless this is requested. When photocopying material, copy on one side only.

Don't use any odd-shaped or colored papers in your attachments, as they will not copy well.

Do use standard margins on the page with your paragraphs aligning left. Use at least one inch on the top, bottom, and sides of all pages.

Do type all application material. Use black type and at least a twelve-point font.

Don't reduce or condense type or line size; leave space between paragraphs in narrative material.

Don't go over the funder's page limit by attaching additional pages with more information.

Don't bind the presentation with plastic strips or staple them together. Typically, use only paper clips and rubber bands to fasten your material. Most funders will have instructions in their guidelines about the use of binders and staples printed in boldface. This no binding or stapling rule applies to the attachments also, because some of these will need to be photocopied.

Replicating Forms on the Computer

Application forms that can be filled out on a computer are typically downloadable and available on the funder's Web site. Many funders who use application forms will allow you to replicate these on your

computer, but they must be identical replicas of the actual forms. Again, do not add pages. Failure to prepare and format an application correctly may lead to disqualification.

✑ THE ORDER OF THE PRESENTATION

The standard order for presenting a proposal is as follows:

* Cover letter: One page that stands alone on your letterhead that informs the funder of the contents, i.e. a proposal for X dollars for a special project
* Executive summary: One page that stands alone to summarize the entire proposal
* Narrative: Five to ten pages, with the typical length to be seven pages
* Program and organizational budgets
* Financial statements, audits, or 990 form
* Attachments: Attach a cover sheet referencing these if you have submitted many

✑ THE AESTHETICS OF A PRESENTATION

When you are writing the narrative of your proposal, imagine yourself as the person reading hundreds of these. Even if you follow my directions, you may still miss providing enough "white space" on the page. This is space in between headings and paragraphs. It is breaking up long paragraphs with the use of bullets and numbers to help give the reader's eye a rest. Even though I mention margins, left alignment and such, I can't tell you how many proposals funders receive that have pages filled chock-a-block with words, and few—if any—breaks.

✑ GOOD HABITS FOR FINISHING PROPOSALS

Finishing proposals and having them complete with all the proper attachments is a matter of developing good grantwriting habits. Be proactive about this part of the process, because when you are still doing a spell check or trying to edit a proposal that is too long, you will be happy that you prepared a few things ahead.

Attachments at the Ready

Have a hard copy of all the attachments you could possibly use and ensure that everyone who "helps" with grantwriting knows to make additional copies when there is only one left in the file drawer.

Board Members at the Ready

Make sure you have checked in with your board members to see who is available to sign off on a proposal. You may sign off on a cover letter, or even an agreement form, if you are a representative, but typically some forms and documents require the signature of a board president or chairperson.

Budgets at the Ready

I make a special note on these, because of all the attached items, budgets, and financial statements, and so on, these are the items with which people have the greatest difficulty. Spend more time on these than you think you need, and ensure that the accountant has the most up-to-date information for financial statements.

Postmarks and Deadlines at the Ready

Look carefully at the requirement for each funder, since most have hard-and-fast deadlines. Check these twice because some deadlines are "postmarked by" deadlines, and others are "received by" deadlines. This is an important difference, and you will miss a deadline if you mix them up, as the "received by" deadlines need to be in the mail a few days ahead of the date noted.

Typically, those who use "postmarked by" deadlines do not allow metered stamps so you will need to have proper postage. Since the package containing your grant could be quite weighty, have plenty of stamps on hand. Remember, some funders will require more than one copy of a proposal, so be prepared to mail a lot of paper.

Overnight, Federal Express, and Hand Delivery

Typically, funders want to receive your proposal in a timely fashion. Using overnight and express mail signals to funders that you may

have rushed the application, and some funders think it is a waste to spend the extra costs in overnight mailing. Deadlines are deadlines, and so many of us nearly "die" getting ourselves and the proposal to the office of the funder by hand-delivering it because we "run down the clock." For whatever reason, many of us procrastinate, thus showing poorly at "the finish line."

Be the First One In

Developing sound habits for grantwriting and its presentation are underscored when you think about how competitive the process can be. It would be prudent and downright smart to try to get your proposal in the door before others.

It is called an "early read," and if you can get your proposal to the funder a week to three weeks ahead of the deadline, you may improve your chances of having someone read it early and with less pressure as the mountain stack of proposals has not yet piled up. Of course, not all funders have a system that processes applications as they come in, but many do, so try this tip and see if it doesn't help you out in the long run.

At the very least, by getting your proposal in early you avoid making mistakes that are caused by hurrying and undue stress when approaching deadlines.

Postcards and Follow-up

Some funders require that you send a self-addressed postcard, which they mail to you once your application has been received and it is in process. This will be part of the package you send, so keep your eye out for these special instructions.

❧ THE GRANTS ZONE

Presentation skills *are* an important aspect of grantwriting, so avoid being sloppy.

Take great care in preparing the final version of your application, and avoid making unnecessary mistakes by doing an eleventh-hour application.

⊱ BOARD PET PEEVES

Applicants who don't follow directions.

Rather than meeting the stated deadline, applicants who plead for an extension.

Stapled proposals.

Applicants who waste their money by sending proposals via FedEx overnight service.

CHAPTER ELEVEN

Interpretation of Decisions

Courage doesn't always roar. Sometimes, courage is the quiet voice at the end of the day that says, "I will try again."

—MARY ANN RADMACHER

Understanding the decision-making process for funding sources is yet another waystation on our quest for grants. This chapter delves into the factors that determine your success or failure, and will help you understand the board or peer decision.

We will review the various programs in grantmaking for artists— that is, fellowships, organization, and project grants, within the context of the decision to approve or decline support. I will present standard practices from the perspective of private and public funders for handling the grant agreement and what the expectations are for you as the grantee.

In developing the information for this chapter, I draw upon my previous experience as a program officer, and upon the experience of peers and colleagues in the world of philanthropy. Some of this will be anecdotal as well as experiential, but in all, it will help you understand the business of making grants. Even though it is charitable giving and philanthropy, there is a professional and business side to this, which you will come to understand. This will help soften the blow if or when your project is not funded.

In the preceding chapters, I described various pet peeves, which give you some indication of those flash points that can make or break your application. Let's look very specifically at some typical

scenarios in how private foundations make their decisions. Again, we can't generalize, but these practices hold true for some funders.

☞ THE PROCESS FOR GRANTS BEFORE THE BOARD MEETING

The behind-closed-doors status of board of director or trustee meetings evokes great mystery and curiosity among grantseekers. Given the sometimes intense process of applying for a grant, many of you want to understand just what happens after the proposal leaves your hands. Where does my application go? Who reads it? How does the foundation make its final decision? In spite of many variables, there are some common practices among today's private funders that we can study. Let's review the process for organizational and project grants, then look at the process for fellowships.

Before a board convenes, much preparation occurs. Typically, a grant round is closed upon the deadline and all of the requests that have come in for that period are reviewed. Foundations generally publicize the estimated time for a board meeting, but understand that these can change from what is stated in their guidelines. It can be quite difficult to get everyone in the boardroom at the same time, so you may not know when the board meeting is held. On the other hand, many funders send postcards or notes telling you exactly when the meeting will occur. It can be up to six months between that notice and the board meeting, especially if the foundation meets only twice a year, so understand that it takes time.

Time for what, you may ask? Processing and reviewing hundreds of proposals is a daunting task. After a grant deadline passes and the mountain of proposals is left at the door at the close of business, a staff member usually enters the information into a database. This is also done in an ongoing way, as applications are collected and a record of them is created. This process can take up to a week or more, given the number of requests.

Group Review, Reading, and First Cuts

Once all requests are received and entered, the reviewing process has variability, but here is one scenario. For the preliminary review of a grant application, there is usually a staff of people who review the

docket, read, and investigate all the requests and prepare recommendations for the board of directors. This usually means that all applications are photocopied, and in the most judicious way all the staff read all proposals. Sometimes, when this is not feasible, the proposals are assigned to various staff members who then make first-cut decisions at a preliminary stage of the review.

Each staff member makes a preliminary determination as to whether or not the application meets the most basic eligibility criteria. This first cut is done in as quick a fashion as possible, and a large grant docket is culled down to a smaller size whereby each person is assigned a packet of the most competitive applications to review further.

The Site Visit

After reading, reviewing, and making the first cut, they begin the arduous task of investigation and discovery. The discovery process in grant review often comes in the form of the application review and a site or studio visit. We touched upon this somewhat in chapter 5, where I explained that some grant review processes involve meetings to view an artist's work in his studio. We haven't talked about the site visit in the context of an organizational grant request, and it is a bit different.

The site visit is a short meeting in which the funder asks all the necessary questions to understand the need for the grant. It is usually done with a program officer or foundation staff person, but that is not always the case. I know of foundations whose board members are actively involved in grant review, and their members do the investigation and necessary fact-finding.

In the end, it really doesn't matter who is coming for the visit. Just know that the interaction can range from chatting about an issue over a cup of coffee to going through a set of questions that provide deeper understanding about your application.

It's Only a Site Visit

Site visits are a tricky part of the business of philanthropy, because they sometimes send the wrong message to the applicant. Organizations know that the process is competitive, and they assume if they are getting a site visit they must be getting the grant. This is unfortunately not

always the case, and it can be disappointing and confusing when the decline letter arrives.

Site visits do serve an important purpose to funders, even though they may seem like a show-and-tell. In my experience, I met many consumers, board members, and staff members of organizations, and sometimes I felt overwhelmed when the visit was superficial or obviously orchestrated by the organization's leadership. The best site visits are with people who are passionate about the project and who can answer specific questions about the program, its budgets, and the organization's ability to implement the project.

The following excerpt from the Minnesota Council of Foundations provides great advice and tips to guide you in saying and doing "the right thing" in your site visit.

FROM THE GIVING FORUM

Representatives from Minnesota's philanthropic community agree: Site visits provide funders with a feel and understanding of an agency or programs that rarely come across completely in a written grant proposal. "There's only so much you can glean from an organization on paper," says Louis Hohlfeld, program officer for the McKnight Foundation in Minneapolis. "You have to get a sense of how the organization is run, who the people are, what the facility looks like."

And contrary to the beliefs of some program directors, site visits aren't just a white-glove inspection, says Donna Sherlock, executive director of the Minnesota Women's Foundation. "You can have a great program run by a mediocre grantwriter, or a mediocre program and a fabulous grantwriter," she explains. "Sometimes the passion of the individuals involved, their vision, their connections with people, don't come through in the written proposal. If you, as a funder, don't make the visit, you might miss a great funding opportunity."

But since, for many nonprofit organizations, a site visit is little more than a means to money, it's easy to see why some agencies feel under the microscope when the foundation representative comes calling. "One misconception is that we're 'suits,' " says Ron McKinley, manager of charitable contributions for the Saint Paul Companies, "that we're going to be critical and prescriptive,

that this is an evaluation and we're trying to find the dirt." But many foundation and charitable-giving program employees have spent a considerable portion of their careers on the other side of the table—founding, managing, or working for nonprofit agencies. "Foundation folks are looking to make good grants," Hohlfeld says. "We're not looking to withhold funds."

RULES OF THUMB

Site visits are a single but critical step in most agencies' attempts to secure funding and implement programming. As with every step in that process—from grantwriting to hiring employees—preparation and planning are key to improving an agency's chances for success in obtaining a grant. Most funders say there's nothing in particular a nonprofit can do to guarantee that a site visit results in funding; the people doing the site visit often only make recommendations about particular programs, while others decide who ultimately receives funding. But grantmaking employees interviewed for this article offered several rules of thumb for agencies readying for a site visit.

1. **Get the details straight.**
 Every site visit begins with a phone call. After a funder has reviewed a proposal and decided to make a site visit, a representative generally contacts the applicant agency's executive director to schedule a visit. Be flexible about the appointment—funders often must complete several site visits within a brief time frame—but choose a time that also suits your calendar. Be sure to ask whether there is any further information you should gather before the funder arrives. Does he have specific questions about the proposal or your agency? How long will the visit last, and who would the funder like to meet—program staff, board members, clients? And how many funding representatives will be coming?
 Take time to get plenty of information in advance—it will make the site visit more worthwhile for both you and the funder. Also, don't forget to give careful directions on finding your agency: "The biggest challenge for me about site visits is how to get there!" Hohlfeld adds jokingly. "I get lost about 50 percent of the time."

2. **Prepare, prepare, prepare.**

 If a funder indicates ahead of time that it's interested in a particular aspect of your program or agency, you should become an expert on that subject. Or, if another staff member can speak more eloquently and informatively regarding the matter, ask him to put together a brief report or sit in on a portion of your meeting. Be prepared to answer both general and detailed questions about the particular program, including additional funding prospects, the scope of services, staffing needs and capacity, and community demand.

 Executive directors should also be prepared to discuss their financial statements. These reports serve as a litmus test of an organization's capacity to carry out its aims. Executive directors who are not trained accountants would be wise to spend some time with their chief financial officer before meeting with the funder. In fact, it may be wise to have the "numbers guru" on call during the meeting.

 Likewise, be sure to review the annual report of the philanthropic agency you're meeting with, or visit its Web site if one exists. You'll likely uncover some additional information about the foundation's funding strategies and priorities.

3. **Talk and listen carefully during the site visit.**

 "Site visits are where the real connections happen," says Karen Starr, senior program officer for the Otto Bremer Foundation. After putting everyone at ease, Starr likes to cultivate an atmosphere for discussion during site visits in which everyone contributes equally and feels free to suggest alternative answers to the problem at hand. "Site visits are about creating a relationship of partners, and it's very hard to have such a relationship if the foundation and the grantee aren't speaking the same language," Starr says. "Clear communication requires face-to-face contact."

 The St. Paul Companies' McKinley keeps his site visits short (an hour to an hour and a half, at the longest), so naturally he's intent on drawing out the enthusiasm of the program's planners. "The biggest thing for me is to give people twenty-five to forty minutes upfront to talk about their organization and programs," McKinley says. "And usually, if there are gaps in my understanding of the program, the opportunity will come up during that time to ask my questions."

Occasionally, you may have the perception that the funder hasn't read your proposal thoroughly. Or that in his scramble to pack a dozen site visits into just a few days, he's gotten some details mixed up in his questions. Don't be afraid to step in and offer an overview of the program, Sherlock says. A sketch or synopsis proffered in a polite tone is often welcome. "I think it's perfectly fine to say, 'I know you read hundreds of proposals, so let me just give you a quick overview of what we're doing and why it's important,'" she says.

4. **Skip the show.**

It may be tempting to try to dazzle funders with entertainment, presentations, and firsthand testimonials indicating how your program has impacted clients' lives in immeasurable ways. Don't succumb. "I usually try to discourage the dog-and-pony show. If there is some aspect of the program I want to see, I'll tell them about it," Sherlock says. "If I come out and someone's got a prearranged performance, it might be entertaining and interesting, but I'm not going to get my questions answered."

Other funders may prefer to mingle with clients. McKinley, for example, recently visited Baltimore to conduct site visits for the St. Paul Companies' newly expanded philanthropic forays in the area. While visiting the Maryland Historical Society, McKinley had a chance to slip into the back of an exhibit room where young public school children were learning about the role African Americans had played in developing the port and city of Baltimore. "I spent three minutes watching the teacher and kids," McKinley says. "It was a completely interactive classroom—hands were up, and the kids were asking questions left and right. You could feel the energy. It was different from a lot of other history programs I've seen."

Take it from the seasoned experts; such moments can't be staged. If your program doesn't spark such interaction, don't try to fabricate it. And if the tug-at-your-heartstrings approach doesn't work, neither does the hard-driving sale. Hohlfeld describes his worst site visit experiences as "a pre-engineered series of presentations by different staff members that are best characterized as hard sell. They tell me little more than what I learned in the proposal."

5. **Be honest.**

 Whether it's the particulars of your proposal or your staffing or financial situation, be upfront about the challenges your agency faces. Experienced funders can tell when you're skirting an issue, even if they don't know why. If you're honest with them, they're more likely to empathize with your situation or suggest solutions than to blackball your program.

 Your agency's needs may be broader than the specific proposal you've put forth, and it may be helpful for the funder to know that, says Sherlock. An agency may have financial troubles or need board training. "I try to open up the doors," Sherlock says. "I try to let them know everything doesn't have to be perfect. As a funder, you need to let applicants know that you understand the realities of small community agencies. We understand that you can't take care of everything at once."

 If an agency does have hidden problems, Hohlfeld says, they usually come to light in his conversations with community members outside the organization. He encourages agencies to talk openly about their challenges—financial or otherwise. "Usually we can help," he says.

6. **Always follow up.**

 Take a moment at the end of every site visit to make a checklist of any issues the funder asked you to follow up on. Were there reports you should fax or send? Perhaps just a dollar figure that you'd forgotten to factor into the budget? If a funder requests such items, double-check the timeline: Does he need those figures in two days or two weeks? And in a formal report or simply over the phone?

 Don't overdo it. Generating extra paper may not have the type of positive impact you want. "I remember a final report that was a one-inch, three-ring binder full of articles and newspaper clippings," McKinley says. "To be honest, I'm not able to give that much material the attention it deserves. It's better to be brief and highlight successes."

 And even though you should follow up with any additional information requests, give funders time to process your information. Non-emergency phone calls and letters may not necessarily be answered the same week after the visit. "During a grant cycle, it may not be possible for me to return calls as quickly as I would like," McKinley explains. "I try to

return all calls within three days. But because the volume of work can be consuming, I ask applicants to be as patient as possible so that no one is pressuring the other."

7. **Ask about your chances.**
 It's only natural to want to know what a funder is thinking as the site visit wraps up, so go ahead and ask, the experts say. Although the final decisions regarding funding are rarely left to the foundation representative alone ("The grant decisions are not in the hands of the staff," says Otto Bremer's Starr. "We operate under the assumption that a site visit doesn't mean they will get funding"), he is likely to give you a sense of what your chances are. "I don't mind someone asking for feedback," says Sherlock. "Ask for suggestions. Ask about your chances. I'll give honest answers."

 In fact, even if you don't receive funding from that particular donor, you may get a better sense of why not if you inquire as the site visit concludes. "I can't tell an agency that it's guaranteed to get funding, but I will let people know if I see a red flag," says Hohlfeld.

8. **Relax; Show your enthusiasm.**
 Starr claims that the worst site visit she endured was a scripted show-and-tell. After being herded into a room and given no introductions, Starr and her fellow funders found themselves listening to letters of recommendation being read aloud. "There was no interaction. Literally, the person in charge of the program read from a script," Starr says. "Clearly, that was not a way to begin a relationship."

 Being alert is important, of course. But anxiety and nervousness get in the way of a good dialogue. "The more nervous people get, the less rapport happens," says Hohlfeld. "If people are more laid back, the connection between us is better. Most program officers are honestly there to find out about your program. Not to offer you instructions."

 Most site visits aren't really even about the actual physical site. Instead, they are about cultivating a relationship, a bond between funders and nonprofit agencies. And in the best of these relationships, there are long-term benefits and a long-term commitment. "A site visit gives us an opportunity to create a relationship with grantees," says Sherlock. "And if we look at a grant as not the end of a relationship but as the beginning of a relationship, in which we're going to grow and

learn and make changes for the greater good, then it's a vital part of the grantmaking process."

The fruit of that relationship, says Hohlfeld, is progress toward a common goal. "Enter into dialogue with your investor," he advises. "You're both interested in helping the community. That's the bottom line—to help people in the community. And as the funder and the service provider, you each have different roles in that help. We're all in the same basic business."

Site Visits and Technical Assistance from Foundations

Technical assistance is the in-kind aid you receive from a program officer, director, or staff member of a foundation. Oftentimes, this is provided during a site visit. Like the availability of monies for grants, technical assistance provided by a funder has its ebb and flow. When staff and resources are plenty, you see formalized technical assistance forums hosted by funders that help organizations understand various aspects of nonprofit development and management. These come in the way of workshops and small meetings sometimes held at the funder's location.

The trend in philanthropy is to provide more technical assistance, and much of this is done through the informal exchange that occurs during site visits, grant review, and relationship building.

When I was a director and program officer, I didn't write, rewrite, or draft narratives and financial information for applicants, as that would have been inappropriate. But oftentimes, there would be a great program and the organization and its representative just didn't have the skills to present it well and in a captivating way. Much coaching and teaching was provided to help them understand how best to pre-sent themselves to funders. Some foundations pride themselves on offering this kind of support, whereas others simply do not have the time. It's important to note that the site visits may end up being a coaching session, so be prepared to learn something new.

After the Site Visit

After the site visit, the program officer or foundation staff person is very busy. Again, there are many variables but most foundation boards of directors rely upon written memos, briefs, or abstracts that can be reviewed by a board member prior to a board meeting. In my tenure at two different foundations, "board books" were created with five-page memos written for every recommendation that was being

made by staff. The book also included the meeting agenda, financial information for the quarter, and other pertinent business that needed decision-making or discussion by board members.

The Program Officer Is Your Advocate

Once a determination is made to forward a request to the board, the program officer becomes an advocate for you and your request. So help him and be patient when the inevitable happens and you are asked for more information.

Sometimes I had more than thirty of these memos to write up, and this was after culling down from a hundred or more requests. And for you grantwriters out there, if you think proposals are tricky to write with various requirements, these memos were no bed of roses, as they say. During a five-year period, the template and process for presenting these memos changed many times. They had to be perfect, and you couldn't make a case for supporting a project or individual without good, solid, substantiated fact, rationale, and information.

The memos from this particular foundation also included specific information on the financial position of the organization being reviewed. This is a variable with foundations, some of whom highlight this in their review. It was always a challenge for a small organization to grasp the critical need to get this part right. This was something the foundation excelled in, and we became the "resident coach" on financial statements, although our applicants probably thought it was all a pain in the neck. At least, I know there are many grantseekers like myself who can now read audits and financial statements with a degree of expertise that is somewhat uncommon, but which really gets at the health of an organization.

And whatever your notion is about program officers and foundation staff, they really are your advocates. If they are recommending that your project have grant support, they will do their professional best to speak on your behalf, translating the language and jargon of an artist or organization into a foundation's own set of jargon and language.

❧ THE BOARD OF DIRECTORS MEETING

All right! The board book has been delivered and reviewed. The big day has arrived, and in the offices of foundations these days are particularly heightened as staff are on their toes. They know too well

that they may need to discuss, rationalize, deliberate, and, yes, convince board members and trustees that the recommendations to fund a program or not are sound and valid.

Board meetings can be stressful for the program officer, staff, and director of a foundation. It is a time to inform and educate board members, some of whom are very busy and quite honestly may come to the meeting ill-prepared, not having read a word of what has been developed in the memos. It is also the time when the mission of the foundation evolves, is tested, and validated.

Translation and Adaptations

The foundation board meeting may have three to thirty people sitting at a table listening and discussing how the memos and recommendations in front of them translate into the mission under which the foundation lives. This isn't always conscious, but good board members analyze each of the applications with the mission and focus of the foundation somewhere in their minds.

As staff members interpret the foundation's interest and mission through the work of grant review, the mission may evolve and adapt in response to community needs. The real work of a foundation as mentioned in chapter 1 is to live its mission but not in a vacuum, and so each board meeting is an unconscious test to the foundation as to the relevance of the mission to the community. As staff and board members translate vision and mission into action via grants, there is bound to be great discussion, adaptation, and sometimes conflict.

Even though the memos are written and compiled in such a way as to evaluate each recommendation, the burden is often on the staff to orally present and deliberate about the grant docket in front of them. Meetings can take the better part of a day because so much business is packed into periodic meetings.

The Decline, Approval, and Tabled Decision

Board meetings certainly have their share of drama and intrigue, but at the end of it all, decisions are made. Since meetings deal with the official business of the foundation, all of what occurs is recorded in meeting minutes. Board meetings are usually structured in a participatory way, with most groups using Robert's Rules of Order. That said, there is a wide spectrum in how these rules are implemented, from

some semblance of motions and votes to the strict following of every rule. At the very basic level, the chairperson of the board will invite a motion to be stated on a grant request or slate of requests; once that is done and a second board member concurs, discussion proceeds, with the pros and cons of the request presented.

Finally, after what seems like an eternity (if you are a staff member) the chair asks whether everyone is prepared to vote. At this time, people who are recusing themselves due to conflicts of interest will step out of the room and abstain from voting. The results look like some of the following:

A request is declined officially at the board meeting when all requests are presented. As mentioned earlier, many of these will have been deemed less competitive by staff in a first cut, but it is the board that actually authorizes the "declined" requests with an official vote. Oftentimes, the board book lists the organizations to be declined, with dollar amounts and the specific request for the grant. There may be a code or rationale given that summarizes why these requests are less competitive. Board members will often accept the slate without further discussion, but sometimes there are situations where they know the work of an organization and do not understand why staff members think it is less competitive and deserves a decline. In these instances, discussion ensues, with the board affirming the decision or in some cases asking that it be resurrected and further investigation or explanation given for the rationale to decline.

Those requests that have been deemed more competitive have progressed to a staff recommendation to approve a grant. However, the staff's suggestion that the organization should be supported may still result in a decline. Remember, the board has the final say, and despite staff's belief in the merit of a request, the board may not agree and some of these will be declined.

There are many reasons why board members decline requests for grants. Here are a few that provide greater understanding about the ever-mysterious process.

Fit

The request does not fit within the parameters of the basic interests and mission of the foundation. In the scenario described above where preliminary decisions are made about grant requests, an organization usually misses the first cut because of a poor fit.

No matter how much coaching and no matter how clear the guide-lines are for submitting a request to a foundation, many applicants have not done their homework and the request is simply inappropriate. It is oftentimes clearly beyond the purview of the foundation, but because grantseekers don't really understand this they think it's worth a try. For example, many foundations do not provide grants for capital projects. The foundations I worked with had this restriction, and despite this there were always 10–25 percent of the requests pending for capital grants. Other instances like this are common, where a foundation has a pretty definite limitation and it is still disregarded. Unfortunately for the applicant, these requests are the "easy declines" and quite honestly the request may not even be read.

Organizational Capacity

This rationale for decline says that the applicant has merit but is questionable as to the ability to really carry out the stated goals. Perhaps it looks good on paper, but through the discovery phase the applicant has shown a lack of ability. Too often, there is not a sound plan to sustain the project and organization, and it is then a very diffi-cult decision to make. A lack of ability is also demonstrated in weak or flawed leadership, where the board of directors of an organization is not committed and involved, or the executive director is unreliable. It may be as simple as the fact that the director will be leaving for a new position elsewhere, and funders get nervous when there is transition and seeming instability in leadership.

Financial Instability

The review process for many foundations involves a look at the audited statement, and/or financial statement of the organization. If an audit is "qualified," which means basically something has to be corrected in the way the organization accounts for its monies, a foundation may not feel the greatest confidence with this applicant.

When foundation staff members look at trend budgets, much can be seen about the financial stability of an organization. I can't tell you how often these budgets would show downward trends—but that, in itself, was not the issue. The red flag went up because staff members were unaware or unable to discuss potential strategies to correct the course of the trend.

Timing

A large percentage of requests for grants are declined due to the timing of the project, the need for fundraising, and the ability of the foundation to respond. For instance, in the examples we used in our role play in chapter 9, we needed grant support for a summer program. That is great, but if the board meeting and grant decision don't come until well after the timing of the program, there is a missed opportunity and the funder will invest somewhere else.

Limited Resources of the Foundation

A large number of requests that are declined usually fall in this category. As explained in chapter 1, foundations have an ebb and flow of resources, which are tied to the health, and stability of the economy. Sometimes, they have budget constraints and the requests they receive are well beyond what can be granted. If your request has merit and the average size of a grant from the foundation is $20,000 but your project budget is well beyond this, a foundation may think that even if you leverage other grants, you will be hard-pressed to raise all of what is needed or to have a sustainable program.

Risk

Simply stated, your request has merit, but the projected outcome, methodology, or need may seem too risky for the foundation to undertake.

The Successful Grant Application

After reading the various ways that requests are declined, I think we are ready for the bright side of philanthropy. At the very least, understanding the decline process should de-personalize it. In fact, the very word "decline" (as in demur or refuse) establishes that this request is not "rejected."

We have spent nearly an entire book talking about how to develop winning grant proposals. In the final hour when the board is deliberating on the merit of your request, the following key items help win the grant approval.

The Interests and Priorities Match

The request is a natural fit with what the foundation funds, and the common sense of that speaks volumes for the merit of the proposal.

Clarity

The request, and all the particulars related to need, goals, objectives, and outcomes are clear and straightforward. Budgets are understandable and aren't encumbered in any way.

Organization's Capacity to Carry Out the Project

Through its leadership, board representation, its relevance to the community, and its program capacity, there are no challenges or insecurities about the organization's ability to follow through.

Foundation Staff Presentation

Yes, fortunately or unfortunately, this does help. Basically, when questions arise at the board meeting about the merit of a project, the staff's ability to answer these questions will help a request stay afloat. Some of you are thinking, well, you don't have a chance if some of it depends on the staff, but the truth is that the staff members are only as strong as you make them. During the discovery phase, when they ask you for more information, your ability to provide it will help educate and inform them in such a way that they will be well-prepared for any and all questions.

Remember, a lot goes into this work and in this scenario, staff advocate strongly for all of the requests that they are recommending. There were many occasions in which I recommended grant support, and the case was less strong because additional clarification never arrived. When staff members ask for more information, you have to feed it to them quickly. Being lax and not following up weakens the request, and it may even get you disqualified.

The Tabled Decision

If I haven't already alluded to the idea that board meetings are tough, then I am stating it now. Sometimes, a decision to approve a grant

cannot be made until some other finding comes through. It doesn't happen a lot, but sometimes a board will "table" a decision, which puts it on the back burner. This is done to give staff a chance to request a missing piece of information or for some timing issue to be resolved.

Tabling is a motivating and positive tool used by a foundation for the benefit of the applicant, rather than a punishment. A tabling decision is not punitive and is not an indicator of ultimate success or failure in the final review process. A tabling decision provides the impetus to immediately address weaknesses and can, where needed, provide the leverage to secure resources and support for the applicant to implement changes.

Sometimes the process to defer a grant is used in a similar way, although this usually has less to do with a missing piece of information. The point in all of this is that sometimes a board decision is not clear and an organization will need to follow up. Foundations communicate this well through follow-up letters and phone calls, so no need to worry about it, as they will tell you exactly what they need to process the request.

The Challenge Grant

In the context of decision-making, I want to explain what a challenge grant does. An organization applies for a grant in straightforward fashion. Typically, the project budget or fundraising goal is ambitious for this organization and it lacks a track record in raising the necessary dollars. The project has merit, and the foundation wants to help and it does so in making the grant a challenge grant.

This is stipulated in such a way that says, we will grant you, say, $50,000 if you raise an additional amount of money. It could be determined that you must successfully raise half of what is needed, or in some cases that you should have the balance of what is needed. It is somewhat conditional in that the funder is saying it will give you the monies if you raise other monies. The language is more positive, though, and helps a fledgling organization by saying that the foundation believes in the project but doesn't want to be the only donor involved.

I was on the receiving end of a challenge grant early in my career, and I used to get very upset, thinking it showed a lack of confidence by the funder. Now, I understand it is a matter of a foundation wanting to hold its dollars while you do your great work. It will usually have

greater return and success leaving its monies in its coffers and waiting to hear news that you have met the fundraising goal. It's not a bad strategy, and it usually is an encouragement and leverage to other funders to join in.

⌖ LETTERS, GRANT AGREEMENTS, AND PAPERWORK

Well, the decisions have been made, and in most cases you will receive a letter of determination that tells you of the decline, approval, or tabled decision. These letters are pretty standard and as a grantseeker, I never liked the sterility of them.

As a grantmaker, I tried to avoid this rather cold approach, and instead of sending out a form letter, I tried to personalize the letter. But it was very difficult to do, as the volume of paperwork was overwhelming. I ended up with a compromise: a form letter with a handwritten postscript, which I hoped would soften the blow for the declined decisions. Sometimes, when a great amount of work had been done, I would call the applicant and tell him over the phone that his request was declined and the reasons why. This was a form of technical assistance in my mind, and I hoped the direct feedback would help him improve his next attempt. This personalized approach is not the standard approach because it is simply too difficult to keep up, and so what I have explained here is the exception to the rule.

Grant Agreements

An approval letter and a grant agreement are sent out to those applicants who have received favorable decisions. These two pieces of information are not always sent together. Oftentimes, a letter comes first, with the determination stating the decision and the grant agreement later.

And as I have said all along, there are a lot of variables and so don't be surprised if you receive a letter and a check at the same time, with some instructions about where and what to sign and send back. We would all like the quick response, but note that after the paperwork is finalized sometimes the grant is paid out in quarterly distributions.

The Components of the Grant Agreement

The grant agreement's components are fairly straightforward with some variation of terms about publicity of the grant and reporting. Aside from these two areas, grant agreements are somewhat standard and include the grantee agreeing to terms that address tax-exempt status, prohibitions of the grant's use, the auditing and accounting of the grant, and noncompliance.

The following sample of a grant agreement from the Dyson Foundation will give you an idea of an agreement used for an organization.

Date of Agreement: _____

Name of Grantee: _____

Purpose of Grant: _____

Amount of Grant: _____

Award Date: _____

Grant Period: _____

Payment Schedule: _____

This grant is awarded by the Foundation subject to the following terms and conditions:

A. Grantee confirms that it is an organization that is currently recognized by the Internal Revenue Service (the "IRS") as a public charity under sections 501(c)(3) and 509(A)(l), (2), or (3) of the Internal Revenue Code (the "Code"), and Grantee will inform the Foundation immediately of any change in, or IRS proposed or actual revocation (whether or not appealed) of its tax status described above.

B. This grant may be used only for Grantee's charitable and educational activities. While the Foundation understands that the Grantee may participate in the public policy process, consistent with its tax-exempt status, Grantee may not use any Foundation grant funds to lobby or otherwise attempt to influence legislation, to influence the outcome of any public election, or to carry on any voter registration drive. This grant must be used for the project identified above, as described in Grantee's proposal and related correspondence, and may not be expended for any

other purposes without the Foundation's prior written approval. Grantee accepts responsibility for complying with this agreement's terms and conditions and will exercise full control over the grant and the expenditure of grant funds. The Foundation may request that Grantee return any unexpended grant funds remaining at the end of the project period.

C. Grantee will provide to the Foundation an Annual Report and Audited Financial Statements at the end of Grantee's current fiscal year.

D. Grantee will provide promptly such additional information, reports, and documents as the Foundation may request and will allow the Foundation and its representatives to have reasonable access during regular business hours to files, records, accounts, or personnel that are associated with this grant, for the purpose of making such financial reviews, verifications, or program evaluations as may be deemed necessary by the Foundation.

E. Grantee will allow the Foundation to review and approve the text of any proposed publicity concerning this grant prior to its release.

F. The Foundation reserves the right to discontinue, modify or withhold any payments to be made under this grant award or to require a total or partial refund of any grant funds, if, in the Foundation's sole discretion, such action is necessary: (1) because Grantee has not fully complied with the terms and conditions of this grant; (2) to protect the purpose and objectives of the grant or any other charitable activities of the Foundation; or (3) to comply with any law or regulation applicable to the Grantee, to the Foundation, or this grant.

Grantee's deposit, negotiation, or endorsement of the enclosed check will constitute its agreement to the terms and conditions set forth above. However, for the Foundation's files, please have the enclosed copy of this agreement reviewed and signed where indicated by an authorized officer of Grantee and then returned to us within three weeks of receipt of this agreement. Grantee may wish to have this agreement reviewed by legal counsel.

On behalf of Grantee, I understand and agree to the foregoing terms and conditions of the Foundation's grant, and hereby certify my authority to execute this agreement on Grantee's behalf.

๔ How to Respond to the Board's Approval Decision

I must write about how to respond to a board decision, especially when it is an approval. It seems like a logical thing, where you would use common sense and respond appropriately. Unfortunately, in my experience on both sides this is not always practiced. With approvals, checks, and grant support, it seems that organizations and individuals will sometimes forget to respond at all. Here are some quick guidelines and tips:

Jump Up and Down First

Yes! It's totally appropriate to celebrate the news the moment you get the grant. I am always reminded of a grassroots organization that I worked with, which wasn't used to getting grants, so when we did it was like a reenactment of a scene from *It's a Wonderful Life* where Jimmy Stewart dances around the $2 that they have at the end of a financially stressful day.

It sometimes feels like that with arts organizations, so go ahead and celebrate your success. In another instance with the same group, a funder called to give me the great news and I had to be careful not to yell or scream directly into his ear, although I did show my enthusiasm. When a program officer calls, it is like he is playing Santa Claus and wants to celebrate with you, so go ahead and jump up and down!

Follow Through with the Paperwork

It should go without saying, but get that paperwork and grant agreement processed. If board signatures, copies of your tax letters, or whatever are needed, follow through and send these items out with the original and as many copies as are requested.

Send a Formal Thank-You

Sending a signed grant agreement is not the same as a thank-you. So don't be shy on this one; send a formal thank-you to the funder or program staff member who worked with you. In a similar fashion, a quick phone call thanking them directly is a nice gesture. Even if the staff person is very busy, you can leave a message on voicemail, as this will be appreciated. Don't gush, blush, or babble—just say thank you.

One final word on thank-yous: In my time in grantmaking, I can't count the number of persistent people wanting desperately to meet and talk on the phone to "pitch" their projects. Yet I can count on one hand the number of times someone actually called with a thank-you. It isn't necessary by any means, but it is an interesting observation on where our energies get spent.

Follow Through with the Reports

This is an area of grantseeking that needs a lot of attention. Reporting on the progress of the project or its actual outcome is vitally important. Foundations rely on this information to determine the efficacy of their grantmaking.

We discussed evaluation methods and reporting in chapter 9, but I must underscore the importance of this area of the grant agreement. Some foundations use a reporting form that is part of the paperwork you will have in processing the grant. Of course, you will follow through and immediately send the signed agreement back to the funder, and then you will file away the reporting form and remember it—right?

Tickler Files and Reporting

Remembering to send in the grant report isn't always easy. Using a ticker file, reminders, and schedules will help you avoid an embarrassing or limiting situation. Some funders will not consider or review another request for support until all reporting requirements are met. You don't want to send in a new request and receive a letter or phone call telling you that the foundation is waiting for your report.

Try to embrace reporting, and I say "embrace" because my experience shows that many grantees dislike this area of grantseeking, and have to be reminded and even nagged for some accounting and reporting of how the grant monies were spent.

↜ HOW TO RESPOND TO THE BOARD'S DECLINE DECISION

We have discussed how we celebrate and say thank you, and now we need to discuss the protocol for handling a decline to support a project. This situation will arise often enough for you to have a routine way of handling it.

As mentioned earlier, a letter will usually come with the determination, which may surprise and, of course, disappoint you. Perhaps you spent a lot of time with the foundation staff person, and you interpreted this interest as a positive sign. Perhaps you even received a site visit and thought certainly *this* was a positive sign.

Graceful Learning

Even though you may be disappointed to receive a formal decline, you must proceed with grace and remember that this is a great learning process and opportunity. As a grantseeker, I always try to follow up with a call to the foundation staff person or representative and ask for feedback about the proposal. These can be tough calls to make, and you must remain calm and never arrogant or obtuse since that would be inappropriate. As a grantmaker, I have had people actually yell at me, letting off steam, of course, but it is not very professional. Some people take it all personally, and so these calls are tough to take if you are the grantmaker.

Foggy Feedback

We have covered some of the reasons and justification for why and how a grant is declined, yet it isn't always that clear and candidly, some funders aren't good at giving specific feedback. Many give reasons in "foundation speak," which isn't helpful.

You, as the grantseeker extraordinaire, can help by asking the right questions. Here are a few examples:

* Can you tell me the reason(s) why the request was declined?
* Are there particular areas that I could improve in the program development and concepts of the request?
* Are there specific areas where the writing and presentation could be strengthened?
* Does the program have merit as it is, and if so would it be prudent to reapply?

The $64,000 Question

I will repeat it for you here: Does the program have merit as it is, and if so would it be prudent to reapply? Many funders dread this question because it causes a bit of a dilemma. Let's say a proposal has merit,

meaning it fits within their guidelines, yet they are still unable to know what other requests will come in during the next grant cycle and how your request will compete, so it is difficult to say whether or not you should reapply. Remember that in most cases, the board of directors finalizes decisions and the staff person representing the foundation can't really speak authoritatively about how the board will vote next time. The dilemma arises in providing some guidance. Even though you can't predict the future, the funder knows it is somewhat unfair to keep a grantseeker hanging on false hopes.

In the case of the grantseeker who really should not reapply, my approach to this when I was a grantmaker was direct but open-ended. Typically, I would say that his proposal "was not as competitive as others and specifically the concept or program idea had less merit than others." Unless that changed, he would have difficulty in getting a favorable review in any future grant round. This pretty much helped avoid the false-hope-to-reapply syndrome and was respectful of the process.

❧ THE DECISION-MAKING PROCESS FOR PRIVATE FUNDERS AND THE FELLOWSHIP GRANT

We discussed the fellowship grant to a great degree in the previous chapters, but let's focus on a typical scenario for decision-making. Unlike grant review for organizations, fellowship and individual grants have a process of discovery, investigation, and analysis that may take longer, and thus they are usually made in an annual, rather than quarterly or biannual, cycle.

As mentioned in chapter 5, there are two sets of reviewers or "judges," one being done in a preliminary review with staff and experts and the final done with another set of judges. The decisions are often made as a cohort group and advanced by recommendation at a formal board meeting where they are officially voted on, much like organizational grants.

Decline and Approval for Fellowships

Notice of these decisions comes in a number of ways, ranging from an e-mail, followed up with a formal letter, to the formal letter preceding a grant agreement and even a phone call, especially when approval is being conveyed.

Responding to an approval for a fellowship has a similar protocol to that for organizational grants. Following through with a thank-you and the signed paperwork is really all you need to do for an approval. One big difference in these grants is that sometimes the awardee, fellow, or grantee will be asked to be involved in some public forum hosted by the foundation, and, like reporting, this is an important condition of the grant.

Responding to a decline in fellowship and individual grants is similar in that you remain graceful, calm, and try to understand the nature of the decline. The process is different, however, in determining what went wrong and how to correct it. Individual grant requests for a travel and study grant or extended learning fellowship may be time-sensitive, and so the question of whether or not to reapply may be moot. If that is not the case, follow-up is a good idea, and asking how you could improve your request and reapply may trigger further discussion from the staff person.

For individual grant review, do not approach judges, panelists, or peers who have been in the process, as this is usually inappropriate and may disqualify you from applying in the next round.

THE DECISION-MAKING PROCESS FOR PUBLIC FUNDERS

The decision-making process for a public funding agency is quite different from that of the private foundation in that the decisions are usually made in a peer review. Some public entities will have boards that officiate a decision, but generally grants are decided by strict criteria used through peer analysis.

Public Hearings

In the public arena, like a state arts board or arts council, board meetings and final review are sometimes held in community meetings that permit the general public to observe the proceedings. In most cases, the applicant is only allowed to observe and will not be allowed to speak, but these are great opportunities for learning about the process.

In Minnesota, I had the opportunity to be a reviewer in a number of grant rounds, and on a few occasions I was an applicant, as well. In

both situations, I found this arena and the people who staff and coordinate it to be highly professional and straightforward.

The process for arts grants in this capacity is similar to a private foundation where there is an application review, and so on. The final grant review and public hearing were very different in that each panelist had the responsibility to begin the discussion about a particular applicant. Each panelist rotated being the "first reader" and usually read from a board book that held all the comments, notes, and qualifications for the applicant. Comments were orally presented with very specific criteria in mind. In fact, comments were positioned with the criteria and if, during the discussion, the monitor felt that a particular criterion had not been addressed, he would request more information be discussed about that item.

Calling the Question

Similar to many participatory processes in public arenas, the monitor calls the question, asking, "is everyone ready to vote?" This question may actually be presented three times if Robert's Rules of Order are being followed. By asking three times, you ensure that everyone has had a chance to speak about the issue or on this application, and it prepares everyone to vote. In this instance, panelists actually vote with numbered cards after deliberating. The numbers were one through six, and oftentimes as a panelist I felt more like an Olympic judge showing my numbers in the air. I can't say enough great things about this process for review and public hearings, because you can learn so much by observing and listening to the discussion.

As an applicant in this process, I was fortunate to have represented an organization that received a grant. We got the grant because the project had great merit, but also because I followed very carefully the instructions concerning how to put an application together.

The Contract or Grant Agreement from the Public Funder

In some public arenas, the grant agreement is really a contract for services, and so these will look different but generally have similar terms related to reporting, payments, publicity, and prohibitive use of the grant.

The reporting and follow-through on public grants is somewhat standardized in most grant competitions. Depending on the public

agency, you may need to file interim reports, and then a final report, which in most cases is a condition of the grant. Without following through you may not be eligible for any continuing or new grant application.

❧ THE GRANTS ZONE

For site visits, review your request to that funder, and try to remember the specifics. It is embarrassing when someone doesn't even remember what he requested or wrote (promised) in his application.

As mentioned earlier, avoid orchestrating the meeting by having too many people attend who are scripted and who are not that helpful in answering the funder's questions.

Have the financial manager, director, or a person who understands the organization's financial statements be present and ready to answer budget questions. You, as the artist or representative, may not understand all of the financial aspects of the organization or project, but it does bode well if you can speak to some of the questions and issues the funder may have.

❧ DOS AND DON'TS FOR GRANTSEEKERS

Do respond to grant agreements in a speedy and efficient way.

Don't automatically reapply if you have received a decline; it is great to be tenacious, but you should first find out why you were declined.

Do double-check that the project has merit and is worth your effort.

Do try to understand the other side of grantseeking and that foundation staff are human beings, too; they do not relish making declines.

CHAPTER TWELVE

The Sum Is Greater than the Total of All Parts

At that instant he saw, in one blaze of light, an image of unutterable conviction, the reason why the artist works and lives and has his being—the reward he seeks—the only reward he really cares about, without which there is nothing. It is to snare the spirits of mankind in nets of magic, to make his life prevail through his creation, to wreak the vision of his life, the rude and painful substance of his own experience, into the congruence of blazing and enchanted images that are themselves the core of life, the essential pattern whence all other things proceed, the kernel of eternity.

—THOMAS WOLFE

You have arrived at the final chapter and treatise on getting arts grants. You have done an amazing amount of work, and as technical as this field may seem to be, you have learned much about the culture of philanthropy and grantmaking.

This chapter allows us to come full circle and return to the place where we began: the place of the independent artist and creative individual who is now prepared and ready to embrace a creative life, knowing that support is out there for his endeavors.

❧ Heaven is a Great Researcher

And via the University of Michigan, we have been given a gift. Through my own research on grants and particulars for this guidebook, I came across a great list of resources compiled by Jon Harrison at the University of Michigan. Not only are these complete, but they are up to date. It is multidisciplinary and covers a wide range of fields in art. Many of the resources will be Web-based and only a click away from you gaining more information to help you develop. The URL for this invaluable Web resource is *www.lib.msu.edu/harris23/grants/3gradinf.htm*.

The site is divided into four sections: Web sites, databases, books, and announcements. Each of the reference points gives basic information about the link, so you won't waste precious time going to links that are inappropriate. Of course, you will still have to do a fair amount of searching but Harrison has simplified it for you.

❧ The Grants are the *Pièce de Résistance*

Before I leave you to research heaven, I want to wish you luck, clarity, and courage to continue living an artist's life. The grants are the *pièce de résistance* and hopefully you have all the ingredients for understanding the process and enjoying this creative journey. Good Luck!

GLOSSARY

Art Residency: A position of employment where an artist produces work for an established program, place, and time. This can be short-term or longer in duration, and is often associated with academic programs and institutions where the artist becomes involved in mentoring and teaching.

Board of Directors, Board of Trustees: A governing board of a foundation or charitable giving program. Persons in this group are also called members, or directors.

Capacity Building: A term to describe the process for organizations to grow and become efficient. It is also a type of grant that helps in the maturation process of an organization or individual.

Charitable Giving: A broad term meaning all types of philanthropy and foundation giving.

Corporate Giving: Charitable giving provided by a corporation, usually demonstrated through cause-related marketing, in-kind and product donations, and grant funds that support a wide range of activities.

Family Foundation: A private foundation that has been created through a family's wealth, bequest, trust, or name.

Fellowship: A type of grant and support that provides an individual with monetary support while he or she pursues a specified plan for career development and community benefit.

Fiscal Agent, Fiscal Sponsorship: The umbrella entity that provides individuals and organizations the oversight and required conduit for some grant funds. For example, public grants in New York that can support an individual artist but only through the fiscal sponsorship of a bona fide nonprofit organization.

Funder: A general term describing an entity that usually provides grant support. It usually connotes an organization, as opposed to an individual donor.

Grant Docket: The group and cluster of grant requests that will be presented for decision-making by a board of directors.

Grantmaker: A general term connoting a person or entity that provides grants to a wide range of programs and needs.

Grantseeker: A person or entity looking for grants to support a wide range of programs and needs. May also be called a fundraiser or in a more specified activity, a grantwriter.

Philanthropist: Typically a generous person, contributor, donor, or patron who provides monetary support through charitable means.

Private Foundation: A nonprofit or nongovernmental organization with funds that are distributed by a board of directors for purposes to provide aid and support for a broad range of causes.

Portfolio: In the context for artists, it is a collection of work that is shown and exhibited by way of a case, or portable means.

Program Officer: A staff member of a foundation who reviews grant requests for and with the board of directors.

Prospect Research: The research that is usually done in advance of grantseeking and fundraising. It consists of identifying and understanding the nuances of people and entities that can provide charitable contribution.

BIBLIOGRAPHY

Biden, Senator Joseph R., Jr. Web site: *www.biden.senate.gov/services/grants.cfm*.

Bush Foundation. Web site: *www.bushfoundation.org*.

Chronicle of Philanthropy. Web site: *www.philanthropy.com*.

Covey, Stephen R. *The Seven Habits of Highly Successful People*. New York: Simon & Schuster, 1989.

Dictionary of Quotations. London and Glasgow: Wm. Collins, Sons and Co., 1985.

Dyson Foundation. 2005. Web site: *www.dysonfoundation.org*.

Foundation Center, in cooperation with Grantmakers for the Arts. *Highlights of the Foundation Center's 2003 Study Art Funding IV; An Update on Foundation Trends*. New York: Foundation Center, 2003.

——. *Foundation Growth and Giving Estimates/2004 Preview Report*. New York: Foundation Center, 2004.

——. *Foundation Giving Trends/2005 Report*. New York: Foundation Center, 2005.

Hoekstra, Joel. *A Day in the Life of a Program Officer*. The Giving Forum of the Minnesota Council of Foundations, 1999.

——. *The Truth About Site Visits/Why Grantmakers Do Them; What You Should Know*. Minnesota Council of Foundations, 1997.

Internal Revenue Service. *Internal Revenue Code, Annual Return 990-PF*. Washington, DC, 2004.

——. *Internal Revenue Code, Q.IRC 4941-The Nature of Self Dealing*. Washington, DC, 1985.

Jerome Foundation. Web site: *www.jeromefdn.org*.

McCarthy, Kevin F., Elizabeth H. Ondaatje, Arthur Brooks, and Andras Szanto. *A Portrait of the Visual Arts: Meeting the Challenges of a New Era*. Santa Monica: Rand Corporation, 2005.

McKnight Foundation. Web site: *www.mcknight.org*

National Endowment for the Arts. *A Brief Chronicle of Federal Support for the Arts, 1780–2000*. Washington, DC, 2000. Web site: *www.arts.endow.gov*.

New York Foundation for the Arts. Web site: *www.nyfa.org*.

Proscio, Tony, *Bad Words for Good: How Foundations Garble Their Messages and Lose Their Audiences*, commissioned by the Edna McConnell Clark Foundation, *www.emcf.org*

Quotations. Web sites: *www.brainyquote.com* and *www.thinkexist.com*

Renz, Loren, and Caron Atlas. *Arts Funding 2000: Funder Perspectives on Current and Future Trends*. New York: Foundation Center, 2000.

Stafford, William. "You Reading This, Be Ready," Friends of William Stafford. Web site: *www.willliamstafford.org/spoems/*

Yeats, William B., *Selected Poems: He Wishes for the Cloths of Heaven*. London: Macmillan London Ltd., 1962 and Pan Books Ltd., 1974.

Index

Books from Allworth Press

Allworth Press is an imprint of Allworth Communications, Inc. Selected titles are listed below.

The Artist-Gallery Partnership: A Practical Guide to Consigning Art, Revised Edition
by Tad Crawford and Susan Mellon (paperback, 6 × 9, 216 pages, $16.95)

Legal Guide for the Visual Artist, Fourth Edition
by Tad Crawford (paperback, 8½ × 11, 272 pages, $19.95)

Business and Legal Forms for Fine Artists, Revised Edition
by Tad Crawford (paperback, includes CD-ROM, 8½ × 11, 144 pages, $19.95)

Selling Art without Galleries: Toward Making a Living from Your Art
by Daniel Grant (paperback, 6 × 9, 256 pages, $19.95)

The Fine Artist's Career Guide, Second Edition
by Daniel Grant (paperback, 6 × 9, 320 pages, $19.95)

The Business of Being an Artist, Third Edition
by Daniel Grant (paperback, 6 × 9, 354 pages, $19.95)

An Artist's Guide: Making it in New York City
by Daniel Grant (paperback, 6 × 9, 224 pages, $18.95)

How to Grow as an Artist
by Daniel Grant (paperback, 6 × 9, 240 pages, $16.95)

The Fine Artist's Guide to Marketing and Self-Promotion, Revised Edition
by Julius Vitali (paperback, 6 × 9, 256 pages, $19.95)

The Artist's Quest for Inspiration, Second Edition
by Peggy Hadden (paperback, 6 × 9, 288 pages, $19.95)

The Quotable Artist
by Peggy Hadden (hardcover, 7½ × 7½, 224 pages, $16.95)

Caring for Your Art: A Guide for Artists, Collectors, Galleries and Art Institutions, Third Edition
by Jill Snyder (paperback, 6 × 9, 256 pages, $19.95)

Please write to request our free catalog. To order by credit card, call 1-800-491-2808 or send a check or money order to Allworth Press, 10 East 23rd Street, Suite 510, New York, NY 10010. Include $6 for shipping and handling for the first book ordered and $1 for each additional book. Eleven dollars plus $1 for each additional book if ordering from Canada. New York State residents must add sales tax.

To see our complete catalog on the World Wide Web, or to order online, you can find us at **www.allworth.com.**